Photographic
Composition

PHOTOGRAPHIC COMPOSITION

Tom Grill & Mark Scanlon

FOUNTAIN PRESS LIMITED
65 Victoria Street, Windsor,
Berkshire SL4 1EH England

First published 1983 in New York, New York by American Photographic
Book Publishing: an imprint of Watson-Guptill Publications, a division of
Billboard Publications, Inc., 1515 Broadway, New York , NY 10036.

First Published in the UK by Fountain Press Ltd, 1984

ISBN 086343 0600

Library of Congress Cataloging in Publication Data

Grill, Tom, 1944—
Photographic Composition.

Includes index
1. Composition (Photography) I. Scanlon, Mark.
1945— .II Title.
TR179.G74 1983 770.1'1 82-22780
ISBN 0-8174-5419-5

Phototypesetting by Tenreck Limited, London
Printed and Bound in Spain by Graficromo S.A. Cordoba

CONTENTS

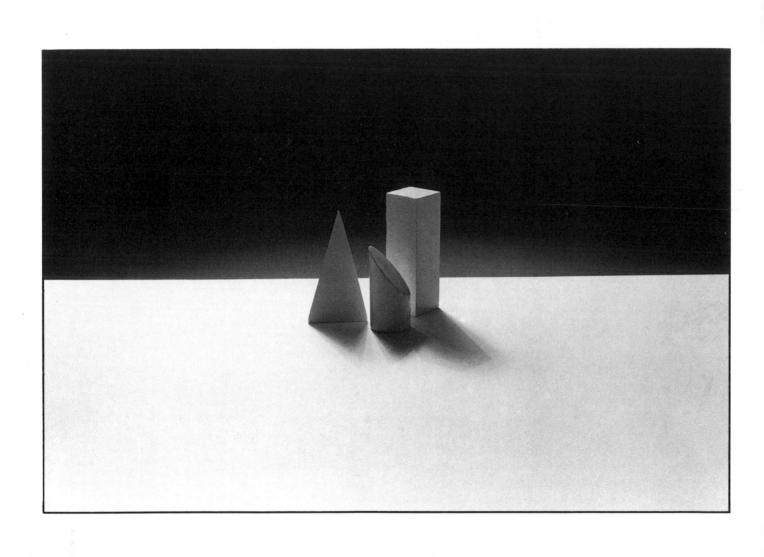

CHAPTER ONE

EXPRESSING IDEAS

Behind every photograph is an idea. The idea may be mundane: "This is the way I looked standing in front of the Eiffel Tower on my vacation;" profound: "Man's vanity is surpassed only by his capacity to deceive himself;" or abstract: "This pattern evokes a feeling of tension;" but every photograph has its origin in the desire of a photographer to say something meaningful.

For some people, photography is useful only for preserving memories, or for making a record of a place or event. At this basic level, most of the photographer's message remains within his own head. The finished photograph jogs his memory, but means little to someone else without an accompanying explanation. ("Here's one of my little girl the day she got married. You should have seen her. She was very happy. See that vase in the background? It was a wedding present. During the reception, it got broken. It almost ruined the day for her.") The visual content of a photograph in such cases is very limited, and, consequently, so is the amount of visual communication that takes place.

Yet the photographer did not set out to produce a shallow photograph, even though that is what he ended up doing. Had he been asked to put his intentions into words, he would have *not* have said, "What I really want to do is create a vague likeness of my daughter that I can use to discuss her wedding day." Instead, if pinned down, he would have said something like, "My daughter is getting married tomorrow, and I want to capture her joy, the excitement of the event, and the pleasure I know everyone present is going to experience." Never having identified his real intent, however, he was unable to make the photographic decisions that would have enabled him to realize his goals.

Therefore, an important reason why photographs often fail to communicate ideas is that effective communication does not result unless a photographer identifies why it is he wants to take a particular photograph. He cannot decide how his photograph should be composed unless he knows what he is trying to convey. Muddled thoughts result in muddled compositions; clear thoughts are the cornerstone of good composition and effective photography. Most people, however, encounter great difficulty in trying to crystallize their thoughts with

sufficient clarity to serve as the basis for making appropriate compositional decisions.

Thus, although all photographs are motivated by the desire to communicate an idea, that idea must be focused before a photographer will be able to convey his message effectively. Indeed, if even a modest proportion of photographers could express their ideas successfully on film, the words, "Why not stop by this evening and look at the slides I took on my trip," would not generate such dread and inspire so many creative excuses. No one aims to bore an audience, but few photographers are able to convey through their images the fun and excitement that they had wanted their cameras to capture.

Why are most photographers unable to communicate ideas effectively? Primarily because the visual medium of photography is much less familiar to twentieth-century man than the spoken and written word. Even though a visual "language" exists that has an identifiable, learnable structure that is analogous to that of the verbal language with which everyone is familiar, and even though in today's world the importance of visual forms of communication is rapidly approaching that of verbal forms, visual "illiteracy" abounds. Consequently, most photographers are unable to exploit the medium effectively, and those comparatively few photographers who *can*, have as an audience only a limited number of people knowledgeable enough to understand and appreciate the fine points of photography.

A language without any rules or conventions is unintelligible. In the verbal medium, the applicable rules and conventions are called grammer and syntax. Effective communication requires that all parties involved know and employ the agreed-upon grammer and syntax patterns. Communication is impeded to the extent that any party does not know or does not follow the established rules and conventions.

In the language of the visual arts, grammer and syntax are called *composition*, which we define as *the controlled ordering of the elements in a visual work as the means for achieving clear communication*. All discussions and evaluations in *Photographic Composition* will relate to the role a compositional device plays in supporting or detracting from the expression of ideas. The goal will be to develop a visual "vocabulary" that a photographer can draw upon in the course of translating ideas into images, and that a viewer can use to develop an appreciation for the art of photography.

Fortunately, through an understanding of the principles of photographic composition, any photographer can

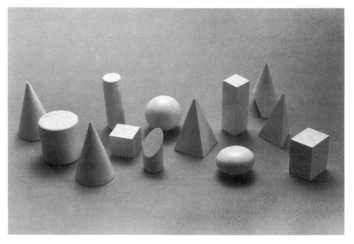

Compositional Controls

In broad terms, a particular photographic composition can be thought of as the product of *graphics* (points, lines, and spaces), *photo*graphics (the unique ways the implements of photography influence the final image), and *colour* (wavelengths of light affecting the viewer both physically and emotionally). However, objects in the real world are recognizable and have *meanings* that frequently interfere with a photographer's ability to analyze the visual components of an image in purely abstract, compositional terms.

To alleviate this problem (which occurs to a greater or lesser extent in all the visual arts), artists have traditionally refined their compositional skills by using simple geometric forms as subjects. Certainly cones, circles, squares, rectangles, and other geometric forms have meanings as identifiable shapes, but those meanings are rather easily separated from the way the objects are arranged within the frame of the photograph—which is an important aspect of composition.

The photograph above presents a collection of geometric shapes that were purchased from an art supply shop. Although the objects themselves are fundamentally simple, their use as photographic subjects has the potential for contributing significantly to a photographer's appreciation of compositional relationships. In particular, the various surfaces provide an excellent vehicle for developing not only an appreciation of arrangement, but also a sensitivity to the effect of light on the appearance of objects.

The photographs on the following four pages employ these geometric figures in various ways that preview some of the types of compositional considerations that will be discussed in detail throughout the book. Although many of the later photographs will necessarily include objects more complex than geometric forms, the reader will benefit from attempting to evaluate all photographs in terms of the placement of shapes in the frame, regardless of what those shapes represent in the real world. By doing so, the reader will begin to develop the skill that lies at the heart of composition: the ability to look at a scene as a collection of independent elements that must be included, excluded, or manipulated in the process of composing a photographic image.

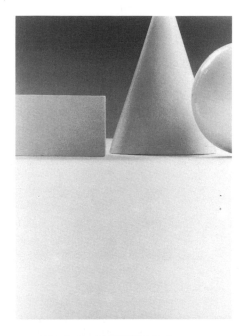

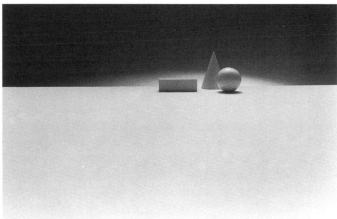

Involvement

The way a photograph is composed directly affects the relative sizes of the objects within the frame. Moreover, these size relationships can strongly influence the emotional reactions of a viewer.

In the two photographs shown above, significantly different compositions produce radically different viewer reactions. In the lower photograph, the viewer feels somewhat detached from the scene. He is an observer. His relationship to the geometric shapes is as remote as that of a traveller flying over a city. In contrast, in the upper photograph, the viewer is a participant. He is involved with the objects, as if the traveller has landed and is now exploring the city.

Specific compositional decisions were made to create the different types of viewer involvement present in these two photographs. The feel of the lower photograph results from the decision to render the objects small within the frame and to shoot from above the plane of the table. In contrast, the feel of the upper photograph results from the compositional decision to have the frame cut off the figures and to shoot from "ground" level.

Skill in composition requires first that a photographer recognize how the visual relationship he establishes among the various elements in a scene will affect the emotional and intellectual reactions of a viewer, and second, that the photographer adjust those elements as necessary to reach a specific photographic goal.

improve his ability to use photography as a form of communication and thereby turn those slide shows into entertaining, engaging experiences. In addition, a knowledge of photographic composition can introduce a photographer to new, deeper, more satisfying dimensions of photography, dimensions of which the casual photographer is completely unaware. Certainly, effort is involved, but the effort is unquestionably worthwhile.

WHY COMPOSITION SEEMS INTIMIDATING.

The idea of learning about composition intimidates many people. The reasons for this reaction are rooted in our culture and our experiences.

Visual education is routinely undervalued—Before the advent of a written language, preserved communication necessarily was restricted to pictures. Indeed, the earliest written languages evolved from collections of pictorial symbols. As more sophisticated written languages developed, they were understood only by an elite few, even well into the Middle Ages. The common man was accustomed to obtaining information from sketches and paintings. The great paintings of the period from the time of Christ up to the Renaissance may have great value today as works of art, but in their time their function was to help an illiterate populace understand and accept the dominant religious tenets of the day. As a result, the ability of individuals to understand, appreciate, and respond to visual imagery may well have been more acute during the Middle Ages than now. The consequence for modern youngsters is that visual education is afforded a low priority in the schools.

What happened to undermine the importance of visual communication? The printing press was invented and, freed from the burden of being laboriously copied by hand, books became widely available. As more and more people learned to read, the written word gained dominance as the foremost purveyor of information and knowledge. Painting and other visual arts continued to play an educational role, but the importance of that role diminished substantially in the everyday life of the average citizen.

Although nobody realized it at the time, the arrival of the camera in the early nineteenth century was to begin the process of restoring visual communication to prominence in everyday life—if not in the schools. In a way, the camera has had nearly as strong an effect on the relationship between the verbal and visual as the printing press. Being so close to the effect, however, we tend not to recognize it.

Learning about composition is in many ways like studying a new language. Effort is involved, and progress at first seems slow. Ultimately, however, the skill becomes second nature, and the effort is seen to have been eminently worthwhile.

Over the course of 150 years, the technology initiated by the camera has resulted not only in still images, but also in cinema and more recently in television and video. These advances have changed the way we live, and especially the way we obtain information. For example, with disconcerting regularity, newspapers, unable to compete with the visual approach to news characteristic of television, are folding. In an effort to retain their readers, those newspapers that remain viable are cutting back on news coverage in order to carry more entertainment features. Indeed, the impact of television has become so pronounced that many commentators have credited the influence of television news coverage with precipitating the revulsion to the Vietnam war that eventually developed in the American populace.

Visual education has not kept pace. During the early 1970s, when money for education was plentiful, the number of positions available for teachers of the visual arts increased rapidly. However, many people consider education in the arts to be expendable and even frivolous. Therefore, as declining enrolments produced budget restrictions in the latter part of the decade, and as a grassroots "back-to-basics" movement began to take shape, among the first categories of courses to be eliminated were those concerned with the visual arts. Today, the traditional subjects of English, mathematics, science, and social studies alone receive primary emphasis in most of our schools.

Thus, the quality of education in the visual arts provided by our schools is sadly deficient, and becoming worse. Those courses that do exist tend to be so elementary, or shortsighted, as to be of limited value. At best, children are encouraged only to learn to draw recognizable figures and not learn about the communication content of imagery. How many children, even those who have taken formal art courses, have been taught to be sensitive to the emotional content of lines, shapes, forms, and colours? Since these concepts go to the heart of understanding composition, it is little wonder that composition seems to be an alien, frightening topic to learn.

The "rules" of composition are not really rules at all, but guidelines—The analogy between the verbal and visual languages breaks down somewhat with respect to the applicability of *rules*. In the verbal and written languages, most grammatical rules can be applied uniformly. If the conditions fit the rule, then the rule applies with few, if any, exceptions. In the visual arts, however, the rules are much more flexible. Indeed, "rules," in a sense, do not exist at all.

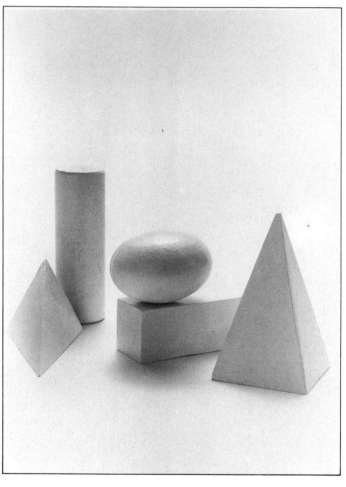

The Control of Light
Ultimately, photography, and therefore composition, can be described as the control of light. Consequently, part of the process of learning composition involves developing both an awareness of light and the ability to alter the light present in a scene—either directly or indirectly—in order to make an effective visual statement.

The primary difference between these two photos results from the way they are illuminated. At left, diffused light produces soft shadows and a light, airy, and delicate feeling. On the right, harsh, directional light produces a much stronger, more dramatic feeling. Moreover, the

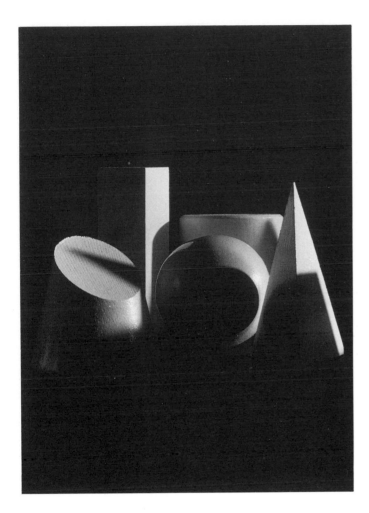

locations of the shadows are by no means random. Each is so prominent and has been so carefully positioned that together they play a more powerful compositional role than the geometric figures themselves.

Not every photograph will contain such dominant shadows, but a photographer must always look at light as a physical element to be controlled. Because light can produce shadows, he must decide whether he wants shadows to be present and if so, he must deal with them just as decisively as he does with every other element present within the frame.

Historically, rules of composition were developed after the fact. Some people (call them "visual thinkers") are born with an intuitive sense of good composition. They do not need to be taught composition, and their work is immediately perceived as being well composed by other visual thinkers. In an attempt to help nonvisual thinkers learn composition, art critics analyzed well-composed works in the hope of recognizing patterns and trends that anyone could employ to achieve similar results.

The problem with those patterns that have been identified is that they are by no means universal. A compositional rule is useful only so long as it enhances the idea that the photographer is trying to express. If for any reason adhering to the rule detracts from the ability of the photograph to convey the intended message, then the rule not only can be, but *must* be, broken.

In essence, there is no objective standard by which to judge whether a given composition is "good" or "bad". Any composition that efficiently conveys a photographer's intended meaning is perfectly acceptable. Any composition that muddles that meaning is not. The evaluation is entirely subjective.

As a result, the study of composition can seem at first to be full of contradictions. Nevertheless, learning the rules, such as they are, can still be useful as an exercise in developing a repertoire of options. The so-called rules have been derived because they describe identifiable patterns that have recurred in the works of many different artists. Awareness of the rules is thus part of the process of understanding composition, and as long as they are not considered to be inviolable, they can be quite useful.

New languages, like new skills, are difficult to learn— young children seemingly learn without pain and without effort. Adults usually find the learning process much more challenging.

Learning about composition is in many ways like studying a new language. A substantial amount of effort is involved, and progress at first seems tedious and slow. Moreover, as with any new skill, there is a period during which the ability to accomplish a task takes longer using the new technique than the old, and, even more frustrating, produces results that are often inferior. It is somewhat akin to learning to touch-type. Keyboard drill is drudgery, and for quite a while the process of typing by touch is substantially slower than writing longhand or "hunting and pecking". Often, the finished product is embarrassingly full of errors. Ultimately, however, the skill becomes second nature, errors decline, and the effort seems, in retrospect, to have been eminently worthwhile.

The process of mastering composition follows a similar pattern. Many people initially become discouraged and question the value of what seems like an enormous effort. Those who persevere, however, eventually experience the satisfaction of being able to produce photographs that are vastly improved æsthectically and that communicate ideas with dramatic effectiveness.

Myth: Only a talented few can master the techniques of good composition—There is no question that a few fortunate individuals are born with an innate visual sensitivity. Even without formal instruction, these people are able intuitively, efficiently, and effectively to communicate their ideas visually. Likewise, they are very receptive to visual signals generated by others.

People without such sensitivity, who have not been trained in the visual arts, often have great difficulty in understanding intellectually the depth of information that can be contained within even a simple visual image. Because they do not respond to visual images as easily and profoundly as others seem to, these people view the visual arts with awe. They assume that the world of art is so abstract and esoteric that it is comprehensible only to an elite few.

The irony is that, regardless of native talent or formal training, everyone who can see is at least *subconsciously* responsive to visual cues. Over time, common responses to visual stimuli have evolved that are almost universal, and people react to these stimuli intuitively. For example, advertisers know that a viewer need not be versed in the visual arts to be susceptible to visual suggestion in a television commercial or magazine ad. Indeed, the most highly sought-after commercial photographers enjoy their status for one reason: they know how to use visual imagery to convey the messages advertisers want mass audiences to perceive.

Exactly the same ability to use imagery to convey ideas that has commercial value in advertising also forms the basis of visual communication no matter what the goal of the photograph or the photographer. However, before a photographer can begin to develop his visual skills, he must truly *want* to. Many, if not most, photographers express an interest in improving their photograph, but few translate the wish into action. A photographer must be willing to devote the time, attention, and self-discipline necessary to concentrate on his goal and pursue it until it is reached.

While it is true that some learn more readily than others and that there are individual differences in the maximum

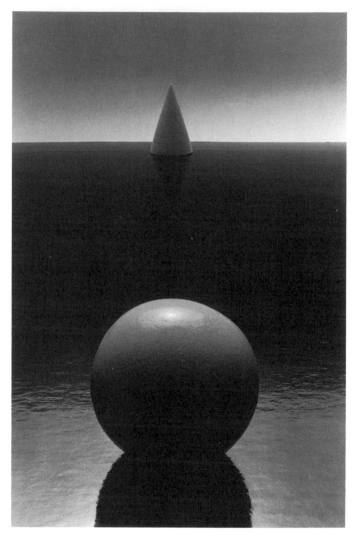

Image Alteration
The nature of the photographic equipment is to alter the light entering a camera. Consequently, a photographic image always differs from the original image to some extent. The photographer's responsibility is to be aware of the alterations that will occur and use that awareness to his advantage.

The sphere in the above photograph is smaller in diameter than the height of the cone, yet was made to appear significantly larger by a placement comparatively close to the camera. The relative difference in size could have been further adjusted by using a lens of shorter focal length from a nearer viewpoint. Although in the photograph at right the size relationships appear to be more nearly correct, other differences between the original scene (specifically with respect to tonal rendition) are present.

Thus, mastery of composition entails an ability to predict how the specific items used to take a photograph will contribute to the appearance of the final image.

Any photographer can benefit from systematic exposure to the concepts and principles of good composition. Composition is knowable, and it is learnable.

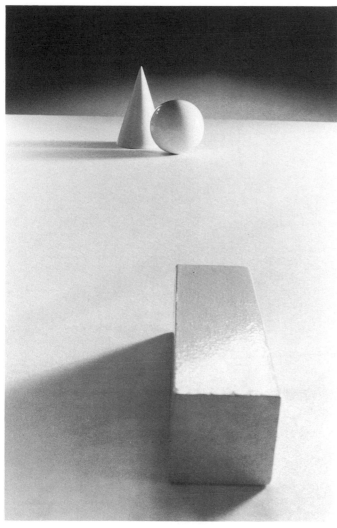

degree to which visual sensitivity can be developed, any photographer can benefit from systematic exposure to the concepts and principles of good composition. Composition *is* knowable, and it *is* learnable, but only if the desire for mastery is really there.

Most photographers cannot see beyond "reality"—When a painter begins a work, he starts with a blank canvas. The image he wants to create exists in his mind. Even if his goal is to paint the scene in front of him, because the process occupies many hours, weeks, or even months, he can decide at his leisure what he will include, what he will exclude, what he will distort, and how he will distort it. The painter may try to reproduce faithfully the "reality" of the scene he sees in front of him, but only if he so chooses. If he chooses not to, he has all the time he needs to make whatever changes he wants.

The nature of the medium of photography can cause the photographer to feel more constrained. The process of taking a photograph occurs over such a short span of time that he has comparatively little time to think about what he is doing. He views the world through a viewfinder that reproduces a scene almost exactly as it appears to the naked eye. He has a much more limited opportunity than the painter to select which elements within a scene to include or exclude. Just as important, the photographer cannot see his work as it progresses. He cannot step back, ponder his results, and make changes piecemeal and experimentally. When the shutter is snapped, the image is frozen.

Nonetheless, the essence of photographic control and the prerequisite to a strong composition is that the photographer think of the image as an independent visual entity he needs to assemble piece by piece, much as a painter does. This approach requires that the photographer detach himself from the reality of the scene in front of him and view it *objectively* as a collection of many visual elements that interact not only with each other but also with the frame of the photograph.

Perhaps no technique of composition is more important than this detachment nor more difficult to develop and sustain. Because of the nature of their medium, most photographers cannot see beyond their subject; that is, they cannot force themselves to view the scene not for what it is in the real world, but as a collection of lines, shapes, forms, and colours. Even if the goal is to present the scene realistically, the effectiveness of the photograph's composition will be critically dependent upon these visual relationships. However, once a photographer

Balance Within an Image
Depending on photographer's intent, the size and space relationships among the elements of a photograph can be controlled so as to make the composition appear either balanced or unbalanced. Visual balance, however, is an elusive concept that is not intuitively obvious to many people.
Although the photograph above is not symmetrical, a sense of balance nonetheless prevails. The balance results from a carefully controlled relationship between the elements in the image and the imaginary lines that bisect the photograph both vertically and horizontally.
Specifically, the upper edge of the rectangular solid lies on the horizontal midline, and the left-hand edge

lies on the vertical midline (which also bisects the sphere). In addition, the upper, left-hand corner of the square falls at the exact centre of the image. Finally, the "weight" of the body of the rectangular solid, which lies to the right of the vertical midline, is counterbalanced by the "weight" of the cone, which lies to the left.
Visual balance is a specific case of the general concept that every photograph should reflect some sort of underlying order. In some situations a balanced composition is desirable, in others it is not, but a photograph that entirely lacks any semblance of order can make no statement other than, "Here lies utter chaos".

is able to shed his attachment to reality, he has taken the first, critical step toward mastery of photographic composition and the effective communication of ideas.

COMPOSITION AS CONTROL

In essence, composition is control. The composition of a photograph is the means a photographer has at his disposal to direct another person toward or through the idea that motivated the photograph in the first place. In that sense, composition manipulates. It extends the influence of the photographer, enabling him to influence the viewer physically, emotionally, and intellectually.

Awesome as it may sound, composition is adequate for the task. Studies have shown what visual thinkers know intuitively: the gazes of viewers follow controllable paths in looking at paintings or photographs. The skilled artist knows exactly how to shepherd the viewer's gaze across the work. He places lines, shapes, and colours where they will attract and lead the eye in a predictable fashion. The viewer succumbs to these cues subconsciously, but willingly. The result is that the photographer has controlled the viewer's gaze and therefore his perception.

A talented photographer knows how to control the emotional content of his work and consequently the emotional response of his viewer. Shapes and colours, especially, have emotional connotations for viewers. For example, jagged shapes imply action and tension, smooth shapes calm and peace. Reds, yellows, and oranges, all "warm" colours, evoke different feelings in a viewer from those of the "cool" blues and greens. A photographer must be aware of the connotations of all the elements in his photograph, so that in the process of building the image, he knows which components of a scene will support his idea and which will detract from it.

The intellectual control composition provides results from the interaction of the physical, emotional, and subject content of the photograph. A provocative idea combined with an effective composition elicits an intellectual response. The photograph seems worth discussing, or at least pondering. The viewer obtains stimulation and perhaps pleasure from the idea behind the photograph—an idea that is perceivable by means of the instrument of good composition.

In short, a serious photographer cannot hope to use the medium of photography to communicate his ideas without an understanding—and ultimately a mastery—of good composition. The process may not be easy, but the goal is certainly attainable. And the rewards for the conscientious photographer, as well as for the interested viewer, are worthwhile indeed.

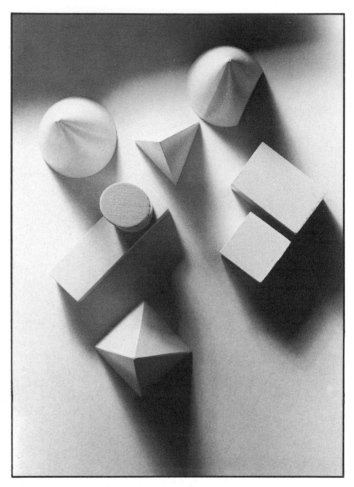

Being Unconventional

In general, the more imaginatively an image expresses an idea, the more effective that image is. Therefore, a photographer should try to avoid being too traditional and should instead *explore* a subject with his camera, looking for novel approaches that a less conscientious photographer might miss.

For example, the approach above was to look straight down on the subject, rather than limiting the views to a conventional, horizontal perspective. As a more extreme example, in the photograph at right the unusual orientation of the frame immediately attracts attention. How-ever, that orientation is not selected simply for novelty. The elements are carefully arranged to work together and reinforce each other, and at the same time complement the diamond shape of the frame.

Film can be the equivalent of an artist's sketch pad. A photographer can use film to investigate a subject visually—to experiment with different views and under different conditions in order to extract from a scene a variety of different images. Rarely will the first image be the best. Almost invariably, one of the subsequent images will stand out as being substantially more eloquent than the other.

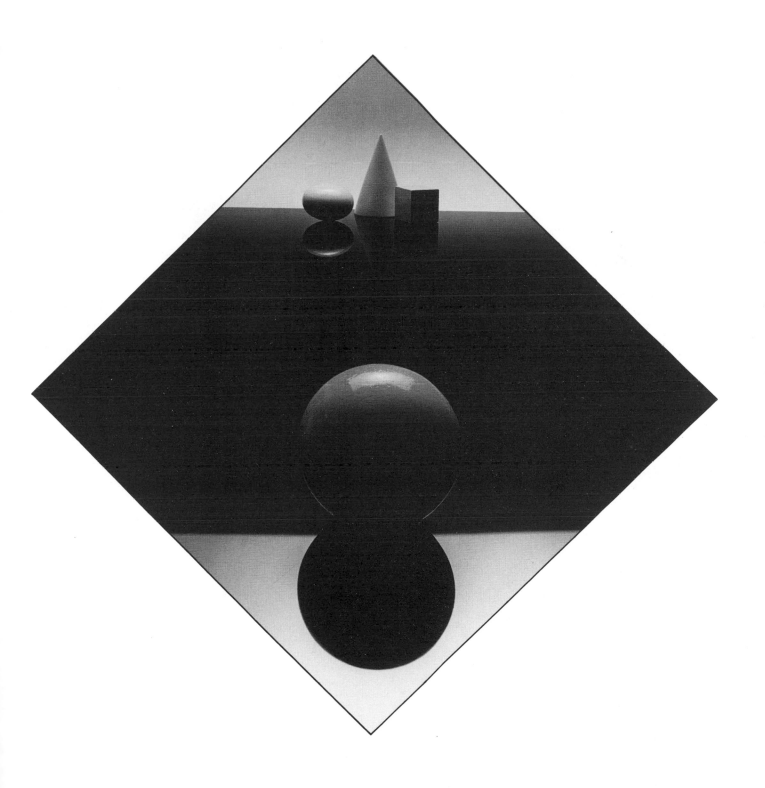

Statements: The Basis of Composition

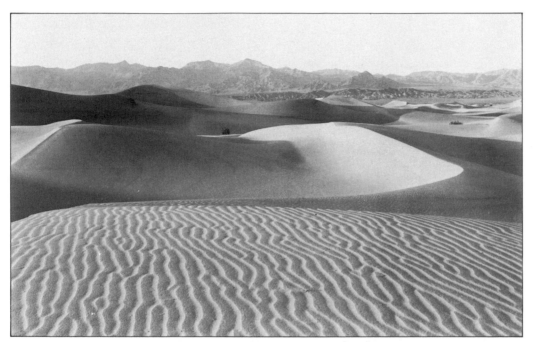

A Feeling of Depth
Normally, a feeling of depth is generated in a photograph by the presence of converging lines and by the tendency of atmospheric haze to make background objects seem less distinct than those in the foreground. In this photograph, because the lines in the foreground appear to be parallel and because the atmosphere was crystal clear, a feeling of two dimensions is preserved. Furthermore, the lines that are present are generally horizontal, or at most, gently curved—a condition that contributes significantly to the feeling of calm.

When a photographer is not attempting to say something with his camera, then he has no good criteria by which to make decisions about how the photograph should be taken.

Should he include this object or exclude it? Which lens should he use? What should be in focus and what should not be? Should he change his viewpoint or should he stay where he is? As a consequence of this lack of criteria, the objects within the frame tend to dictate the composition. One object "looks nice" next to another. Another object happens to be there, so it might as well be included. A colour seems pleasant, so it is used.

The situation is quite different when a photographer has a specific idea in mind that he wants to convey. Automatically, he can include or reject elements on the basis of whether or not they help him express his idea. Choices of film, camera size, lens, filters, and so on, all are arrived at more easily. The scene within the viewfinder can be adjusted so that the final cropping and arrangement of the items make sense. In short, what the photographer has to say becomes the point of reference, not what the objects within the scene seem to be saying on their own.

To illustrate the way having a clear statement to make dominates photographic composition, a series of photographs is presented here and on the following three pages. Even though the subjects of these photographs run from the commonplace to the unusual, and from the concrete to the abstract, and include such divergent subjects as a landscape, two cities, a nude, and an arrangement of pipes, the idea behind each photograph was the same: to generate a feeling of cool, calculated order. The result is that despite the different subjects, it is the idea that dominates and serves as a common element that links all of the various images.

Specifically, the images all share a type of line: basically straight and joined into geometric shapes. All of the photographs share a light, airy tone. They all share a straightforward treatment that avoids distortion. And they all seem more two-dimensional than three-dimensional in appearance.

Brief comments accompany the five photographs to point out some of the aspects of composition that are at work. These aspects will be discussed in greater detail in subsequent chapters.

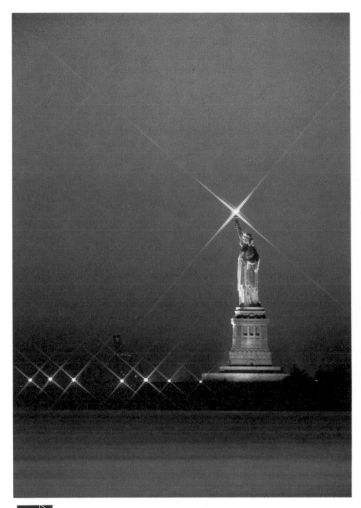

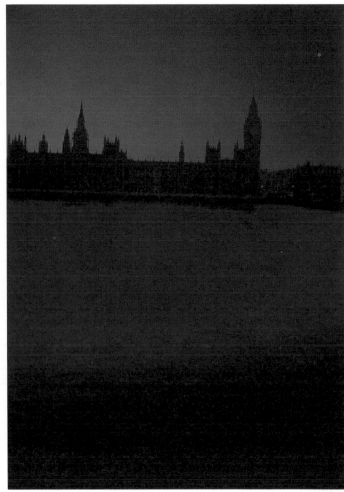

Two Cities, One Statement

Cities can be regarded as places of frantic activity and even violence. In this case, however, the statement is intended to reflect a different side of city life.

In both of these photographs, the city is presented as a dignified, peaceful place. Nowhere is disorder apparent. The subjects of the two photographs, New York's Statue of Liberty and London's Houses of Parliament, are intentionally kept small within the frame. The compositions are mainly monochromatic, that is, mostly one colour. Lines are straight and ordered. Even though the star effect produced in the statue's torch by a star filter is diagonal, the various points of the star balance each other.

In the New York photograph, timing was important to maintain the feeling of balance. The scene was photographed just when the light intensities of the sky, the statue, and the water complemented each other. Less than five minutes later the water turned completely black. Had the intent been simply to show what the statue looks like, this balance of light intensities would not have been so important. However, the photograph as it stands better expresses the feeling of calm and order that the photographer sought.

In the London photograph, purple, the colour of royalty, contributes to a regal feeling. Moreover, the buildings appear to be calmly emerging from the river, rather than being thrust out forcefully. In keeping with the message of reason and order, the photograph does not say "London" loudly, but presents just enough skyline detail to make the city identifiable.

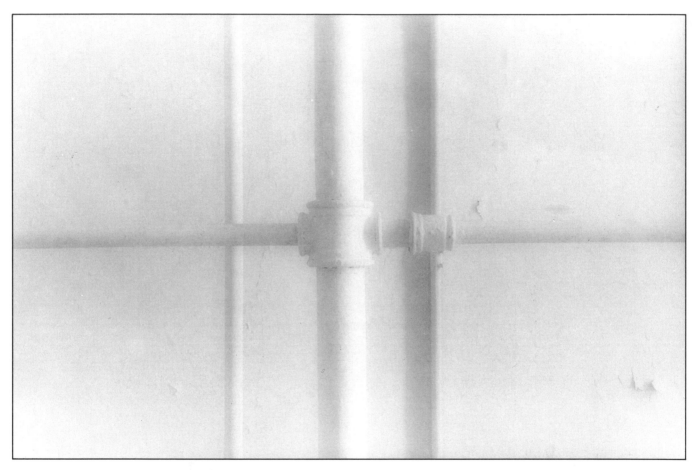

Stable Asymmetry
At first impression, this photograph seems to be symmetrical. Lines are horizontal and vertical, and seem to be balanced around the centre of the frame. On closer inspection, it is apparent that slight differences exist between different halves of the frame.

Thus, the overall effect is of order. Asymmetry is present, but stable, adding visual interest to the image without making the composition seem awry. The subject is abstract, but the statement made is nonetheless similar to that in the other photographs.

A Geometrical Composition.
Most people think of the female form not as being geometrical, but as being softly curved. In this composition, all of the elements contained within the frame and all of the photographic techniques used have been directed toward transforming the figure into a regular, geometric form.

For example, framing the photograph so that the woman's head is not included helps distract attention away from the fact that the subject is human and toward the idea that the photograph is primarily a collection of angular lines. In some ways this photograph actually has more in common with the photograph of the pipes on the previous page than with the nude figure on page 44, which projects a strong, dynamic feeling due to sharply curved lines and a feeling of muscular tension.

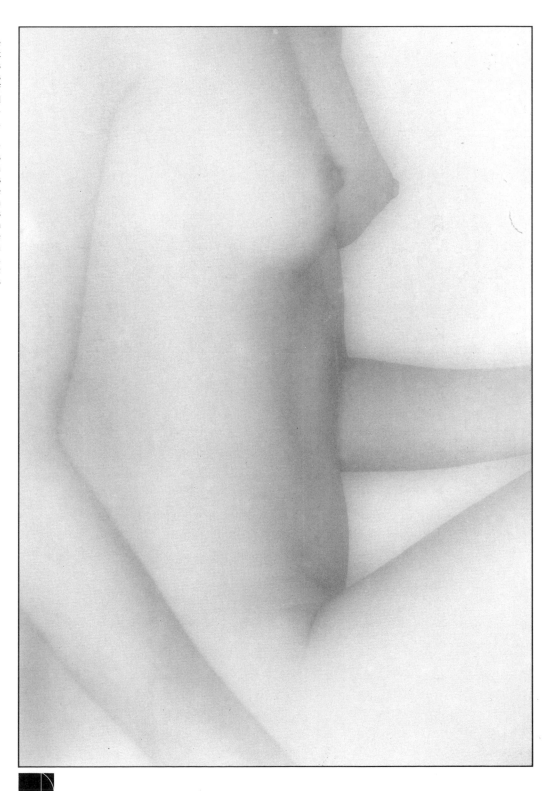

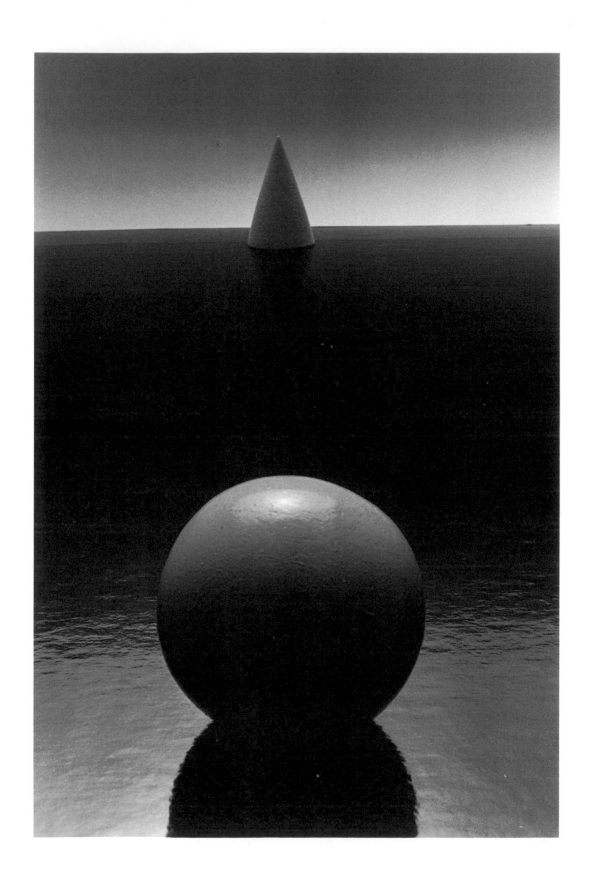

CHAPTER TWO

GRAPHIC CONTROLS

Despite photography's three-dimensional appearance, a photograph really consists of nothing more than a two-dimensional surface on which deposits of different tones and colours have been laid. In this regard, a photographer has much in common with a painting, a lithograph, a printed page, or any of the other two-dimensional media collectively referred to as the graphic arts. Because photography shares so many of the characteristics of other two-dimensional disciplines, a skilled photographer needs to be familiar with the basic concepts of the graphic arts if he is to use his medium effectively.

The fact that relatively few photographers have any formal art training helps explain why most photographers consider photography to be significantly different from the other graphic arts. Of course, photography does have unique characteristics that set it apart, but the photographer who is unaware of or ignores the role

It is the photographer's responsiblity to ensure that within his photograph there is some type of order imposed on the objects enclosed within the frame.

graphics play in photography severely limits his ability to communicate.

This does not mean that a photographer must become an artist *per se*. Although a background in painting, for example, can be extremely helpful, informal training can certainly be sufficient. As long as a photographer has a grasp of the fundamental principles characteristic of all the graphic arts, their effect will be to enhance his work. Conversely, the work of a photographer who is unaware of these principles is likely to seem deficient to anyone with a discerning eye.

On a practical level, graphics—the interrelationships of the points, lines, shapes, and frame of a photograph—penetrate to the heart of photography. Because graphics directly control the response of a viewer, they are the primary tool with which the photographer conveys his message. If the graphics are correct, if they have been carefully selected and controlled so that they support and reinforce the photographer's intended meaning, then a sensitive viewer will be able to understand what the photographer is trying to say. If the graphics are inappropriate, the message will be garbled and perhaps unintelligible.

THE MIND SEEKS PATTERNS

One of the most basic concepts of graphics is that the human mind seeks to identify patterns. This is hardly surprising considering that without the presence of recognizable patterns, interpretation is impossible. The mind absorbs raw data from the visual field, looks for outlines, shapes, colours, and other familiar patterns and clues, and then synthesizes the individual images it has identified into an overall interpretation of the scene being viewed. The process is involuntary and nearly instantaneous.

Even when a scene contains essentially random elements, the mind looks for order. The man-in-the-moon, shapes within clouds, figures within ink-blots, all spring into consciousness spontaneously. It is almost as if the mind does not believe that anything can be random. If there is a pattern, it will be found, and if a pattern truly is not present, the mind will feel unsatisfied.

These patterns exist on various levels. At the simplest level, the mind merely tries to identify object. "Is this something I have seen before? Ah, yes. It is a tree." At a more subtle, intuitive level, the mind looks for patterns in the relationships between the objects it sees before it. If a photographer has arranged the objects in a photograph so that they appear to fit into a pattern, the mind will

The Golden Section

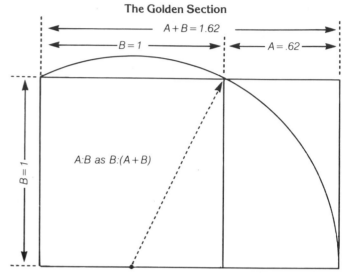

The Golden Section

A "Golden Section" is defined as a line that has been divided so that the length of the smaller segment as compared to that of the larger is equal to the length of the larger segment as compared to that of the entire line. In practical terms, a Golden Section is a line that has been divided into two segments with a ratio of approximately 8:5 (Figure *a*). By extension from the Golden Section, a rectangle is called a "Golden Rectangle" if the ratio between the long dimension and the short dimension is 8:5 (figure *b*).

Mathematically, ⁵⁄₈ – 63, and therefore the ratio 8:5 can also be expressed as 1:63. Since 3:2, the proportions of the 35mm frame (figure *c*),

can also be expressed as 1:67, the 35mm frame closely approximates the proportions of the Golden Rectangle (1:63 versus 1:67).

If the 35mm film frame is mentally divided into thirds, both vertically and horizontally (figure *d*), and objects within the frame are lined up along these vertical and horizontal lines or at their intersections, experience has shown that a harmonious balance among the various elements will often result. (However, this so-called *Rule of Thirds* is hardly rigid. Many situations will occur when an arrangement based upon the Rule of Thirds will not be appropriate for executing the photographer's intent.)

The 35mm Frame

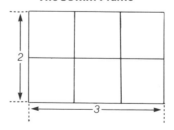

The Golden Rectangle

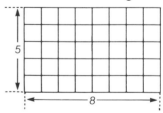

The "Rule of Thirds" Grid

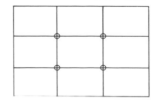

perceive some sort or order. The pattern behind the appearance of order may not be obvious to a viewer—he may not be able to describe exactly what the pattern is—but he will sense its presence. Should there be no recognizable order, the mind will either create its own or sense that something is missing.

Thus, it is the photographer's responsibility to ensure that within his photograph there is some type of order imposed on the objects enclosed within the frame. This order can follow some established formula or it can originate from within the photographer.

Established formulae in the graphic arts have existed for thousands of years. An elementary formula involves nothing more than dividing the visual frame into an imaginary pattern of squares and then distributing the objects within the frame along these lines or at their intersections.

A graphic formula can be based on any geometric rule, but one, derived from what is called the *Golden Section*, has been especially popular for many centuries. The Golden Section is a rectangle of a shape such that the ratio of the length of the short side to the long side is the same as the ratio of the length of the long side to the length of the long side *plus* the length of the short side (see the illustrations at right)

Not only is the formula well defined mathematically, it is also widely reflected in the natural world. Flowers, snails, the pattern of leaves growing around a stem—thousands upon thousands of natural phenomena reflect the same mathematical relationship described by the Golden Section. The ancient Greeks, who first identified the Golden Section, did not know about its widespread occurrence in nature; they applied it to their art and architecture simply because they found the proportions pleasing. Thousands of years later that same shape is still widely used and appreciated. Indeed, the very shape of a frame of 35mm film fits the proportions of the Golden Section closely.

Imposing a grid over a scene and then orientating objects in conformity with the grid pattern is a perfectly acceptable way to impose order on a photograph. The exact shape and pattern of the grid is important only to the extent that it fits the needs of the situation. There are no "right" or "wrong" patterns, only patterns that work or do not work in a particular situation. A photographer who is unfamiliar with photographic composition can benefit greatly from developing the habit of mentally superimposing a grid pattern over the scene he is photographing, then arranging the objects in the scene accordingly. With practice, the process becomes automatic.

POINT, LINE, AND FRAME

Every work in the graphic arts begins as an empty surface. The problem in photography is that the blank field is always obscured by an image that is essentially complete. As a result, the photographer finds it difficult to ignore the overall scene that he sees in order to consider only its graphic characteristics. The situation is a little like knowing the words to a tune. Whenever the tune is played, the words jump into mind, making it difficult to conventrate on the music alone.

Graphic interrelationships can be complex, but can be boiled down to some elementary concepts. The great Russian painter Wasily Kandinsky (1866-1944) described the fundamental units of the graphic arts as being in essence point and frame. He felt that all of painting could be considered in terms of the relationship between a point of colour and the frame within which the point (or more than one point) was placed.

Kandinsky's point is more flexible than that of the geometrist. Move Kandinsky's point and the result is a line. Expand the point and the result is a circle. Distort the expanded point and the result is a shape. Thus, the point is really any unitary object that serves as a visual element. The important aspect of Kandinsky's concept, however, is that independent of anything else, it is where the point is placed within a frame that has meaning; that is, the location of a point within a bordered space in and of itself conveys a message to a viewer. The placement alone has graphic impact that evokes a response. Regardless of how the point is expanded, distorted, or moved, and no matter how many additional points are added, the various points, lines, and shapes will always interact with the frame that encloses them and with each other. The interaction may be subtle and it may be complex, but it is ever present and should never be ignored.

In summary, every photograph comprises visual elements within a frame. The Elements may have literal meaning as identifiable objects in that they may explicitly tell an obvious story. But they will also have a less obvious meaning, one that may appeal as much to the emotions as to the intellect and that exists simply because of the presence of certain visual elements enclosed by a border. In the worst case, the meaning may simply be "randomness" or "disorganization." In unfortunate cases, the meaning of the graphic interrelationships may conflict with the literal meaning of the individual visual elements. However, in the best cases, the graphic meaning is compatible with and supports the overall meaning of the photograph. It is the photographer's responsibility to make certain that in his photographs the latter condition prevails.

Point

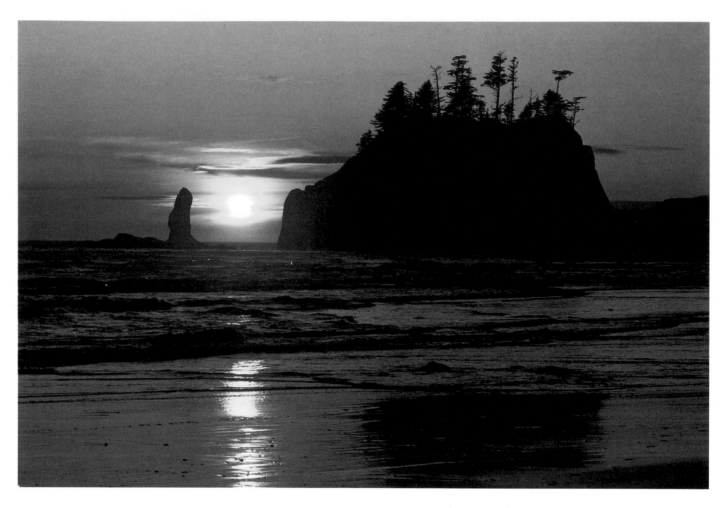

Whether an object is depicted as being big or small affects a viewer's perception of what the photographer is trying to say. Yet the viewer does not arrive at a conclusion by laying a ruler across the face of the photograph. Instead, he looks for clues provided by the photographer, clues that are derived from the relative sizes of the elements within the photograph and the size of an object in relation to the overall size of the frame.

These two photographs are of the same subject taken with two different lenses. In both cases, the centre of interest (a seastack off the coast of Washington state) is clearly apparent in the frame. Yet the message conveyed by the scene differs significantly from one photograph to the other.

In the photograph above, left, the decisions to depict the object large within

the frame forces the viewer to consider the object itself. The viewer perceives that the photographer wants him to study the object and learn something abouts its structure, shape, texture, or size. In the photograph above, right, making the seastack much smaller within the frame immediately shifts the emphasis. The viewer's attention is now partially diverted to the environment surrounding the seastack. The object no longer stands alone, but shares the limelight. The statement has changed.

In every photograph, the sizes of elements relative to each other and to the frame contribute significantly to the photograph's message and therefore cannot be ignored. Consequently, a photographer's choice of lens dictates more than simply how much detail will be apparent in an object; the choice of lens

colours the viewer's perception of the photographer's intent. For example, when the centre of interest is rendered large within the frame, the signal sent to the viewer is that the photographer's reaction to the scene was a sense of power and crowding. Objects rendered small signal that he sensed a feeling of loneliness, insignificance, and isolation.

Diminishing the size of an object within the frame can cause the object to be lost. In such circumstances, the photographer must use appropriate graphic devices to compensate for the object's lack of physical prominence. A valuable technique, the one used in the right-hand photograph, is to make the object the point of highest contrast within the frame. Another is to provide graphic lines that lead the eye onto the object.

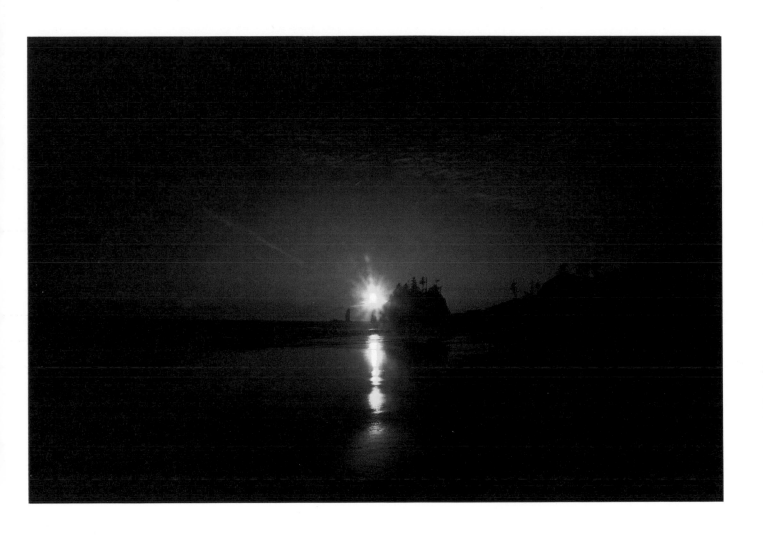

Lines

The nature of the lines present in a photograph directly affects the emotional impact the photograph has on a viewer.

These two photographs of the same subject are treated identically in terms of photographic technique. Nonetheless, the statement made in each instance differs substantially, solely on the basis of the graphic impact of lines.

The dominant feeling in the upper photograph is of gentleness and peace. The graceful curves of the plant's leaves seem relaxed and reminiscent of a plant in its natural state. The eye follows the bend of the leaf around and back again onto the flower in a pleasant, circular pattern. No sense of time or haste intrudes.

In the lower photograph, the rigidity of the plant, as suggested by straight, almost brutal, lines projects a feeling of hardness and tension. Moreover, the centre stalk leads the eye right out of the frame. The lines alone have drasticly altered the message the photograph transmits.

Whereas the first treatment of the plant seems perfectly fine, the second treatment contains what could be considered a compositional flaw. Soft-focus technique seems consistent with the feeling of gentleness in the upper photograph, but seems incongruous in the lower. Thus, conflicting compositional messages are being sent in the lower photograph that are confusing to the viewer.

In studying a scene in the viewfinder, a photographer must always make sure the lines present support his photograph's intended meaning, or, at the very least, do not conflict with it. If necessary, he must make sure adjustments as finding a better viewpoint or switching to a different lens if the lines are not appropriate as they stand.

Multiple Functions of Lines

The lines present in a photograph can have different functions or can serve more than one function at the same time. In this photograph, the lines both set a mood and control the movement of the eye.

The mood is set by the gentle curve of lines formed by the top of the dunes. In a manner similar to that in the upper photograph on the previous page, the curved lines suggest a peaceful environment. Clearly, this photograph is not attempting to comment on the harshness of the desert at noon, but on the state of calm at dawn.

At the same time, the foreground S curve attracts the eye and draws the viewer into the photograph. Without the line, the viewer's eye would remain in the foreground. With the line, the background assumes the dominant role. The foreground provides detail information about the photograph's centre of interest: the background scenery. In essence, the presence of the curved lines leads the viewer from the particular to the general—a common role for foreground lines to play. At the same time, the line contributes to an overall sense of the rhythm of the dunes.

In composing a photograph, a photographer needs to look for lines that will lead a viewer into the photograph, but at the same time must make sure that the lines he uses are compatible with the overall emotional mood he wants to create. Every situation is unique, but wide-angle lenses are particularly useful for incorporating and emphasizing the lines present in foreground areas.

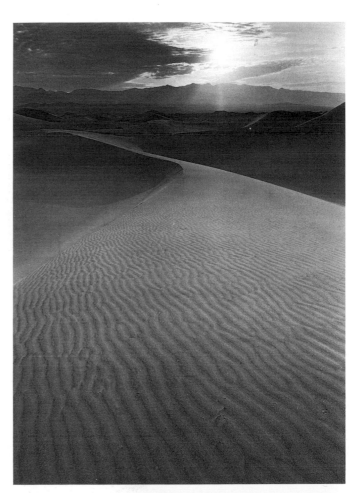

Emotional Content of Lines.

Aside from playing a role in directing a viewer's attention, lines have emotional content and therefore contribute to the overall meaning of a photograph.

In this photograph of a building's facade, straight lines strongly project a viewer into the background. These lines serve the same function as the curved lines in the foreground of the photograph above. However, because they are straight, the lines in this lower photograph convey more of a feeling of mass and power. Meandering lines, while appropriate in the above photograph, do not imply mass and solidity the way straight lines do. Thus, the emotional content of the straight lines is consistent with both the nature of the structure depicted and the emotional content of the photograph.

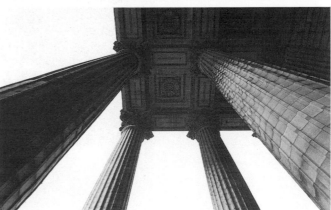

The Impact of Lines

An Abstract Composition

In some compositions, the graphic characteristics of the lines alone are the subject of the photograph. In such compositions, the viewer need not be able to identify the objects being photographed. Indeed, identification would detract from the intended effect. The point of the photograph does not extend beyond the shapes depicted and the relationships that exist between the shapes and the frame.

This photograph is totally graphic in content. Knowing that the subject is the Gateway Arch in St. Louis, Missouri and a nearby streetlamp contributes nothing to the photograph's impact. The arch and the lamp are being used exclusively for their shapes and not at all for their identities.

Such abstract compositions can be tricky to execute effectively. In this case, the meaning of the photograph relates to the contrast between two dissimilar shapes. The lamppost, composed of a straight pole topped by a circle, is firm and definite, rigid and heavy. In contrast, the arch is curved and graceful. The two masses, despite their different shapes, balance each other within the frame, and the eye is guided in a rough circle up the curved line, onto the circle, down the lampost, and again onto the arch.

When a photographer's eye is attracted by shapes, emphasis and definition can be achieved by using silhouette (as was done here) to abstract them, give them emphasis, and help eliminate distractions.

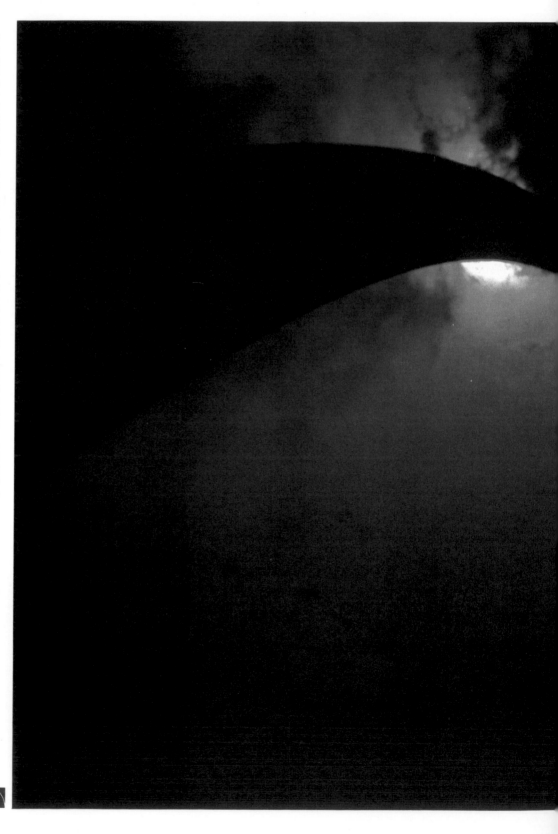

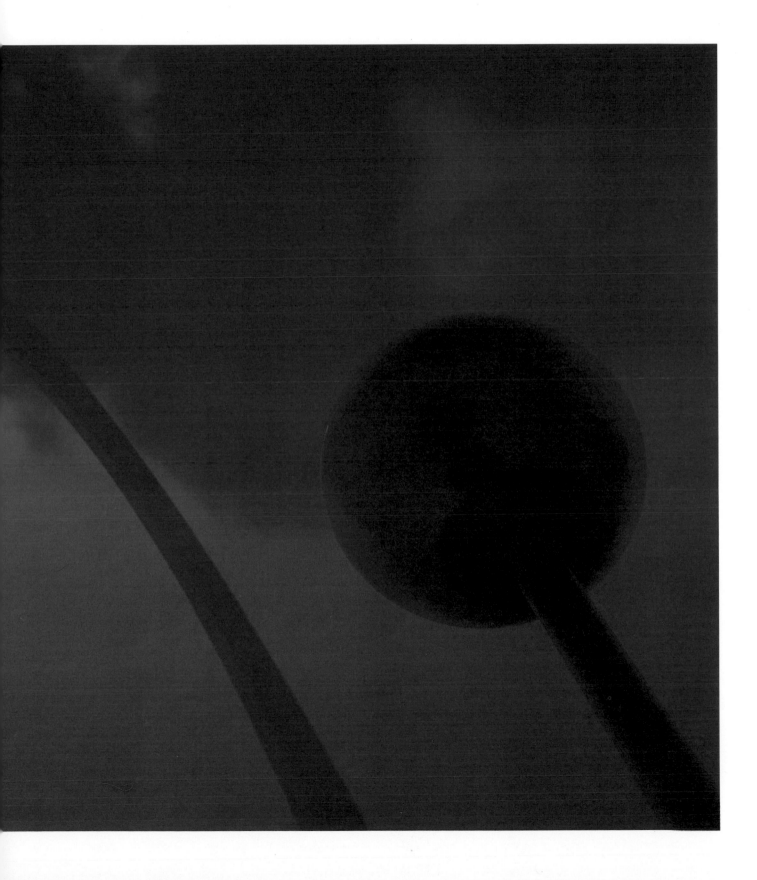

The Meaning of Lines

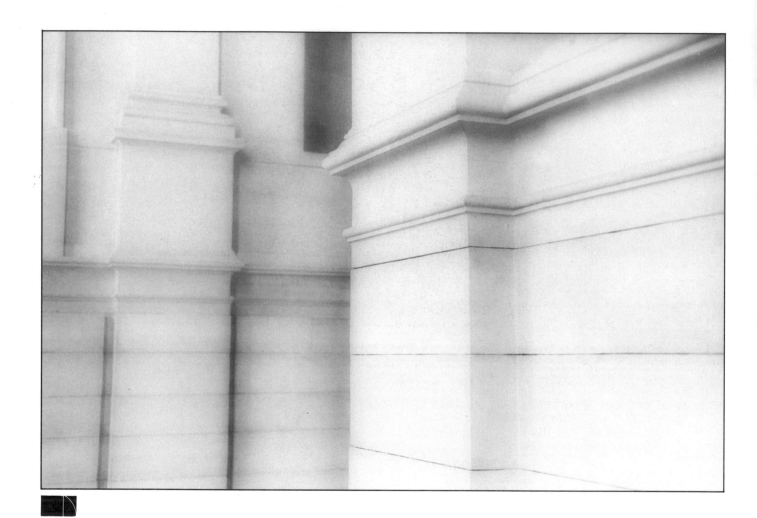

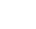

One of the reasons composition can be mystifying is that there are no absolutes. Although trends exist, the compositional contribution made by any single element in a photograph must always be considered in context. For example, both the photographs shown here contain straight lines, but the effect is quite different in each case.

In the photograph at left, the feeling is decidedly calm. The wall is hard marble, but, despite the presence of straight lines, the surface does not seem especially harsh. The overall feeling is one of grace and peace.

In the photograph at right, straight lines produce a strikingly different effect. In this case, the lines are strong but jumbled. They crisscross haphazardly, producing acute angles. The viewer senses action, conflict, and even confusion.

Why the difference? Viewed in context with other elements of the photographs, the variation in effect is understandable. In the photograph at left, rather than crossing over each other, the lines converge gently. Moreover, their uniformly horizontal orientation is decidedly placid. In the photograph at right, the erratic orientation of the various lines suggests activity and tension.

Although straight lines usually imply action and curved lines peace, exceptions can occur because the ultimate effect depends on the context within which the lines lie. A line alone has little meaning. The way that line is oriented relative to other lines and other elements in the photograph conveys far more information. The horizontal lines in the left photograph conform to the feeling of calm because, relative to each other, they are ordered. Had the camera been tipped so that the lines converged more severely, their visual impact would not have been consistent with the way the rest of the scene was treated in the photograph. In short, a photographer must pay attention to all the elements in a scene to make sure they are consistent with the message of the photograph and with the photographic techniques being used.

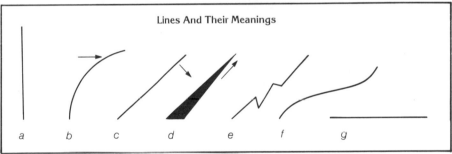

Lines And Their Meanings

a b c d e f g

Variations In The Shape Of A Line

The shape and orientation of lines within the frame of a photograph evoke emotional responses within a viewer. These responses seem to be grounded on associations that exist automatically between the lines and similar shapes found in nature. In the figure above, the basic shapes that a line can take are shown.

Line a is straight and upright, like a tree standing on a windless day. Although the tree could be uprooted and fall over, in this state the implication is that all forces are in balance and the tree is at rest.

Line b is curved, as if the tree described above were being blown by a breeze. The greater the bend in the line, the greater the feeling of tension and force, but the shape is inherently graceful and the implication is usually of peaceful movement.

Line c is straight but leaning. This is an unbalanced, dynamic position. The implication is that the line is either falling or about to fall. Thus, diagonal lines in a photograph evoke a feeling of action, or at least tension.

Line d is leaning and because of its point also has direction. In this case, a viewer would infer movement in that direction. Like line c, this line exists in a dynamic condition.

Line e is jagged, like a bolt of lightning or an object that has been snapped apart. Jagged lines are therefore active and filled with tension and anxiety.

Line f is wavy, like the surface of the ocean on a calm day. Wavy lines are gentle, peaceful, and relaxing. They imply movement, but movement that is unhurried.

Line g is horizontal. The tree has fallen. It is at rest. A horizontal line implies the absence of any forces acting at all.

The Compositional Frame

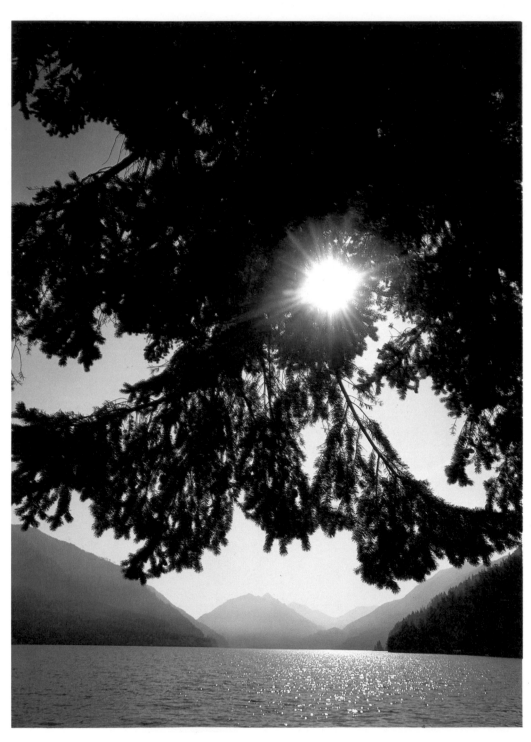

Compositional Frames

A good compositional frame has two characteristics: it has an interesting shape, and it contributes something indispensable to a photograph's composition.

In the photograph at left, the tree branches that comprise the foreground frame are quite prominent; indeed, they occupy almost two thirds of the photographic field. Nonetheless, the photograph's centre of interest, the mountains in the background, are not overpowered. Instead, the frame directs attention onto them by echoing their shape. Without the presence of the frame, much of the scene would have consisted only of empty sky, and therefore, without the presence of the frame, the photograph would have suffered. Because the frame counts and has a graphically interesting shape, its inclusion is appropriate.

Compositional framing—the technique of including foreground objects in a photograph to set off a centre of interest located in the background—has become so common that many applications border on being trite. Used imaginatively, however, compositional framing is an effective photographic device.

Many photographers have heard or read that including a foreground object (such as the branch of a tree in a scenic photograph) they can increase visual interest. However, this is true only if the frame actually contributes something positive to the photograph. Too often, the frame merely serves as a distraction. Or, just as bad, the frame ends up dominating the photograph and becomes the centre of interest.

The basic requirement for a frame is that if it does not have an interesting shape, or if for any other reason it can be removed without materially detracting from the photograph, then the frame is weak and should not be included. Thus, if a branch in the foreground of a photograph provides useful information about the environment or if it effectively serves to lead the eye into the scene, then the branch can probably stay. But if it intrudes and merely distracts the eye, the branch should not be there.

In composing such a photograph, the photographer must try to visualize the scene as it would look both with and without the frame. He should ask himself, "Does the frame actually improve the photograph?" Just as important, he must try to make the application imaginative by ensuring that the frame has an interesting shape or pattern. In any event, the compositional frame should either echo or contrast with the shape of the photograph's centre of interest, or provide detail information about the scene. If the frame is an object in silhouette, the photographer should make sure the shape is clean (i.e., easily identifiable) or else the frame will add no interest and will constitute only dead space.

Weak Frames
A weak frame, instead of improving a photograph, detracts from it, or at least contributes nothing positive to the composition.

In this photograph, the frame is composed of two disjointed elements. Neither element has an interesting shape, and neither bears any apparent relationship to the subject. In essence, the frame consists of no more than two projections extending inward from the frame. They do not complement the shape of the subject, nor do they provide any useful information about the building or the locale.

Part of the problem is that overall, this photograph makes no real statement. When a photograph is composed with a statement in mind, whether or not to include a frame, and how to arrange it, becomes almost obvious. Conversely, when no statement is being made, it is difficult to decide where and how to include a frame.

Psychological Lines

The existence of implied lines can control a viewer and his gaze just as effectively as those lines that are physically present.

In its continuous effort to interpret the world, the mind actively examines, explores, and draws conclusions from what the eye perceives. On the basis of past experience, the mind makes inferences about what it sees in a photograph. Consequently, by carefully controlling a photograph's content, the photographer can influence the conclusions at which the viewer will arrive.

Implied, *psychological lines* exist because of these inferences. If two people in a photograph are gazing at each other, a psychological bond exists between the two that has much the same effect on a viewer as if an actual line had been drawn between their eyes. Almost irresistably, the viewer's eye will travel along the line. Or, if someone in a photograph appears to be looking at a particular spot, the viewer's eye will follow the line implied by the glance.

The photograph at left illustrates psychological lines very effectively. Even though the figures are in silhouette, their interactions are readily apparent. The adults' expressions are invisible, yet they are obviously gazing at each other. Together, the three figures clearly comprise a unit. A viewer's eye echoes the interaction among them by travelling from one adult to the other then down to the child, who is included by virtue of hand contact. Although the extended arms form a physical line for the eye to follow, the psychological connection exerts an equally powerful influence.

Inanimate objects can also project psychological lines. For example, such a line would exist between a ball and the pane of glass it was about to hit, or between the floor and an egg poised above it on the edge of a table. Indeed, any time motion is implied in a photograph, a psychological line will extend away from the object in the direction it appears to be moving. As a result, psychological lines are almost invariably present in sports photography, where movement and action are usually implied.

A photographer must anticipate the flow of a scene in order to be able to incorporate and use to best advantage the psychological lines that are present. When people are included, psychological interactions nearly always exist and, if encouraged instead of stifled, can improve a photograph. For example, one of the reasons the standard family portrait is usually so unexciting is that the figures demonstrate no psychological interactions. A photograph of a family scene can therefore be significantly enhanced if the family members are interacting in some meaningful and appropriate way. They could be encouraged to talk to each other, or at least look at each other instead of directly into the camera. The resulting image will be far more dynamic than the routine family portrait.

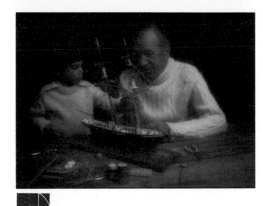

Psychological Lines

Psychological lines result from both actual and implied contact between the figures in a scene.

Above, the man and the woman are linked physically, and therefore psychologically, by close physical contact. A viewer's eye perceives this contact, and therefore his gaze travels in a rotary motion along their bodies toward the man's feet, then back again toward their heads. Because of the implied line joining their eyes, the viewer's gaze bridges the gap between their faces and repeats the circuit.

In the photograph at left, contact is completely implied. Psychological lines between the two human figures and the ship in this photograph support a single theme: the transfer of knowledge from one generation to another.

All attention is directed toward the ship. Not only do the figures' gazes fall on it, but their arms, shoulders, and entire bodies are also focused there. Even though the figures' hands are obscured, a viewer knows what they are working on, and it seems clear that learning is taking place. As in all effective compositions, physical and psychological lines are working toward a common goal.

Shape and Form

The real world is fundamentally different from the graphic world. In the real world, objects move, occupy space, and interact (at least potentially) with everything around them. In the graphic world, objects are static, physically exist only in two dimensions, and are artificially isolated from the rest of the world by the photograph's frame (i.e., in a photograph, the frame may divorce the appearance of an object from reality by rendering it grossly out of scale or context).

Similarities exist between the two worlds, but the closeness of the relationship is variable and under the control of the photographer. He can make the relationship between the real world and the world in his photograph approximate, he can make it precise, or he can make it anywhere in between. The choice is his. He is restricted only by the limits of his ability to use the medium to express his wishes.

For example, when the emphasis in a photograph is completely graphic, the objects within the frame consist exclusively of points and lines organized into abstract patterns. In a less graphic photograph, the patterns formed by the points and lines resemble identifiable, real-world objects. Once recognizable patterns are present, both the graphic and real worlds exert an influence on the viewer simultaneously.

Even among identifiable objects, there are degrees of abstraction. A silhouette of a person, for example, is more abstract than a full-colour view. The person may be equally identifiable in both cases, but the silhouette is inherently more graphic.

Although photography is by its nature two dimensional, through the use of various devices, three-dimensional representations in a photograph are not only possible, but commonplace. (Specific techniques for achieving these effects will be discussed later.) Indeed, because people are accustomed to viewing the real world in three dimensions, they are likely to interpret what they see in a photograph in three-dimensional terms, unless the scene is so abstract that such an interpretation is obviously inappropriate.

Most serious photographers dabble at one time or another with purely graphic, abstract compositions, but few do so exclusively. Instead, most photographers intentionally inject the real world into their photographs through the use of either *shape* or *form*. Shape refers to the organization of lines into cohesive, two-dimensional outlines, while form implies that, in addition to the outline of an object, its three-dimensional volume is also apparent. The inclusion in a photograph of the shape or form of a recognizable object automatically transforms the image from being exclusively a representation of the graphic world into one that also represents at least to some extent the real world. However because photography is inherently two-dimensional, shape and form are actually *graphic* characteristics of the medium. They suggest the real world, but they belong to the graphic world.

Many photographers, taking shape and form for granted, do not realize how important they are in conveying a message. For example although the three photographs at right are all of the same mug, their compositions illustrate different uses of graphics to convey a message.

The composition of the upper photograph is such that the real world identity of the object depicted is obscure. It appears as an identifiable shape (a square), but the shape is exclusively two-dimensional. The mind does not aquire enough information about the object to be able to reach a conclusion about its real world purpose, if any.

The second photograph is identical except that its composition has been altered slightly. A minor change in viewing angle has produced a graphic design that suggests quite clearly what the object is. Only a single short line has been added, but, because it reveals something important about the *essence* of the object, its impact is immense.

Similarly, in the third photograph, the composition has been altered (through a change in camera angle) to provide information about the object's *form*

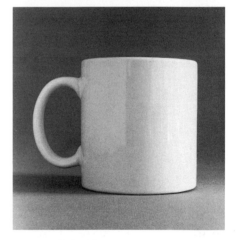

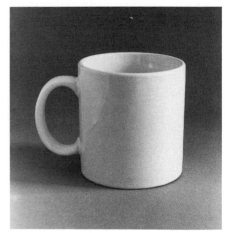

(Specific techniques for revealing shape and form will be presented in the next chapter.) Whereas the statement made in the middle photograph is, "This is a mug," in the bottom photograph the message has become, "This is a thick-walled mug." The form here has yielded valuable information about the mug that shape alone could not provide.

The extent to which shape and form are emphasized in a photograph should result from conscious decisions on the part of a photographer. He must decide just how much he wants the objects to shed their connections with the real world or to retain them. Equally as important, he must make certain that when he wants to reveal shape or form, the results are not ambiguous. Just because the photographer knows that the object he is photographing is a mug and wants to depict it as such does not guarantee that it will actually look like one in the photograph. He must identify those graphic characteristics of the object that most succinctly suggest its shape or form, then take whatever steps are necessary to display those characteristics clearly. He must either move around a scene or move the objects within it, watching in the viewfinder as the shift of positions alters shape and form. He must be sensitive to the effect of different lenses on the shape and form of objects. He must remain ever conscious of the photograph's frame and how it relates to the objects within in. He must remain sensitive to the relationship between the object and the light falling on it.

Only when the photographer is satisfied that all the variables are under control is he truly ready to take the photograph. The emphasis may lean toward the graphic world or toward the real world, but whichever way the pendulum swings, the emphasis should result from choice, not chance.

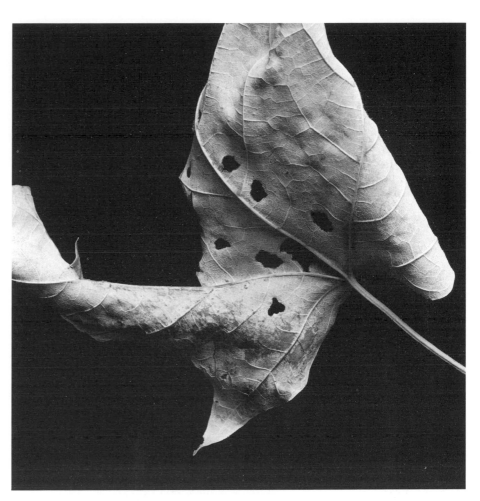

Shape and Form as Subject

Most photographers consider shape and form to be important only to the extent that they provide information about an object. However, shape and form by themselves can serve as photographic subjects. This photograph was taken specifically to illustrate the idea (derived from a thought expressed by the American writer Henry David Thoreau) that what is beautiful about a dying leaf is its form. Consequently, both the two-dimensional shape and the three-dimensional form of the leaf bear little or no resemblance to a leaf as it is customarily visualized. Here, shape and form are ends in themselves; the leaf is merely the vehicle used to achieve the goal.

There is nothing wrong with using shape and form to provide information directly related to an object, but many photographers assume (admittedly without actually thinking about it) that shape and form will pretty much take care of themselves. On the contrary, shape and form as revealed in a photograph change depending on light, lens, viewpoint, and any number of other variables. To produce a successful composition, the photographer must be concerned that shape and form he reveals are the shape and form that he intended.

Matching Shape and Meaning

The Meaning of Shape
When used most effectively shape not only reveals something about an object, but contributes independently to a photograph's statement. In this photograph, shape conveys a specific message on its own. The viewer is provided with nothing more than shape, yet that shape alone is sufficient to enable him to draw many conclusions.

For example, this is obviously a tree. Moreover, it is undoubtedly an old tree, something of a patriarch. It has probably seen better days, but certainly this tree is a survivor. Although no surface detail is present, it seems likely that the tree's bark is deep and rough.

Most important, even without knowing that the image represents a tree, a viewer would conclude that the object being portrayed is massive. Had the image been made proportionately smaller within the frame, the tree would have seemed more fragile. In other words, the shape itself conveys part of the message, and therefore this aspect of the composition is appropriate for the subject.

Pattern and Repetition

The pattern of a photograph refers to the regular, ordered placement of the objects incorporated in it. In the special case of multiple appearances of the same object, the pattern is referred to as repetition.

The mind may perceive the presence of patterns in a photograph at a variety of different levels. At one extreme, the pattern may be so subtle that its presence is sensed only vaguely. At the other, the pattern may be glaringly obvious.

As was discussed earlier, regardless of the message a photographer wants to convey, the visual elements in all well-composed photographs should conform to some underlying order or pattern. However, in some photographs the pattern does more than simply support the message, it *becomes* the message—or at least a large part of it. This condition results because an obvious pattern implies that either the pattern itself or the specific elements that produce it are worth studying. Since the elements of the pattern attract immediate attention, the photograph's message inevitably revolves around the purpose the photographer had in making the objects so prominent.

Although a photographer may choose to emphasize pattern for any number of reasons, two are particularly common. First, patterns abound in nature and in the work of man, and therefore a composition that reveals underlying patterns emphasizes their presence. For example, in most photographs of the Leaning Tower of Pisa, the primary, if not the only, message conveyed is, "In Italy stands a tower that leans at a noticeable angle." The photographer below not only makes that statement, but one about the architecture of the tower as well. The repeated motif evident in the foreground structure directs attention to the presence of the same motif in the architecture of the tower. Thus, repetition of the feature in one structure implies that the additional repetitions in the other must be important and should be noted.

The second common reason a photographer might incorporate an obvious pattern in a photograph is to direct attention to the pattern's alteration or cessation. For example, in the photograph of the Leaning Tower of Pisa, the columns in the foreground structure stand upright. Extensive repetition of the columns emphasizes this vertical state. As a result, the divergent angle of the columns in the leaning tower are immediately apparent. Even without the foreground structure the tower would seem to lean, but the effect of the repetition is to make the statement far more pronounced and to provide a sense of the acuteness of the angle.

Pattern and repetition have become so widely used that some applications are almost trite. For instance, most photographers have at one time or another taken or seen a photograph of a skyscraper's geometrically regular facade, or of a flower's radial symmetry. A photographer must actively seek out statements that can be made or supported through the use of pattern. However, he should generally avoid using pattern alone to make the statement. Instead, he should look for the presence of patterns in a scene, then use them to support or expand a broader statement than simply, "This pattern exists." Expressed another way, the potential for producing a boring photograph is great when it is composed so that the pattern itself serves as the centre of interest. Novel uses of pattern and repetition are everywhere. The photographer who learns to seek them out and use them to support his photographic statements possesses a useful compositional skill he will draw upon again and again.

Pattern
Often, the presence of a repeated pattern in a photograph establishes a visual rhythm that can either make a statement or contribute to it.
In this photograph, the pattern of the columns in the foreground structure continues regularly, drawing the eye smoothly along from right to left. However, when the eye reaches the edge of the structure, a break in the pattern occurs. The eye must then jump the gap. This broken rhythm emphasizes the idea that the Leaning Tower of Pisa, although architecturally quite similar to the foreground structure, nonetheless differs from it in a significant way.

Broken Patterns

Patterns are often most interesting when broken in some meaningful way.

In this photograph, the predominant pattern is the frequent repetition of circular shapes. However, visual interest is provided not so much by the common element—the circles——as by the variations that occur among them. The eye automatically travels from one circle to the other, while the mind recognizes the repeated pattern and becomes absorbed in the process of indentifying similarities and differences. The use of pattern is a well-worked theme on which many photographers have drawn. In most circumstances, a photograph is enhanced if the pattern does not continue without interruption, but is somewhere halted or changed.

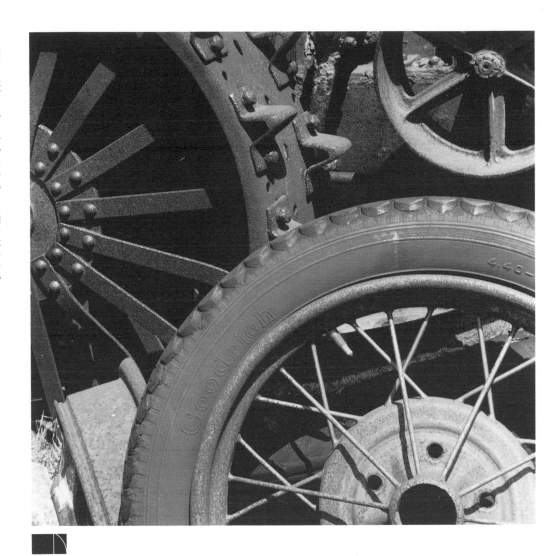

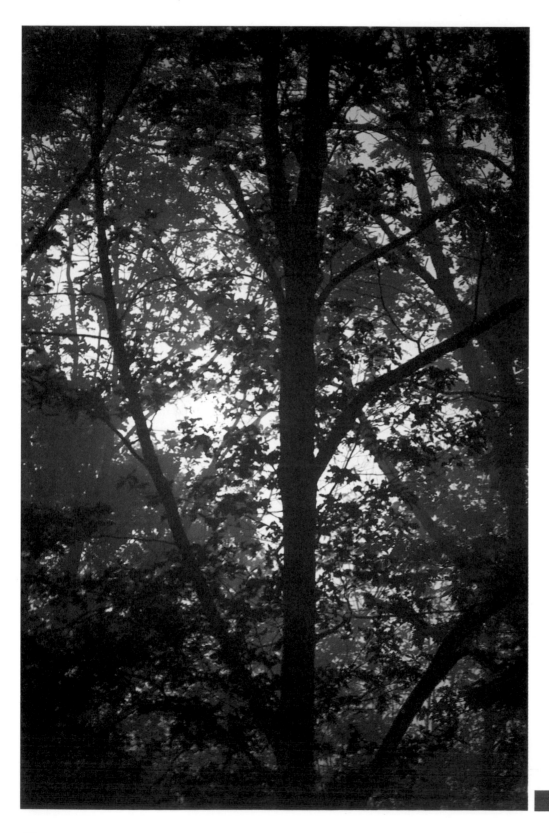

Tying a Pattern Together

Pattern alone may be dull. It may make a statement, but the statement lacks visual interest. The eye recognizes the presence of a pattern, but the mind is not enticed into exploring it.

The pattern made by the leaves of this tree is evident, but borders on randomness. Were the photograph to have consisted of leaves exclusively, the pattern might have been lost entirely. However, this composition is saved by the presence of the trunk and branches, which provide the cohesion and visual direction necessary to make the composition interesting. The eye uses the trunk and branches as a visual pathway and as a point of reference for investigating the overall object.

Before emphasizing the dominant pattern in a scene to the exclusion of all else, a photographer must be convinced that the pattern is sufficiently interesting to stand alone. Otherwise, he should include an additional element or elements to tie the pattern together and provide visual interest.

Searching for a Pattern

Patterns are not always immediately obvious. The photographer may have to actively seek them out.

This photograph contains two contrasting patterns: the light form of the sapling and the dark form of the background trees. The visual interest lies in the regular pattern of trees against the sky contrasted with the lighter, more delicate pattern of leaves as revealed and highly accentuated by the presence of the sun.

In order to produce these patterns, the photographer had to take some positive steps. When he first approached the scene, all he saw was a small, four-foot sapling onto which a shaft of light was falling. The photographer perceived a statement in the setting, which involved the idea of a young plant struggling to assert itself in the forest and drawing the strength it needs from the sun. However, a side view only showed the sapling set against a solid mass of darkness.

By moving around the sapling, the photographer was able to detect a variety of more interesting angles. Finally, when lying underneath and looking up, he noticed that the colours of the backlit sapling were especially vibrant, and that it contrasted well with the background treetops high overhead. By selecting a wide-angle lens, he produced the illusion that the taller trees were converging, and thereby created the pattern that forms the background of this photograph.

Rarely do patterns jump out at a photographer, but if he remains alert for their presence, more often than not he will find them.

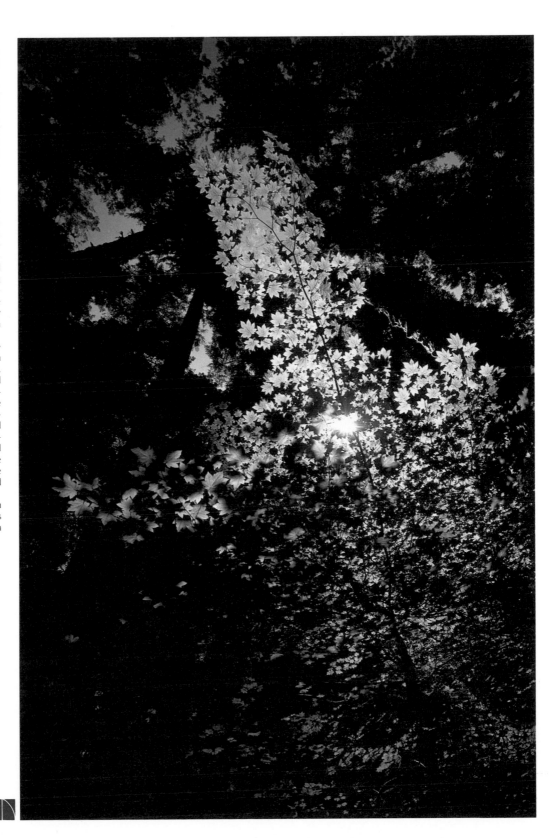

Weight

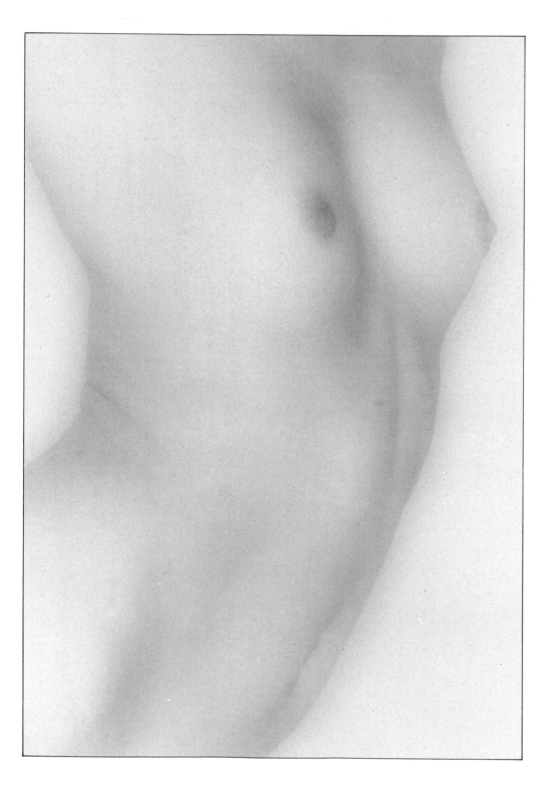

Visual Weight
Photographs have a visual "weight" that results mainly from the psychological impact of the tones in the scene and from the implied effect of gravity. This abstract concept is most easily grasped by studying examples.

In general, light tones imply delicacy or airiness, while dark tones imply heaviness or mass. For example, the fact that the nude figure at left is light in *tone* makes the image seem correspondingly light in *weight*. In contrast, the predominantly dark tones in the other photograph lend the building a feeling of solidity. Additionally, the large, dark area appears to be pointing downward, which implies that the object will move in that direction and is therefore heavy.

The photographer who is aware that the weight of a photograph produces a psychological reaction on the part of the viewer can use the tones and shapes present in a scene to generate a specific emotional response.

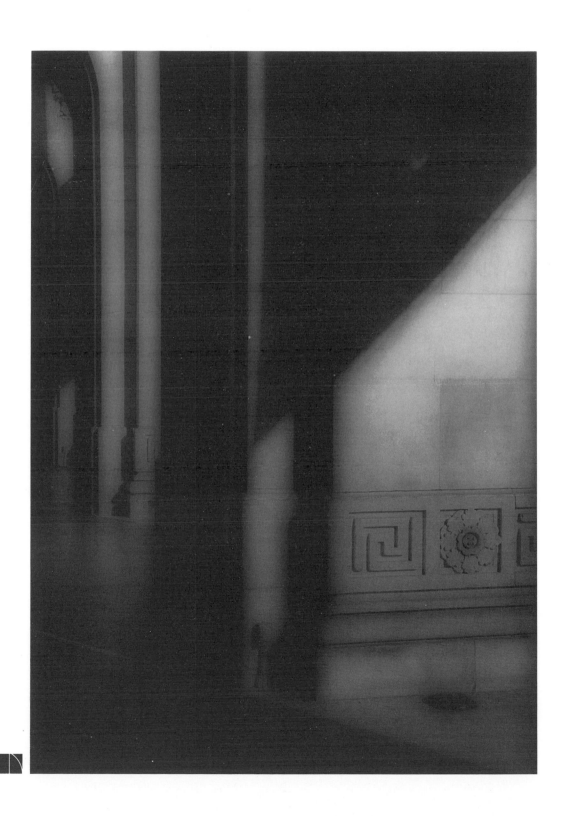

Depth

Graphics and Depth
Graphic devices can contribute directly to a feeling of depth in a photograph.

In the photograph at right, the foreground logs lead the eye to the middle ground and then on to the background, like stepping stones along a path. Similarly, the patches of light on the water help draw the eye into the scene.

In terms of perspective, depth is implied in the photograph at left by the way the size of the trees diminishes. Along the bottom of the photograph, individual trees are easily distinguished. As the eye moves up, the trees become smaller and eventually merge together, implying that distance is increasing. In addition, the zigzag line of the mountain crests pulls the eye from the foreground into the background. Each layer of distance in the scene is recorder on film in a lighter tone, the result of the increased amount of atmospheric haze through which light coming from a distance must travel. Even on clear days, atmospheric haze is noticeable if great distances are involved, and can be used in conjunction with other graphic techniques to imply depth in a photograph.

More than anything else, it is the illusion of depth in a photograph that implies the presence of the third dimension. That illusion results directly from the effect of graphics, especially direction of lines.

Modern man has become so accustomed to the idea of representing three dimensions in two that even without thinking he knows how to interpret a painting or photograph according to the conventions of what is known as *monocular* (or *single-point*) *perspective*. At its most fundamental level, monocular perspective dictates that if one of two identical objects is meant to appear farther away from the viewer than the other, it should be depicted as being the smaller. A person familiar with the concept of perspective automatically interprets the size differences as being the result of the distance differential.

This convention may seem obvious today, but at one time, size relationships in a work of art signified only power. The larger an object, the more powerful it was assumed to be. Even today, primitive people seeing an example of photography for the first time cannot conceptualize the meaning of perspective. They make no connection between image size and distance from the camera.

Most photographers are quite content to follow the conventions of perspective, and do so intuitively. Similarly, most viewers understand the rules. Space relationships are an important part of the real world and therefore are often an important part of photographs and photographic statements. For instance, distance is frequently part of a subject, with obvious examples occuring regularly in landscape photography. A feeling of depth draws the viewer into a photograph and therefore produces a feeling of involvement. Moreover, a sense of depth helps the viewer to interpret size and distance relationships among the objects in a scene. For all these reasons, a photographer can benefit from considering some of the specific devices and techniques that he has available to him that either directly affect perspective or otherwise influence a viewer's perception of depth in a photograph. These will be discussed further in the next chapter.

Balance

Dynamic Imbalance

Complete symmetrical balance within a composition is usually uninteresting. Only when the actual point of the photograph is to emphasize the condition of symmetry should the composition be precisely symmetrical.

In this photograph, everything is symmetrically balanced except for the presence of the single darkened window pane slightly to the right of the photograph's vertical midline. The window makes the composition only slightly asymmetrical, but the eye detects the condition immediately.

Because of the imbalance, what would otherwise have been a static composition acquires a degree of dynamism. The simple fact that the window is off-centre causes a viewer to actively explore the frame and search out other differences. Without the darkened window, the viewer's curiosity would have been quickly satisfied. The single window thus adds immensely to the photograph's visual interest.

This reaction on the part of the viewer is completely psychological, and is not always predictable. However, as a general rule, complete visual symmetry should be avoided.

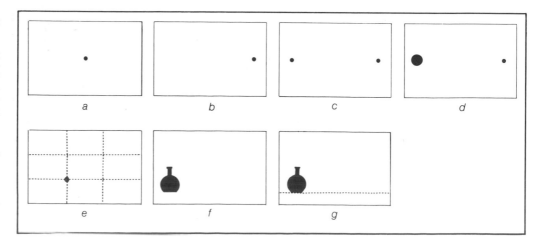

A point is placed within a frame. If the point is located exactly in the centre of the space enclosed by the frame (figure *a*), a viewer will sense that the pattern is symmetrical and hence balanced. If the point is displaced from the centre, symmetry will be lost and a feeling of imbalance will result (figure *b*). However, the addition of another point displaced an equal distance from the centre but in the opposite direction (figure *c*) will restore the feeling that the composition is symmetrical and therefore balanced.

A similar relationship can exist even if the points have different visual weights. If the centre of the frame is thought of as acting like a fulcrum, then a "heavy" point close to the centre counteracts the weight of a "light" point located farther away in the opposite direction (figure *d*).

Why do these visual relationships exist? Probably because they are consistent with everyday experience and the knowledge of the world that a person acquires as a child and that broadens as he matures. For example, the concept of the effects that different weights and distance have on a lever/fulcrum system can first be learned by children as they play on a seesaw. Their minds unconsciously perceive that a certain physical relationship exists in the world around them. The concept becomes ingrained. Eventually, in attempting to evaluate the world as depicted in a photograph, the children begin to respond intuitively to those visual relationships that they have become accustomed to experiencing.

The size of an object, its tone, and (when the object is recognizable) its nature all contribute to a viewer's psychological assessment of how much visual weight the object has. (Unfortunately, there are no reliable objective standards to use in determining how much weight one element displays relative to another. The photographer must rely to a great extent on his experience, his training, his visual sensitivity, and, ultimately, his instincts.

The great advantage of symmetry is that it is readily recognizable even to the untrained eye. As soon as a child understands the concept of "half" he starts learning to make visual evaluations in terms of symmetry ("Mummy, that's not fair—his half of the candy bar is bigger than my half"). As a result, symmetry is so easy to identify and create that its use seems almost intuitive.

LOGICAL PATTERNS

The lever/fulcrum model is really only a specialized case of the more general concept that effective composition requires the presence of an underlying logical pattern. Symmetrical compositions can be thought of as those in which a pattern is formed by mentally superimposing on a scene a simple grid in the form of a cross so that it is divided into four equal quadrants. All determinations as to where to locate elements have been made relative to the lines and to the point where the two lines meet—which in this case happens to be precisely in the middle of the frame.

What would happen if, instead of the visual field being devided into halves horizontally and vertically, it was divided into thirds? Now, instead of a single point where the grid lines intersect, there would be four. If elements within a scene were to be located at the points of intersection along the various lines, they would certainly be following a pattern. Would the pattern be symmetrical? It might, but it might not. Would the pattern be balanced in accordance with the lever/fulcrum concept? Perhaps. But the overall weight of the scene might fall to one side or another of the centre of the frame, or above or below it. Balance in this case would result not from the achievement of symmetry or from conformity to the lever/fulcrum principle, but solely from the presence of the regular pattern.

In other words, although symmetry is a widely known and easily recognized condition, patterns exist that are based upon other conditions. Indeed, the Golden Section referred to previously reflects a pattern based upon a condition widely distributed in nature. It seems likely that just as the lever/fulcrum relationship is learned through experience, the relationship described by the Golden Section is learned in much the same manner and is therefore similarly pleasing to the eye.

This principle of subdividing the field can be extended almost indefinitely. Any regular subdivision will work. However, as the number of subdivisions increases, the mind finds it ever more difficult to identify the pattern being used. Therefore as the grid pattern becomes more complex, the photographer has an increasing obligation to provide visual clues to help the viewer identify it.

For example, in figure *e*, the reason the shape was placed in exactly that position is clear. A viewer senses that the frame was divided into thirds and the shape located at one of the intersections. The placement seems pleasing because it is logical. (Of course, the viewer reaches this conclusion intuitively, rather than as the result of explicit thought processes).

In contrast, in figure *f*, the reason for the placement of the shape in that precise position in the left corner is not apparent. Consequently, the composition is ambiguous. A viewer cannot know intuitively that a ten-mesh grid was superimposed mentally over the frame and the shape placed at one of the intersections. However, by adding a single horizontal line (figure *g*), the underlying pattern becomes immediately obvious, as does the reason for locating the shape where it is.

The point is that a pattern can be as complex—or as simple—as a photographer wants, as long as the pattern underlying a photograph is discernible to a viewer. The mind can easily recognize simple subdivisions, but if the pattern involves subdivisions in which the field is divided into more that three or four segments, enough information must be included to make the pattern apparent to the mind.

Of course, mentally superimposing a grid on a field is only a tool designed to help make understandable what visual thinkers do intuitively. Many such people would object strenuously to the suggestion that every time they view a scene they visualize a system of grid lines. Nonetheless, the outcome is as if they had done so. And photographers who want to improve their skill at composition will do well to keep the grid system in mind. If nothing else, the process of superimposing the grid will help the photographer detach himself from the reality of a scene and pay due consideration to the graphic contributions made by the elements contained within it.

The Horizon Line

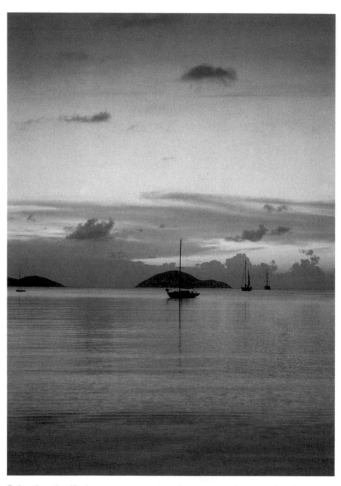

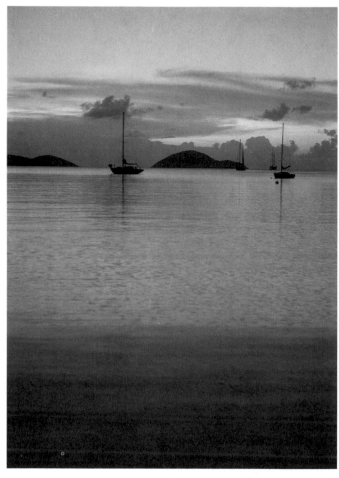

Orienting the Horizon

Sometimes only a slight change in position is sufficient to reorient the horizon so that it contributes to a stronger composition.

In the photograph on the left, above, the horizon bisects the frame across the middle, giving equal emphasis to both the foreground water and background sky, and resulting in a weak composition. Moreover, the composition is further undermined by having the boat centered in the frame, and by having the boat's outline obscured by the shape of the island in the background.

Moving closer to the water line and a few feet to the side enabled the photographer to improve the composition substantially. By standing closer to the water, he was able to tilt the camera downward without having the beach appear within the frame. The result is an image in which the foreground water assumes a noticeably more prominent role than the sky. In addition, by moving to the right, the photographer's perspective on the scene changed and the boat's figure, instead of being obscured by the island, is clearly defined against the water in the right-hand photograph. As a bonus, in this composition the outlines of the two islands point directly to the boat.

Although in this instance only a minor adjustment in position was required, a photographer may occasionally find it necessary to make much larger movements to overcome a weak composition.

Low and High Horizons

When a horizon line is present, the emphasis of a photograph is determined—or at least influenced— by the line's location.

In the upper photograph on the facing page, a low horizon line shifts the emphasis skyward. Even though the meandering river in the foreground is visually interesting, the placement of the horizon line exerts a strong enough compositional influence to draw the eye into the sky. In the lower photograph, a high horizon line firmly places the emphasis on the water.

In both photographs, the point of highest contrast was located within the smaller portion of the frame. The result is that a viewer's eye goes first to the point of highest contrast, but then darts about and lingers, finally, within the broader area the horizon line defines.

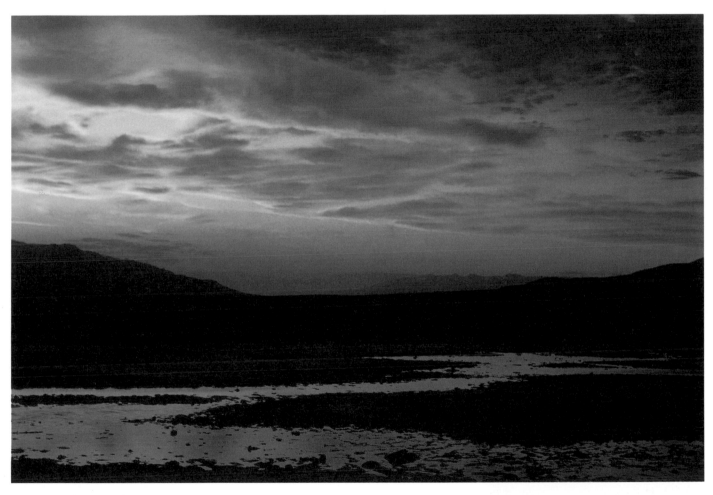

A photographer must always be aware that the presence of the horizon in a photograph automatically divides the image in two. Because a viewer assumes that the larger of the two divisions is the more important, the placement of the horizon helps define the visual emphasis of the image.

Unless the photographer has a specific reason for placing the horizon across the middle of the frame, a centered horizon will produce an ambiguous composition. (Almost invariably, a centered horizon results not from intent, but from inattention.) Therefore, as a general rule, the horizon should be located so that it divides the image into unequal parts.

The specific proportions in which to divide the frame depend upon the specific conditions present in the scene. The greater the amount of emphasis the photographer wants the foreground to have, the higher the horizon should be. Conversely, the greater the amount of emphasis to be given the sky, the lower the horizon should be.

As a practical matter, most 35mm photographers routinely locate the horizon in conformity with the Rule of Thirds described on page 22. That is, they locate the horizon either along the horizontal grid line above the middle of the frame, or along the grid line below the middle of the frame. However, when a good reason exists for displacing the horizon from the grid lines, a photographer must not hesitate to do so.

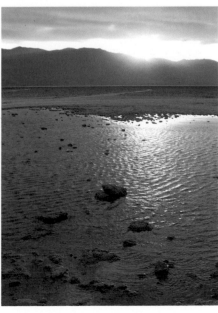

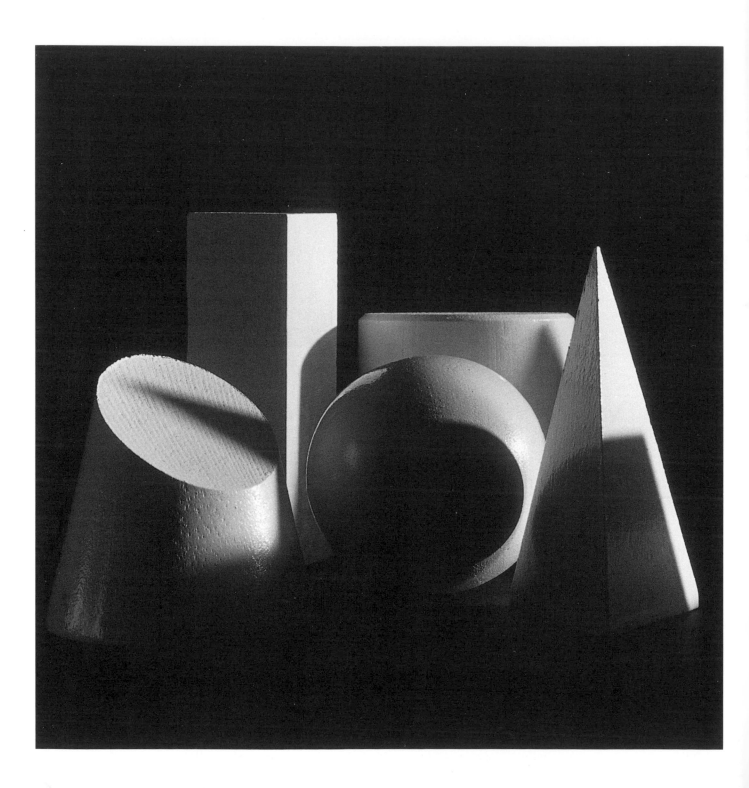

CHAPTER THREE

PHOTOGRAPHIC CONTROLS

Some names stand out in the world of photography: Alfred Stieglitz, Edward Steichen, and Henri Cartier-Bresson, to name but three. What is it about the photographs of these people and others like them that makes their works exceptional? Millions of people roam the earth bearing cameras, yet only a few photographers transcend anonymity. Is there a common factor, a thread that runs through the work of all great photographers?

Indeed, there is. No matter how the great photographers differ in terms of style, subject matter, or even intent, they all share a single, critically important skill: the ability to produce images *that could only exist as photographs.* Certainly, other factors contribute to a photographer's renown, but without exception, these masters exploit the medium of photography to its fullest by capitalizing on features that exist in no other medium. In this chapter those features, which will be called *photo*graphics, will be the subject.

CONTROL OVER THE PHOTOGRAPHICS IS THE ABSOLUTE PREREQUISITE TO MASTERY OF PHOTOGRAPHIC COMPOSITION

In photography's youth, nobody understood photo-graphics, so those who at least understood the principles of *graphics* enjoyed an artistic advantage. Graphic skills remain important, but they are no longer enough. Today, a photographer must understand how the camera itself interrelates with the final image. Without such knowledge, a photographer may be able to produce works of art, but not works of *photographic* art.

The distinction is not trivial. Some art is *conceptual* in nature; that is, only the concept behind the art is important, not the medium in which the concept is expressed. *Non*-conceptual art *does* depend upon the

medium, with the result that what the artist says is intimately related to how he says it: change the medium; change the message.

As applied to photography, a message presented photographically that could be expressed as well via some other medium—paint, for example—is simply not photographic art. The work may technically be a photograph, but it lacks the relationship to the medium that characterizes all great works of photographic art. The acid test of whether a work is conceptual in nature is simply to ask, "Could this image have been created as effectively in some other medium?" If the answer is yes, then the work should not be evaluated as a photograph, but exclusively as an idea.

Because photographics relate in a fundamental sense to the way the camera sees, records, and even distorts images, a photographer need not have great artistic aspirations to benefit from understanding photographics thoroughly. By understanding photographics, a photographer is in a position to make decisions on the basis of how the particular item of equipment will affect the image, and how that effect will support or detract from his intended message. First, however, he should understand the most important aspect of his medium: light.

LIGHT

All of photography can be discussed in terms of light. Film is a collection of chemicals that react to light in predictable ways. Lenses are devices for bending and concentrating light rays. Shutters are mechanisms for excluding and admitting light. A photographer uses light by evaluating it, anticipating it, and finally physically capturing it on film at exactly the right time. A photographer need not be a physicist in order to take photographs effectively, but every photographer should be familiar with how each item of equipment he carries affects the light entering a camera.

Because of the importance of light, all serious photographers must be acutely sensitive to it. Indeed, the degree of sensitivity a photographer has developed is an important measure of his skill. No one can be insensitive to light and expect to take good photographs.

Sensitivity to light exists at various levels. At the most obvious level, a photographer must simply be able to discern whether objects are illuminated properly to show up meaningfully on film. This does not mean that he must be able to decide whether there is enough light present to take a photograph—light meters make the decision a routine matter—but whether the interplay of light and shadow provides enough separation between tones to delineate objects and their features adequately.

Images Unique to the Medium
When the *photographics* are used to the fullest, images that are unique to the medium of photography result. Times Square in New York City is noted for its lights, but it is difficult in a single photograph to convey the same feeling a person experiences in walking down the street. The above photograph consists of nine separate exposures of a single frame of film taken over a period of approximately one hour. The result is an image that could not have

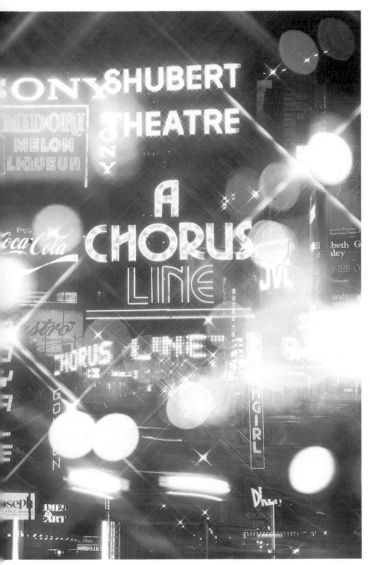

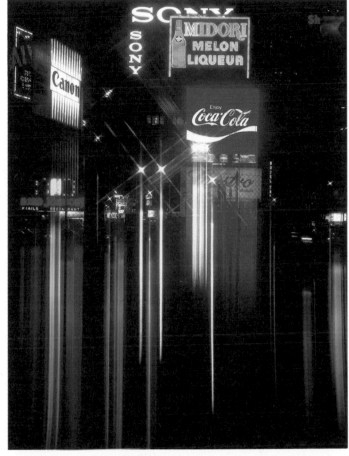

been produced in any other medium.

In the photograph at upper right, the unusual image was produced through the use of a prism filter, which created a streaked effect that gives the scene a sense of motion. Prism filters are unique to photography.

In the photograph at lower right, the camera was set for a long exposure and moved while the shutter was open. The image as shown was therefore produced over a relatively long (for photography) period of time. It does not freeze an instant, but draws the instant out.

Each of these photographs presents a scene in a manner that is different from the way a person might expect to see it. Yet the images are both understandable and meaningful. Moreover, much of their impact derives exclusively from effects that are possible only in the medium of photography.

At a somewhat higher level, a photographer must be sensitive to the *quality* of light. Anyone can distinguish a difference between the way sunlight looks at dawn and at noon, but the experienced photographer notices much finer distinctions and uses them to meet specific photographic needs. He recognizes even subtle differences in light quality, and then uses the quality appropriate for the particular message he want to convey, much as a painter might draw upon the colours of his palette.

At the highest level, a photographer has learned to visualize how the scene he sees in front of his camera will be altered by the photographic process. The image created on film is *always* different from the scene as viewed with the unaided eye. The camera lens, its focal length, the aperture and shutter speed used, the type and age of film, the processing chemicals employed to develop the image, the type of enlarger as well as the paper used, these and many other factors influence the final image. For example, the beginning photographer is surprised to find that when he uses daylight film with incadescent light, the image acquires a yellow cast. Also, he is probably obivious to the distorting effect on the image that his lens generates. However, the sensitive photographer not only anticipates image alterations, he exploits them. He can predict exactly what effect each decision he makes will have on light and therefore on the ultimate appearance of the image. That is to say, he controls the photographics, and is therefore the master of light and of the medium.

How does a photographer gain a feel for photographics? Through experience. There is no other way. Only by taking thousands upon thousands of exposures can a photographer even begin to become sensitive to the role played by photographics. Experience provides the foundation on which knowledge is built.

A SYSTEMATIC APPROACH

Hand in hand with experience goes study. Not study in the sense of a formal course, but study as a conscientious attempt to derive the greatest possible benefit from experience. After studying thousands of images, a photographer develops the ability to discern subtle differences on the basis of his accumulated knowledge and skill. Anyone who shoots large quantities of film becomes aware of how his equipment operates, but the learning process can be accelerated if a photographer uses a systematic approach. Rather than shooting randomly, a photographer should create learning experiences for himself. Every item of equipment, every feature of his camera should be tested thoroughly so that he knows precisely how each change will affect an image.

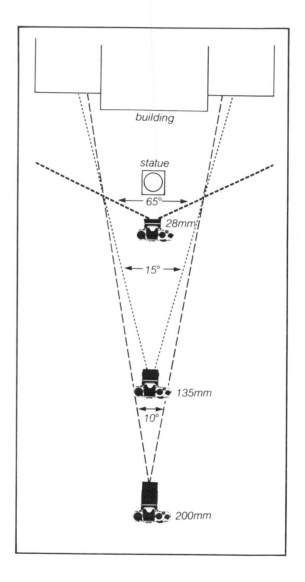

Angle-of-View versus Distance
The different angles-of-view characteristic of different lenses affect the size objects appear to be relative to the frame.
In the illustration above, due to the effect of different angles-of-view, the "statue" occupies the same proportion of the frame from all three camera positions. Therefore, the building would appear in a photograph to be the same size in all three cases. However, the situation is different with respect to the background "building." The angle-of-view of the 28mm lens is so broad that the building would appear relatively small within the frame. In contrast, with the 135mm and 200mm lenses, the building occupies the entire frame.

Lens Selection

The choice of a lens means far more than merely changing image size. Lens focal length works hand in hand with camera-to-subject distance to affect a photograph's emphasis.

In these two photographs, a different lens combined with a change in position significantly alters a photograph's message. In the upper photograph, standing under the statue and using a wide-angle lens places the photograph's emphasis squarely on the statue. The building in the distance is clearly subservient. In the lower photograph, moving farther away and changing to a telephoto lens reduces the statue's prominence and enhances that of the background building. No longer does the statue dominate. Now it shares centre stage. The building is no longer a minor detail, but forms the backdrop of the entire scene.

As a consequence of the lenses' different angles of view, the change in lens focal length has altered the way the scene appears. The longer lens incorporates a narrower visual field than the shorter lens and therefore causes the objects in the scene to occupy a greater proportion of the frame. Had the lower photograph been taken from exactly the same position as the upper photograph, the narrower visual field would have caused both the statue and the building to appear quite large. Instead, the camera was moved back far enough to cause the statue to appear to be nearly the same relative size in both photographs. However, the building is so much farther away from the camera than the statue that the change in position had little effect on the amount of space the building occupies within the frame. Thus, the size of the statue seems to be almost unchanged, while the background has aquired additional prominence.

Both statements are valid. Circumstances—that is, the meaning the photographer wishes to give to the various elements in the scene—dictate the most appropriate choice of lens and position.

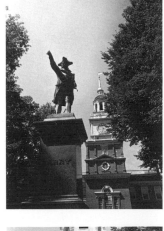

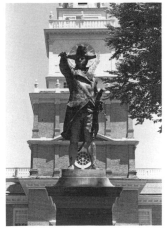

For example, a photographer might experiment first with shooting the same scene through different lenses, and then from different distances with the same lens, so the he can learn everything there is to know about how focal length and distance relate to an image. At one time or another he should experiment with every type of film made. How will changing film affect the image? What exactly *is* the effect of film speed on image grain? How does contrast vary in films from different manufacturers? What are the interrelationships between film speed, degree of image enlargement, and image grain? What effect do polarizing filters have on colour film? How do under- and over-exposure and under- and over-development affect an image?

Answers to all of these questions can be acquired from books, but a photographer can no more rely on theory to learn photography than a pilot can rely on theory to learn flying. Nothing can replace extensive, hands-on experience. And nothing is more valuable in developing a reservoir of useful experience than a systematic approach.

Perhaps the best example of a photographer who has approached photography systematically is the well-known scenic photographer, Ansel Adams. Not only did Adams spend decades experimenting with this equipment, he also carefully recorded his observations and evaluations, codifying them in his famous Zone System. The Zone System is nothing more than a summary of his experience, presented as a collection of rules that express what he has observed about the effects exposure time, development time, and paper grade have on the way tones are rendered in a black-and-white photograph. As a result of having developed the Zone System, Adams has at his disposal an approach that helps him visualize, *even before he releases the shutter*, precisley how the tones in the scene before his eyes will differ in the course of being captured on film and transferred onto photographic paper.

There are too many variables simultaneously active in photography for a photographer to be able to study everything all at once. However, by studying one or two variables at a time, he can progressively learn what he needs to know about each. The process is slow and continuous.

Eventually, when he has become so familiar with the roles played by the different variables that his knowledge has become second nature, he will be able to integrate everything all at once at the moment he takes the photograph. At that instant, all that he has learned will fall into place, and will form the foundation for making compositional decisions that use the photographics of the medium to the fullest.

Lens Perspective

In photography, perspective—the size relationships among objects that are at different distance from the camera—is not a function of the focal length of a lens but of the distance between the lens and the object being photographed. For example, the photograph of New York City at far right was taken with a telephoto lens. Had a wide-angle lens been used instead, and had the exact same section of the scene been blown up to be equal in size to the version shown here, the images would have been identical (except, of course, that film grain would have been more noticeable in the enlarged version). This characteristic of focal length is not well understood by photographers, but awareness of it is crucial for those who want to be able to translate visual ideas into photographs. Any photographer who is familiar with lenses is aware that focal length affects how large within the frame an object will appear: the longer the focal length, the larger the size. And, as was discussed in the chapter on graphics, the size of an object relative to the frame contributes significantly to the visual statement being made.

Once a photographer has determined the location at which he should stand in order to obtain the perspective he wants, then he can base the decision about which lens to use upon how much of the scene he wishes to include in the frame, how large he wants the centre of interest to be within the frame's confines, and the optical characteristics of the various focal lengths.

Focal length characteristics can be roughly divided into three categories. Wide-angle lenses produce a feeling of expansion; the distance separating foreground from background appears exaggerated. "Normal" lenses (those with a focal length approximately equal to the diagonal of a frame of film—in the neighbourhood of 50mm with 35mm film) reproduce distance relationships more or less naturally. Telephoto lenses produce a feeling that distance is compressed; distant objects that are in fact far apart appear to be closer together than they really are. Of course, expansion and compression are illusions. It is the presence of both very near and very distant objects within the same photograph that gives the impression of expansiveness. Conversely, the telephoto encompasses only a shallow field of view and enlarges it, which causes distant objects to seem unusually close together.

Compositionally, the primary basis on which focal length is usually selected should be either for the expansion or compression effect, or to produce an image that bears a size relationship within the frame that is appropriate for the message the photographer wants to convey (or for both reasons).

The photographer does not always have enough freedom of movement to select the distance he stands from an object, but he can improve his compositions immensely merely by training himself to keep focal length selection dependent in his mind on the distance between lens and object.

Lens-to-Subject Distance

Because lens-to-subject distance—
not lens focal length—determines
perspective, the distance a photo-
grapher stands from his subject is
an important compositional consid-
eration that should not be ignored
or left to chance. In general, focal
length selection should follow the
distance determination, rather than
precede.

The difference in the statements
made in these two photographs of
the World Trade Centre in New York
City results more from changes in
lens-to-subject distance than from
the fact that the photograph on the
left was taken with a wide-angle lens
while the one on the right was taken
with a telephoto. In the right photo-
graph, the perspective resulting
from a longer lens-to-subject dis-
tance makes the Trade Centre

appear only slightly larger than sur-
rounding buildings. Thus, the
photograph's statement revolves
around the idea of the Trade
Centre's presence in the midst of
other structures, rather than its size.
In the left photograph, the Trade
Centre is taken from such a close
vantage point that the building com-
pletely dominates the scene. Here,
the message *is* the structure's size.
In both cases, the focal length was
determined solely on the basis of
the portion of the overall scene the
photographer wanted to include
within the frame.

Even when the compression or ex-
pansion effect of a lens is the
primary basis on which it is selected
for use, distance—and hence
perspective—must be carefully
considered.

Distortion

If an object is held close to the eye—within six inches, for example—the object appears extremely large. However, because people are accustomed to the immense size of even small objects when they are held up close, the unusual size does not seem odd. In photography, if an object is held close to the lens when a photograph is taken, the object will appear immensely large relative to any background objects present. But when the photograph is viewed, the distance from the viewer's eye to the photograph is much greater than was the distance from the lens to the object at the instant the shutter was released. Consequently, the size relationships in the photograph appear unnatural: foreground objects appear disproportionately large and background objects disproportionately small. Thus, one source of distortion is simply the fact that photographs are viewed at arm's length, even though the objects within the photograph may have been closer than that to the camera at the time the shutter was released.

Another source of distortion occurs with three-dimensional objects. When an object has volume, the farther away that any part of it lies from the lens, the smaller that part appears. If the object lies far from the lens these size differences are barely, if at all, noticeable. However, if the object lies close to the lens, the differences are significant. For example, if in

taking a portrait, the photographer holds the lens closer than about four feet from the subject, the subject's nose will be significantly closer to the camera than his ears, and therefore will appear disproportionately large. "Portrait" lenses are so named because at distances between four and six feet away (just far enough so that no distortion is apparent), the subject's head and shoulders fill the photographic frame comfortably.

The impact of the photograph at right results almost entirely from the abnormal size relationships produced by placing an object unusually close to a lens. While a wide-angle lens was used, it is theoretically possible for this same photograph to have been taken with a telephoto lens and for the same size distortions to have resulted. However, there *would* have been a difference. A telephoto lens cannot render objects located as close to the lens as the tree in sharp focus. Moreover, the angle of view of a telephoto lens is so small that it might not have been possible to include both the tree and the buildings simultaneously.

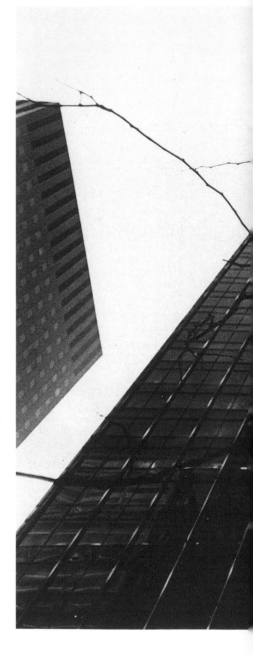

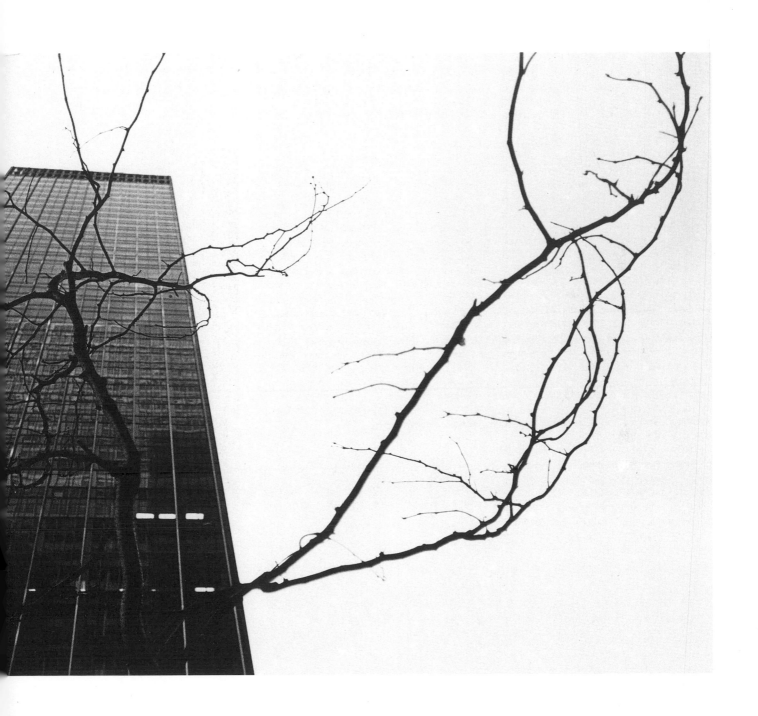

Lenses: Focal Length

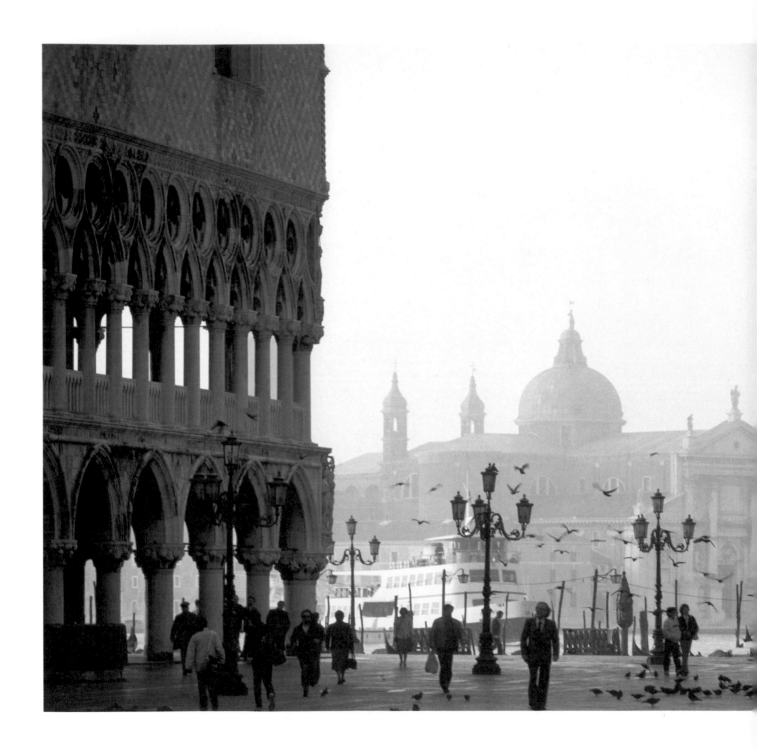

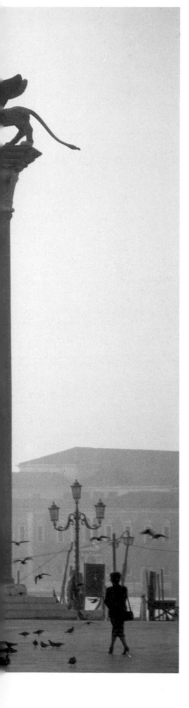

Building Relationships

Photographic statements result when a photographer creates visual relationships with his camera. The nature of a statement flows from the way he formulates his thoughts, organizes the visual elements present, and controls the photographics.

These three photographs have several visual elements in common: the same building in Venice, water, and a boat. Moreover, all three photographs were taken at approximately the same distance from the background building (although the exact locations were, of course different). In each case, a relationship among the various elements has been established by capitalizing on the visual characteristics of lenses.

The photograph at far left was taken early on a workday morning. In this case, the visual connection that exists among the people, the plaza, the boat, and the building is produced by the compression effect of a telephoto lens. By making all the disparate elements appear to exist within a much shallower range of distances than is actually the case, the lens builds a visual relationship among elements that, to the unaided eye, seemed unconnected.

The upper photograph at near left was taken later the same day, but the visual relationships in this case are built with the use of a "normal" lens. The broader angle of view characteristic of this lens permits the foreground boat to be included in the same frame as the background scene, thereby establishing a visual relationship between the boat, the water, and the distant building.

The lower photograph at near left was taken from a position only a short distance away from the upper photograph, yet here the scene called for a wide-angle lens. The normal lens did not allow both the full expanse of the boats and the background buildings to be included within the frame. Since the background identifies the scene, establishing a relationship between it and the boats is important to the photograph.

Compositionally, building visual relationships is an important means the photographer can employ to communicate ideas to a viewer. And frequently, the optical characteristics of one particular lens will serve better than any other for creating those relationships in a given scene.

Lenses: Focus

The human eye is marvellously flexible and adaptable. Although only a small portion of a person's field of vision lies in sharp focus at any one time, the eye can adjust its focus so rapidly that the impression is left that the entire field is uniformly sharp.

In contrast, a camera lens freezes focus. When the shutter is released, whatever the lens is rendering in sharp focus is preserved by the film. Since the viewer of a photograph immediately notices a distinction between areas that are in sharp focus and those that are not, focus is an integral part of the photographics of the medium.

FOCUS AS A COMPOSITIONAL TOOL

All photographers are aware of the need to focus a camera, but serious photographers know how to use focus as a *compositional* tool. In general, there are two ways focus can be used compositionally: to direct attention, and to obscure distractions.

Directing attention—A viewer's eye is irresistibly drawn to the area of sharpest focus in a photograph. Therefore, because the photographer controls focus, he automatically controls attention. Sharpness of focus implies that emphasis is being placed for a definite reason. Moreover, all of the elements that are in sharp focus are linked by a psychological bond that separates them from all of the out-of-focus elements within the frame. In other words. focus helps build and support visual relationships.

Eliminating distractions—Often the foreground or background objects in a scene are distracting. When these are thrown out of focus, they lose their ability to attract the eye away from the photograph's centre of interest. In some cases a slight softness is sufficient, in other cases, the condition must be made pronounced. The extent of softness that is appropriate is a compositional decision that the photographer must make on the basis of circumstances and intent.

A photographer who is unaware of the functional uses to which focus can be put is likely first to select a shutter speed and then use whichever lens aperture will provide a proper exposure. While in some circumstances that approach may be necessary or appropriate, a skilled photographer will never take a photograph without first actively deciding which portions of a scene he wishes to render in sharp focus, and which he does not.

Selective Focus

Focus can be used selectively to direct the emphasis of a photograph and thereby fine-tune a composition.

In each of these photographs, selective focus has been employed to direct attention precisely where the photographer wants it. At upper left, the focus is placed on the foreground birds. However, the background has not been thrown so far out of focus that it cannot be recognized as the facade of a building. Indeed, the background, by suggesting the location of the photograph, contributes as much to the statement as do the birds.

In the photograph below, focus could easily have been placed on the scientist instead of the beakers. However, the shift in focus would have significantly changed the nature of the photograph's message: attention would have been concentrated on the person, rather than on what he does. The difference is subtle, but distinct. In both of these images, the photograph has been improved by the photographer's having diverted attention from the conventional or obvious subject and unexpectedly shifted his focus, both literally and figuratively. At lower left, the blur of colour in the foreground was produced by red tulips located so close to the camera and so far out of focus that they are unrecognizable. Here, the out-of-focus elements were not intended to contribute directly to the photograph's message, but to act as a frame and introduce a degree of colour.

Lenses: Focus (cont'd)

The ability of lenses to render some objects within a scene in focus while others appear out of focus is referred to as *selective focus*. Selective focus is one of the most important compositional tools available to the photographer. Although the extent to which selective focus is used in a particular photograph is a creative decision, implementing that decision is a technical matter.

DIRECT CONTROLS OVER SELECTIVE FOCUS

Three technical characteristics of lenses permit direct control over depth of field (the range of distances in front of a lens that are rendered in acceptably sharp focus): lens aperture, lens focal length, and focusing distance.

Lens aperture—Every serious photographer understands that the size of the lens diaphragm, which is controllable in all but the most primitive cameras, affects depth of field. Specifically, the smaller the aperture (the larger the *f*-stop number), the more extensive the depth of field. In most situations, the lens aperture selected for use will noticeably affect a scene's appearance in the final photograph.

Lens focal length—Because of the method used to calculate *f*-stop designations, the actual diameter of a particular aperture varies from lens to lens. For instance, *f*/8 describes an aperture that is physically wider on a 200mm lens than on a 100mm lens. Therefore, although *f*/8 produces the same *exposure* on both lenses, the *depth of field* is shallower in the case of the longer lens. Indeed, in any given situation, the longer the focal length of the lens used, the shallower the depth of field at a given *f*-stop.

Focusing distance—Most lenses have inscribed on their barrels numbers that indicate how far away the lens is focused, as well as depth-of-field indicator lines that show the range of distances that will be rendered in acceptably sharp focus. A careful study of the lens will reveal that as the point of focus is brought nearer and nearer to the lens, the depth of field becomes shallower and shallower. In practical terms, this means that the closer the camera is brought to the subject of a photograph, the greater the extent to which the background is thrown out of focus.

Neutral Density Exposure Factors

Filter Density	Increase in *f*-stop
·10	$\frac{1}{3}$
·20	$\frac{2}{3}$
·30	1
·60	2
·90	3

Neutral Density Filters
Neutral Density filters provide a means for diminishing light intensity without distorting an image or changing its colour. These filters are useful on bright days to enable a photographer to use a slower shutter speed or wider lens aperture than the brightness of the light would otherwise permit. Without the filter, the same effect could be achieved only by switching to film that is less sensitive to light. The table above relates a filter's density (as inscribed on the filter's rim) to the amount that the light entering the lens is reduced, as measured in *f*-stops.

INDIRECT CONTROLS OVER DEPTH OF FIELD

In theory, all a photographer needs to do is decide how much depth of field his composition calls for and then select the combination of lens aperture, focal length, and focusing distance appropriate to achieve his goal. However, practical considerations can sometimes limit the options available. For example, a scene may contain so little light that at the desired aperture, the shutter speed is unacceptably slow.

Two ways to maintain the ability to respond to extreme light conditions are to carry different types of film and to carry a tripod. Experienced photographers realize that they cannot always anticipate the conditions they will encounter. By carrying high-speed films, they always have the option to switch films and thereby gain an additional *f*-stop or two.

Similarly, by carrying a tripod (along with a cable release), a photographer is not restricted in most circumstances to the relatively fast shutter speeds called for when a camera is hand-held. If the scene contains moving objects, the use of a slow shutter speed may not be practicable, but otherwise, having a tripod on hand preserves the photographer's ability to use any available lens aperture without limitation.

Occasionally, the opposite problem will occur: so *much* light will be present that even at a fast shutter speed the lens cannot be opened up far enough to produce a sufficiently shallow depth of field. Changing to a slower film is one solution, but another that professional photographers often rely on is to carry neutral density filters that can be mounted on the lens. These filters reduce the amount of light entering the lens without affecting tones or colours at all and thereby permit the use of a wider lens aperture.

In any photographic situation, the extent of selective focus required depends upon the conditions present as well as upon the photographer's compositional goals. The means the photographer uses to reach those goals must flow from the knowledgeable exploitation of his equipment's technical capabilities.

Lenses: Focus (con't.)

Being Prepared to Handle Extremes

In order for a photographer to be able to implement his compositional goals, he must maintain the ability to handle extreme conditions. Minimizing the equipment one carries has its advantages, but they are purchased at the expense of flexibility.

These two photographs are of the same scene. In the version on the left, depth of field was not an especially important consideration. Since the stream is the object of greatest visual interest, the eye

lingers there, and the slight softness of the background trees presents no problem.

The situation is quite different in the other photograph, which incorporates the sun. The sun vies with the stream for the viewer's attention, but to compensate for its small size, it needed to be rendered in sharp focus. Because the sun is sharp, the eye moves actively back and forth between it and the stream. Had a tripod not been used, it would have been impossible to attain such an extensive depth of field under such low-light conditions.

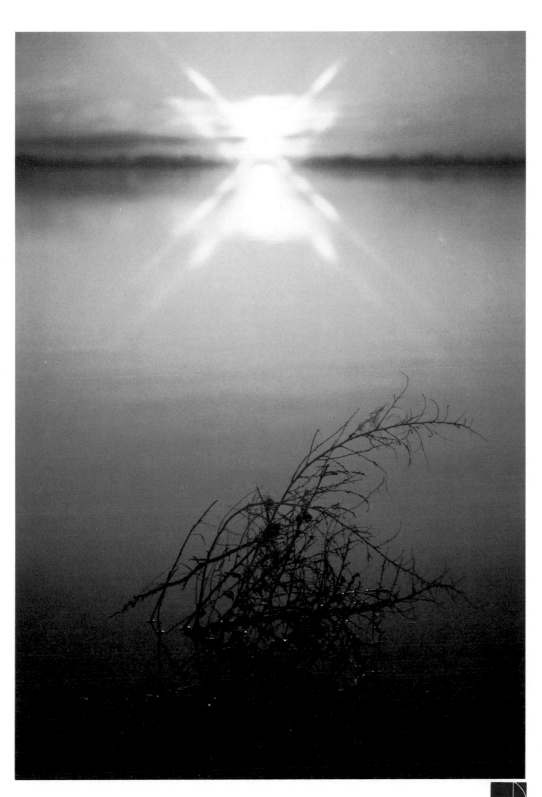

Where Focus Made the Shot

Sometimes focus can be critical to a composition. What makes this photograph successful is the subtle emphasis produced by selectively focusing on the foreground branches.

As suns go, the one in this photograph is relatively uninteresting, and alone would not have served well as the photograph's centre of interest. Likewise, the foreground branches are hardly spectacular. They also could not stand up on their own in terms of visual impact.

Combining the two elements in the same photograph is the start of a visual statement, but again, focusing one the sun would have given it too much prominence. However, with focus selectively encompassing only the foreground branches, the sun assumes a secondary role, and the ultimate result is a photograph that serenely evokes the ambience of that particular locale. Selective focus marries the two elements, and successfully establishes a balance between them.

Light

Light is the most difficult aspect of photography for the beginning photographer to understand—and the most important. Developing a sensitivity to light in all its forms requires the investment of a substantial amount of time and effort.

THE QUALITY OF LIGHT

Not all light is the same. For example, fluorescent light is qualitatively different from incandescent light. The former seems harsh and glaring, the latter soft and gentle by comparison. Most people are aware of these difference and make decisions about which type of light to use to illuminate a room and achieve a desired effect.

Light quality is the general term photographers use in recognition of the many ways in which light can vary. The adjectives most often used to describe light quality include "hard", "soft", "warm", and "cool". Hard light is bright and directional, producing dark shadows and strong highlights. Soft light is even (non-directional) and does not produce tonal extremes. Warm light tends toward the red end of the spectrum, while cool light tends toward blues and greens.

In a studio, a photographer can control light quality relatively easily. He can alter it through his selection of light source (incandescent bulb versus electronic flash), by using multiple light sources or reflectors to eliminate deep shadows, or, if he is using colour film, by employing coloured reflectors and filters.

Outdoors, the photographer has little direct control over light quality. In taking outdoor portraits, the quality of the light can be altered through the use of reflectors, but for the most part, light quality is a product of cloud cover and time of day.

If a day is overcast, sunlight filtering through clouds is diffused and therefore has a soft quality. As a result, light from an overcast sky used in conjunction with reflectors to lighten shadow areas can produce a flattering portrait.

A more important contributor to light quality is time of day. In the early morning and late afternoon, sunlight travelling through the atmosphere acquires a warm, soft quality that is entirely missing at noon. Minute by minute the quality of light around dawn and dusk changes.

With each change, new photographic opportunities appear.

Serious photographers are sensitive to these nuances in light quality and respond to them enthusiastically. Indeed, most knowledgeable photographers allot a substantial portion of their shooting time to the early morning and late afternoon hours. At other times of the day, as often as not the photographer will be exploring to find the best place to locate himself later that afternoon or early the next morning, when the light quality is likely to be better.

LIGHT *IS* THE SUBJECT

Light is so important to photographers that many feel that the objects within a photograph are really nothing more than surfaces by means of which light can be seen and captured. To these people, the subject of every photograph is really light. Unless the light is right, there is no photograph. For example, to take a photograph of a child blowing out the candles on a birthday cake, no sensitive photographer would consider using a flash. The essence of the image is the candlelight; the quality of light from the flash would fatally alter the scene. Similarly, in every scene, what is being photographed is not an object, but the light being produced by or reflected off of that object.

Most good photographers develop a light *style*; that is, a preference for certain specific qualities of light. These photographers identify a particular light quality that they find pleasing, then look for that type of light and exploit it when they can. The evolution of a light style represents a highly refined sensitivity to light quality that only a few, fortunate photographers ever achieve. However, all photographers must recognize that the quality of the light used to illuminate a scene directly contributes to the statement the photograph makes.

Adapting Light Quality to Message
The qualities revealed by the objects present in a photograph result from the quality of the light used to illuminate the scene.
The challenge in taking this photograph of a tulip was to convey the essence of the flower. The problem was that the characteristics and qualities of light as perceived by the eye are often not recordable on film unless they are manipulated.
A lamp located above the tulip directed light *through* the petals, suggesting their translucence. However, there was insufficient contrast between the bottom portions of the flower and the background. To compensate, reflectors were placed below the tulip to reflect light upward.
This photograph is entirely dependent on the quality of the light used to illuminate it. Had a flash been used instead, for example, the translucent effect would have disappeared and consequently the nature of the statement would have been significantly different.
A photographer must always remember that the quality of the light he uses is inseparable from the statement his photograph makes.

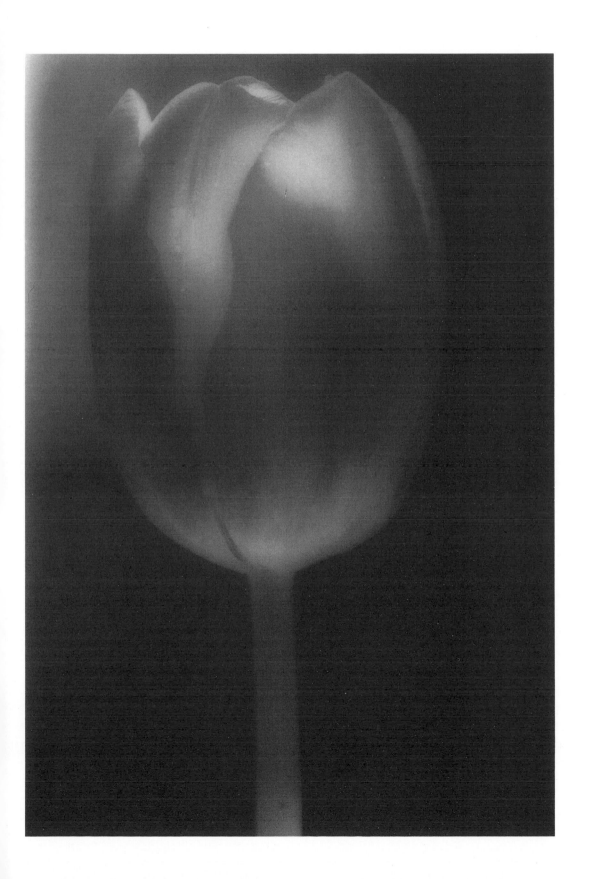

Light (con't)

The quality of the light present in a scene often depends on the relative positioning of the light source and the camera. Depending on where the camera is located relative to the light source, the subject may be a photograph that is *backlit, sidelit,* or *frontlit.*

In a backlit situation, the light source lies directly in front of the camera and is sometimes included within the photographic frame. Contrast is high, and the objects depicted are often thrown into silhouette. As a result, there is no "correct" exposure.

In a sidelit situation, the light source lies somewhere to the left or right of the camera and adds definition to the shape of objects. Because of the deep shadows that are produced, such scenes are often characterized by high contrast. Frequently, these shadows can be useful compositional elements. Side lighting often produces rich colours. This is especially true when a polarizing filter is used.

In a frontlit situation, the light source lies directly behind the camera. This light is flat, producing no contrast or shadow.

Surface details are hidden, and therefore objects appear to be featureless. Compositionally, frontlighting can generate abstract shapes and patterns that can be juxtaposed against each other.

By becoming familiar with how light direction affects a scene, a photographer can learn to anticipate how a scene will look at different times of the day. In addition, a scene that appears dull from one side sometimes may be quite interesting from another. For example, the two photographs below were taken within minutes of each other, but from different angles. The difference, which is attributable solely to the change in light direction, is striking. The character of the scene is radically altered by the different light qualities produced at the different angles.

A photographer who can visualize the effect that changing his position will have on the angle of light will know when the effort involved in changing his position is likely to prove rewarding.

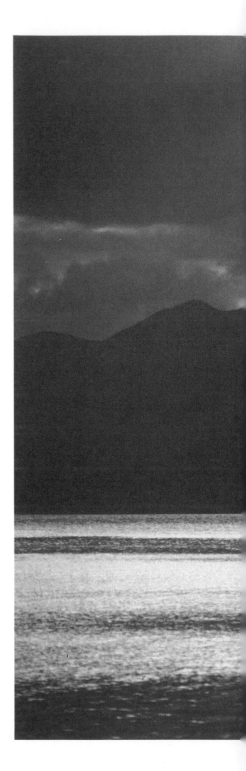

Light is Critical
The success of this photograph is almost entirely attributable to the quality of the light illuminating the scene. Taken at another time of day, this scene would have appeared dull.The shape of the mountains, the colour, and the presence of lens flare, are all essential to the photograph's message, and are all a product of the light striking the scene at the moment the photograph was taken.
A photographer must learn to anticipate the appearance of light at different times of day, and then use the light to execute his composition.

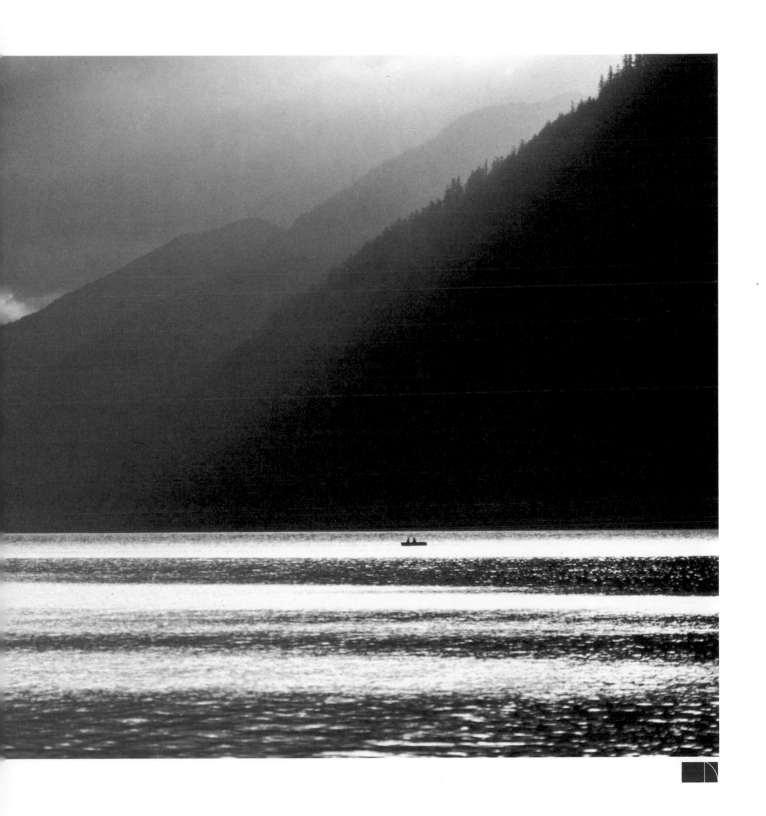

Light and Mood

Capturing Fleeting Moods of Light
A scene that has been viewed many times before may be struck for only a few minutes on a particular day by an unusual light that fleetingly produces an interesting photograph.

The photographer who took this photograph had passed this building almost daily for years, but the scene had never before seemed interesting. On this one day, however, a soft, warm light bathed the building's lobby in such a way that the metallic quality of an escalator was briefly revealed. The result is a composition of light and shadows that creates a mood and conveys a message about the sterility of modern life.

A photographer cannot always plan and anticipate a photograph, but must be constantly looking for interesting qualities of light that generate moods and can be used to make visual statements.

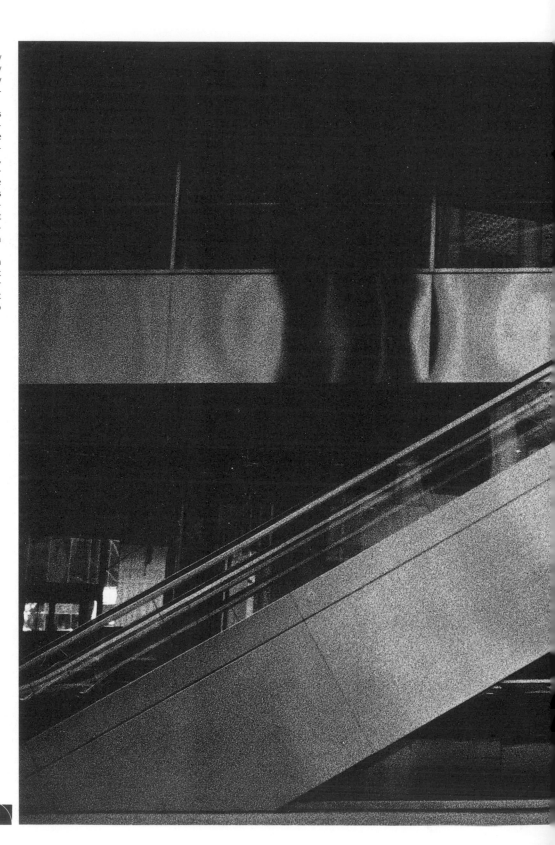

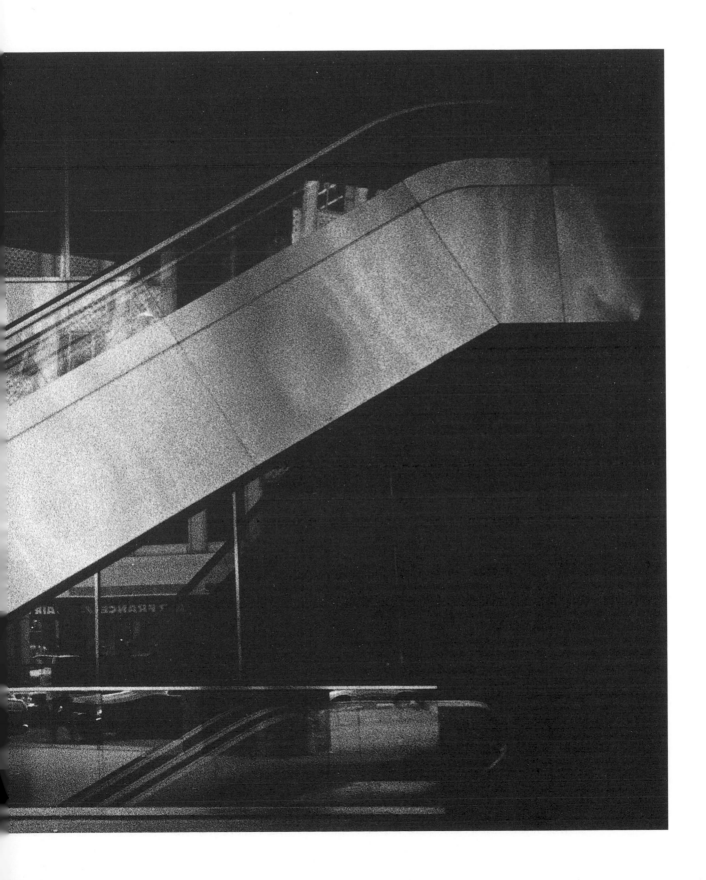

Contrast

In order for a line to be readily distinguishable, it must contrast with its background. Contrast in tone or colour is present in all the visual arts, but in photography, contrast is especially important.

In black-and-white photography, contrast really refers to gradations in the tone of silver deposits running from black at one extreme to white (i.e., no silver at all) at the other. Photographs that progress from black to white via only a few shades of grey are said to display high contrast, and those that make the transition via many subtle shades of grey are described as showing low contrast. (Colour contrast will be discussed in the next chapter.) The amount of contrast in a photograph to a great extent is under the control of the photographer, by virtue of the film he chooses and how he exposes, develops, and prints it.

When a viewer looks at a photograph, his eye is immediately attracted to the point of highest contrast. Therefore, in composing a photograph, the photographer must realize that if the point of highest contrast in a scene does not coincide with his centre of interest, the viewer's eye will be diverted. If a photograph contains more than one point of high contrast, the eye will first be drawn to the one that is "finest" (i.e., visually most compact) and then to any present that are more diffuse.

In addition, contrast can make its own statement. A series of small, high contrast areas in a photograph produces a feeling of tension, and sometimes of confusion. (This feeling is less pronounced if the points of high contrast fall into a regular pattern.) Conversely, broad areas of low contrast produce a subdued, graceful, quiet feeling. However, rarely can the statement made by contrast stand alone. More frequently, contrast is used to supplement and support a broader, better defined message.

Tonal Contrast
Contrast between tones is a characteristic of all photographs. Contrast contributes strongly to a photograph's composition, but usually works hand in hand with graphic elements to convey its message.
Straight lines thrusting toward the centre of the upper photograph produce a feeling of power and tension. This feeling is supplemented by multiple exposures as well as by the high tonal contrast between the buildings and the sky, which both attracts the eye and supports the sense of tension present in the image.
In the photograph of the mountain scene, low contrast complements the gentle feeling produced by the graceful, wavy lines along the horizon. The monochromatic tint to the photo is partially responsible for the low contrast condition of the photograph.

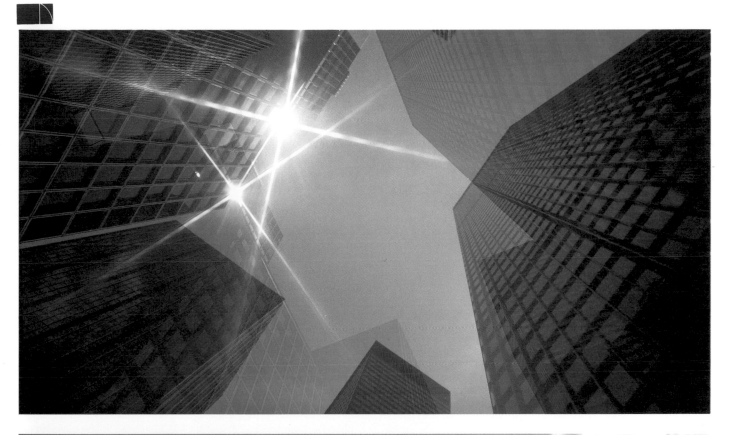

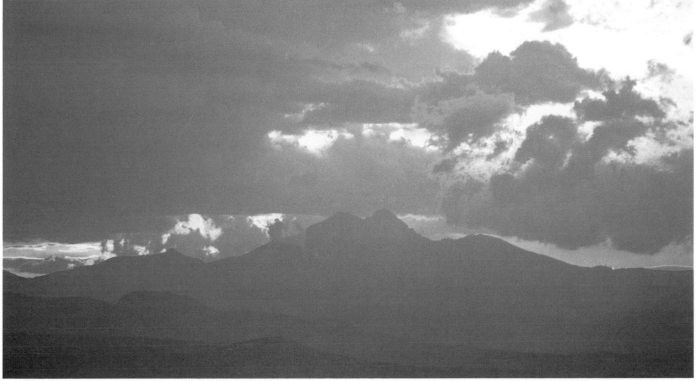

High Key/Low Key

Often, the best way to present an idea photographically is to visually exaggerate it. For instance, extreme examples of the use of contrast for impact can be found in high-key and low-key photography.

In a high-key photograph, light tones predominate but are broken by a small area of dark tones. Conversely, in a low-key photograph, dark tones prevail but are broken by an area of light. Thus, the visual impact in both cases stems primarily from the presence of an overall dominant tone punctuated by a small region of extremely high contrast. High-key and low-key compositions are by nature

simple, and comprise two of only a few situations in which contrast alone can sometimes perform a dominant, rather than supplementary, compositional role.

The statement made by the high-key photograph of a flower on the next page is largely controlled by the light, airy feeling characteristic of high-key compositions. The flower itself is almost a neutral element. Similarly, in the photograph below, the feeling of isolation is primarily a product of the abundance of dark tones characteristic of low-key compositions. In this photograph, the light along the edge of the child's profile draws attention

to her face and the bottle, while the wide areas of darkness help preserve and enhance the private moment of introspection reflected in her eye. Cropping in closely on the child's face would have eliminated the low-key effect and simultaneously reduced the sense of privacy.

Most photographs fall between the extremes represented by high-key and low-key compositions, but in all cases the degree of contrast affects the viewer's attitude toward a scene at least to some extent.

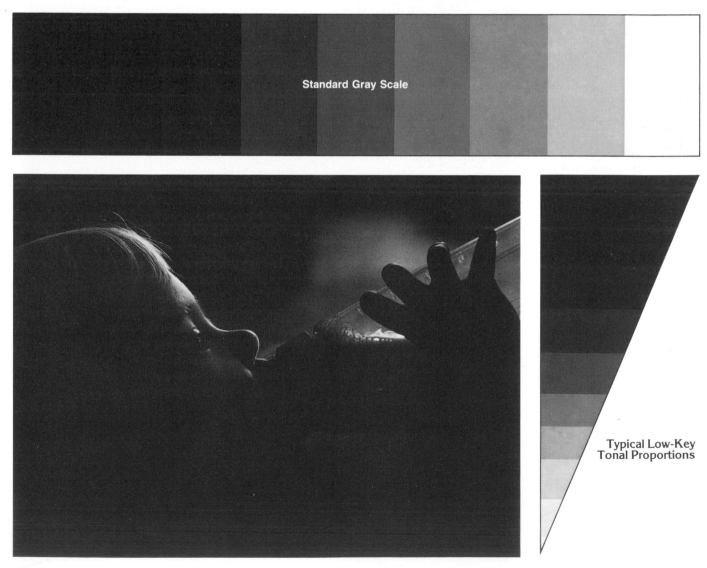

Standard Gray Scale

Typical Low-Key
Tonal Proportions

Tonal Distribution

The tones present in most photo-graphs are equally distributed around middle grey. In high-key photographs, the tones in the scene cluster near the light end of the grey scale. In low-key photographs, the tones cluster near the dark end.

A standard, rectangular grey scale is shown on the previous page. Next to each of the photographs is a trian-gular grey scale that represents the relative amounts and distribution of the tones within that photograph.

In general, high-key photographs require large amounts of fill light. The white flower in the photograph at right was set against a white background and illuminated by win-dow light. In order to reduce con-trast, large reflectors were used to bounce light onto the flower from all angles and thereby reduce shadows. Light passing through the flower made it appear completely white except for areas where the pet-als are thick enough to restrict the passage of light.

In the low-key photograph on the previous page, no fill light at all was used. Fill light would have reduced the contrast of the scene and diluted the feeling of isolation and mystery produced by the abundance of dark tones.

Typical High-Key Tonal Proportions

Time: Shutter Speed

One of the most widely known photographs ever made is Harold E. Edgerton's photograph of a drop of milk splashing into a saucer. That unexpected, ivory crown has delighted people for years and changed both the popular and the scientific perception of a drop of liquid.

Edgerton's photograph is a notable example of a characteristic of photography that most people never consider: photography and time are inextricably related. Every photograph comprises a record of the behaviour of light during an interval of time. The interval may be short, as in Edgerton's photograph; it may be comparatively long, as in the photographs of the heavens that astronomers take; or it may be in between, as in most other photographs.

Time is continuous to the human mind, but not to the camera. The effect of time is always inherent within the image a camera captures.

Time is important to the photographer if only because each photograph involves a shutter speed. Unless the photographer is remiss, every time he releases the shutter he has selected a shutter speed for a specific reason. Sometimes that reason is purely practical, as when it is chosen primarily to prevent blurring due to camera shake. However, in most circumstances, and especially when moving objects are present in a scene, shutter speed directly affects the nature of the image produced and therefore the content of the photographic statement.

Depending on the shutter speed selected, the photographic image will emphasize either the passage of time or its segmentation. That is, if objects within the frame are moving (or the camera is moving relative to the objects), either the motion will produce a noticeably blurred image, or action that is normally too fast to be seen clearly will appear to be frozen by a fast shutter speed. Both conditions affect the viewer's response to the photograph. (The presumption here is that the extent of blurring evident in a particular photograph results from a conscious decision.)

For example, a photograph of a pole vaulter might depict him as a blurred figure, in which case the emphasis is clearly on his motion. If the same vaulter were to be shown frozen in midair, the emphasis would more likely be on his form, or on the positioning of his body at a particular instant during the course of the vault.

In some photographs, time itself is the subject. For instance; in most cases multiple exposures derive their impact by illustrating some change that occurs over time. A long exposure made in a dark room during which a strobe is flashed repeatedly while a figure is moving demonstrates on film how a body changes shape and position over time. A long time exposure of the night sky implies the rotation of the earth.

By its very nature, photography serves as an ideal vehicle for exploring the relationship between time and nature.

A Statement about Time
Every photograph carries with it a statement about time, a statement that must be compatible with the primary message the photographer wishes to convey.
In this photograph, two birds are captured in significantly different states. One bird, "trapped" by the wires, is immobile. The other is unconstrained, free to express that quality most closely associated with being a bird: the ability to fly.
In both cases, the image of the bird was recorded over an interval of time, and the activity of each bird during that interval is implied by its respective image. The stationary bird appears sharp, the bird in flight, blurred. Thus, because the two images make statements about time that are consistent with the overall message of the photograph, the relatively slow shutter speed selected can be judged to have been appropriate.
In some photographs the time content of the image, although always present, is relatively unimportant. However, a photographer should try whenever possible to be conscious of and exploit the unique capability of photography to express the passage of time.

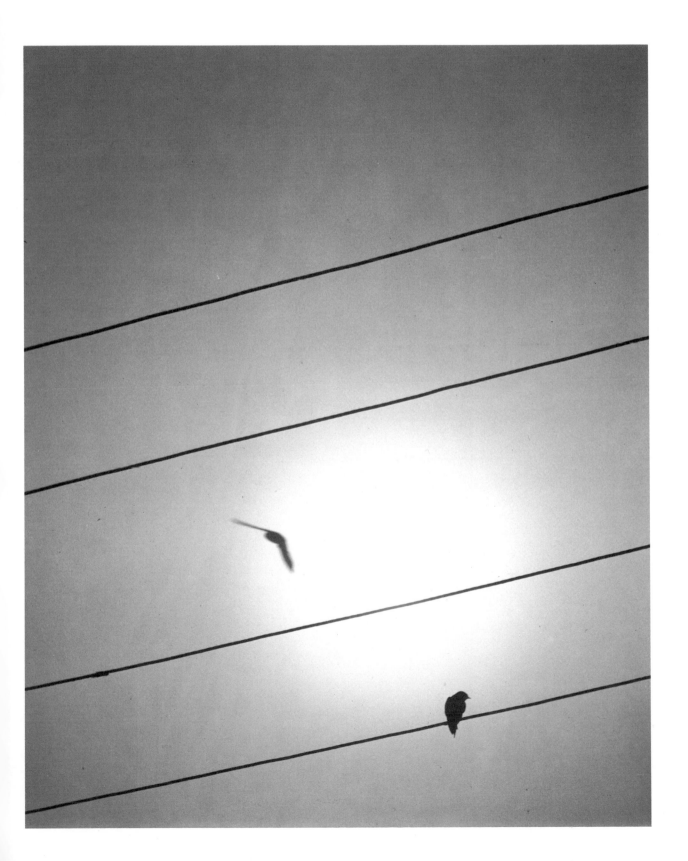

Patterns of Time

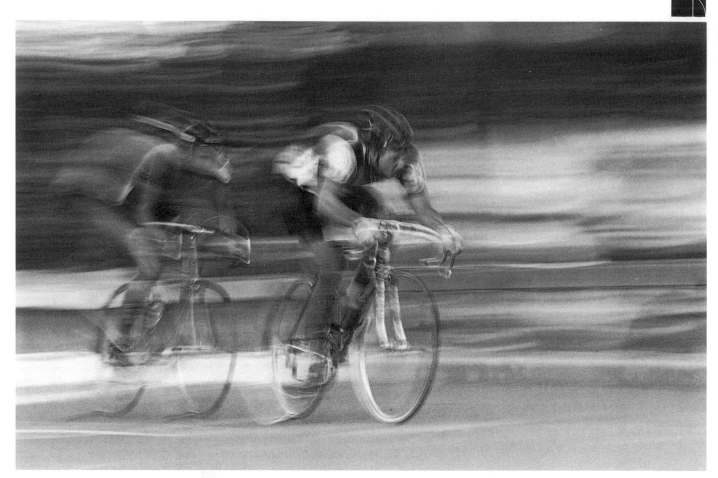

The Pattern of Time

When objects are moving quickly, the eye has no opportunity to break the movement down into small increments. Motion that occurs quickly and continuously overwhelms the mind's ability to discern intermediate movements. The shutter speed of a camera can be used to isolate patterns that are strictly the result of movement but are normally invisible to the eye.

The success of photographs taken of fast motions rely to a great extent on chance. However, after a substantial amount of practice with moving objects, a photographer can develop a sense for the best shutter speeds to use and the best instant at which to release the shutter.

The two photographs shown here both illustrate patterns that are dependent upon time. The image of the cyclist has been spread across the film plane by a slow shutter speed. The resulting blur suggests their rapid movement in a way that would have been lost had the shutter been fast enough to render the figures in sharp detail. To the eye, the cyclist did not appear blurred, but since fast-moving objects sometimes appear that way, the blurring contributes to the impression of speed.

Similarly, the pattern of the woman's hair was invisible to the eye, but materialized in the photograph. Had the shutter been released a moment earlier or later, the effect would have been lost. Not only does the shutter speed in taking a photograph need to be correct, so does the timing. In both cases, proficiency develops with experience.

Shutter Speeds for Stopping Action

Distance	Subject Speed (mph)			
Feet	2-3	10-15	30	100-200
10	1/250	1/1000	1/2000	X
25	1/125	1/500	1/1000	X
50	1/60	1/250	1/500	1/2000
100	1/30	1/125	1/250	1/1000
200	1/15	1/60	1/125	1/500

2-3 mph: adult walking: 10-15 mph: adult running: 30 mph: pony galloping: 100-200 mph: Race Cars

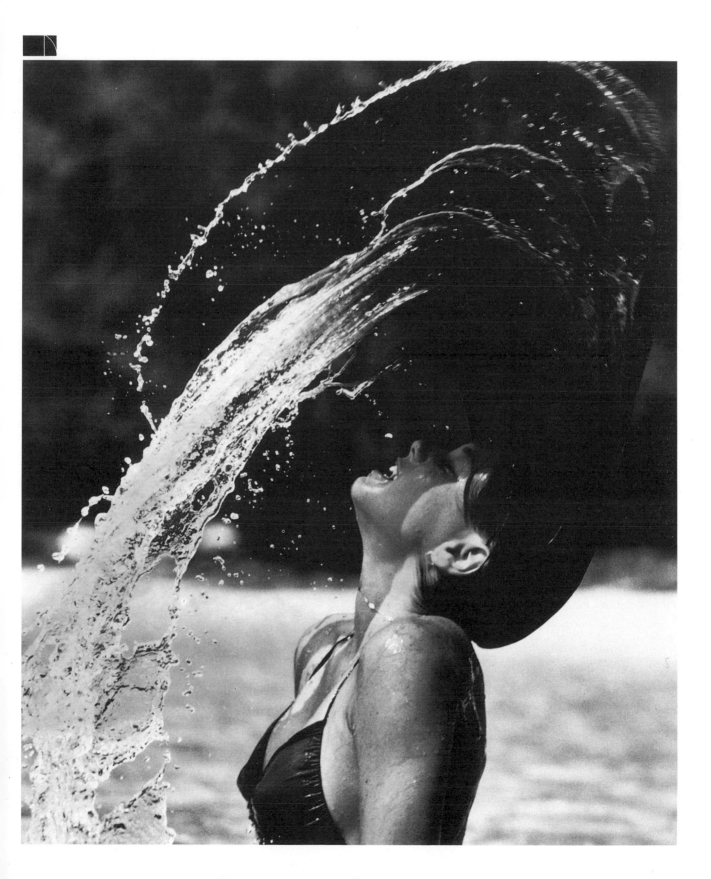

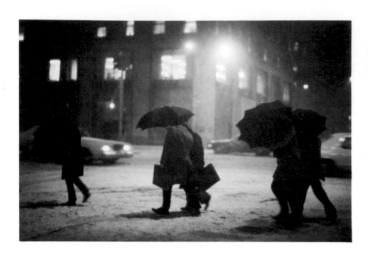

Experimenting with Time

Because the compositional use of time in a photograph is often a hit-or-miss affair, the best results usually occur when a photographer experiments freely and creatively.

These two photographs of commuters struggling to get home through a winter storm in New York City differ with respect to the way time is used. Above, a fast shutter speed reproduces the images faithfully, but less effectively than in the photograph on the right, in which a slower shutter speed allows blurring to occur. The blurring makes the figures seem ghostlike and lonely, introducing a mood that enhances the impact the image makes.

Neither of these images was previsualized exactly. Instead, frames were exposed at a variety of shutter speeds, and the most expressive image selected.

Film and Format

In recent years the 35mm camera has attained widespred popularity and has in many ways usurped many of the roles formerly played by larger format cameras. Nontheless, each format has its own unique impact on photographic composition.

Today, because the 35mm camera is so light and versatile, it is considered the camera of choice when mobility is important. Interestingly, although view cameras (cameras using film 4" x 5" or larger) are now considered too cumbersome when speed is important, not too many years ago the 4" x 5" Graflex camera was the mainstay of most photojournalists.

Camera format directly affects photographic composition in three main ways: through the shape of the frame, through grain structure, and through the "feel" of the camera.

FILM FRAME

The concept has already been stressed that the borders of a photograph play an important compositional function. Consequently, frame shape contributes to the graphics of a photograph and should be taken into consideration. In general, those elements that run parallel to the longer side of the frame receive greater emphasis than those that run perpendicular to it. Thus, the decision as to whether to orient the frame horizontally or vertically depends on which elements within a scene the photorgrapher wants to emphasize. Moreover, the degree of the disproportion between the long axis of the frame and the short determines the degree of emphasis generated. As might be expected, a square frame is essentially neutral.

The frames of a 35mm camera are decidely rectangular whereas medium format frames may be either rectangular or square. Large format cameras are slightly rectangular.

GRAIN STRUCTURE.

Grain, the clusters of silver granules that produce the photographic image, may or may not be apparent in a photograph. If a fine grain film was used and the image was not enlarged greatly, film grain may be practically invisible. If a large grain film was used and the image was greatly enlarged, grain will be readily apparent. The slower the film (the lower its ISO rating), the finer the grain.

As grain size increases, surface detail diminishes. When grain is readily apparent, it actually competes with the underlying image for the viewer's attention. Since detail is lost, the viewer responds more to the shape or form of objects in the photograph than to their fine points. For example, if a photograph of a dancer is extremely sharp and detailed a viewer might notice the presence of perspiration on the dancer and think of the hard work that dancing entails. However, if noticeable grain is present, the same scene might cause the viewer to concentrate more on the dancer's shape and form. In short, grain is another tool the photographer can use to control emphasis.

The first factor to consider in controlling the appearance of grain is the degree of enlargement to which the image will be subjected. An image on 35mm film that will be enlarged to make an 8" x 10" print will be magnified to 60 times its original area. The same image shot on 4" x 5" film would need to be magnified only 4 times. In general, fine grain films can be enlarged approximately 25 times before grain becomes apparent.

In cases where grain is desired, the approach is to use large grain (fast) film in a small format camera. In addition, if the film is *pushed* (exposed as if it had a higher ISO rating than is actually the case and then overdeveloped to compensate), grain is further enhanced.

Grain structure differs between colour and black-and-white films. In colour, no film made can match the fine grain of Kodachrome 25 film. Therefore Kodachrome 25 transparencies shot on 35mm film can be enlarged proportionately more than any other film without the grain structure becoming intrusive. For example, a 35mm Kodachrome 25 image can be enlarged to almost 16" x 20" safely, while for an image shot on Plux-X or other fine grain black-and-white film, 8" x 10" is the maximum enlargement possible before grain becomes apparent. Thus, even with the finest-grained black-and-white film, to achieve the same sharpness as is possible with Kodachrome transparency film, the original black-and-white image would have to be photographed on a larger, medium-format camera.

CAMERA SIZE AFFECTS THE STATEMENT A PHOTOGRAPH MAKES

Because the size of the film affects the size of the camera used to hold it, film size also has an indirect effect on the nature of the photographic statement. The small size of 35mm film permits the 35mm camera to be correspondingly small and unobtrusive, making it an intimate camera that enables the photographer to record a scene inconspicuously. Rangefinder cameras in particular are notable for being quite. The 35mm camer's light weight and mobility make it ideal to use when candidness is a goal.

The larger the camera, the greater the direct impact it is likely to have on a photograph. One of the reasons formal portraits usually lack a feeling of spontaneity is that the subject is aware of the presence of a camera and reacts to it. Moreover, the photographer himself approaches photography differently as a consequence of camera size. The larger formats, especially the view cameras, promote a painstaking, methodical attitude, which is in strong contrast to the more interactive approach encouraged by 35mm cameras.

An Example of Film Format
Film format affects the final image both directly and indirectly.
In this photograph of an old barn, a medium-format negative was selected to highlight the fine detail in the weathered texture of the wood. Extreme image sharpness permits and even encourages concentration on the qualities of the wood surface. The square format of the overall frame is essentially neutral. It does not interact significantly with the image it surrounds. A rectangular frame would have implied that something was important about either the horizontal or vertical elements in the image (depending on which way the long axis of the rectangle was oriented).
The presence of film grain here would have obscured surface detail and changed the emphasis of the photograph.

Grain and Detail

The human eye never assimilates every detail of a scene. Instead, the eye darts from point to point perhaps studying some aspects of the scene carefully, but for the most part only deriving an overall impression. Indeed, this tendency helps account for the inability of people to re-call the small details of crimes they have witnessed.

By making a permanent record of a fleeting event, photographs permit a vie-wer to study details that in an actual situa-tion he would probably have overlooked. However, sometimes a photographer does not want to provide the viewer with that opportunity. The photographer may only want his photograph to create an impression, rather than present every little detail of the scene. In such a cir-cumstance, the fact that a large grain structure obscures detail can be exploited effectively.

In the process of diminishing detail, the noticeable presence of grain affects the mood of a photograph. Because there is a limit to how much information careful study of the image will reveal, the viewer experiences the feeling that the subject is not completely knowable, that not all is being told. The result is a sense of mystery that is not present when fine-grain film is used.

When large grain is desired, the 35mm camera is especially useful. By carefully choosing the appropriate combination of film, ISO rating, darkroom processing, and image enlargement, the photo-grapher can control grain size quite pre-cisely. For example, to take the photo-graph at the right, the photographer de-cided to use Ektachrome 400 film pushed to ISO 800 and overdeveloped. When enlarged to the size shown, grain is readily apparent, and detail is obviously lost, expecially in shadow areas. The large grain diverts attention from specific details about the woman and in so doing converts the statement from being about a particular person to being a general study of the female form.

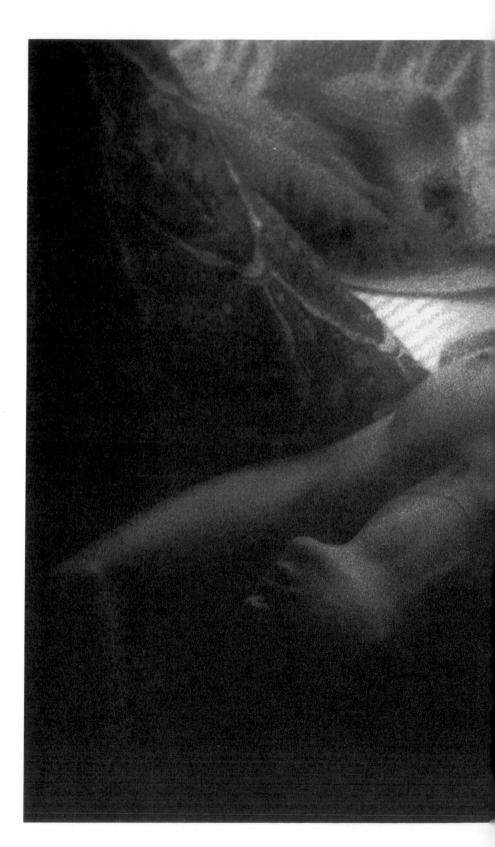

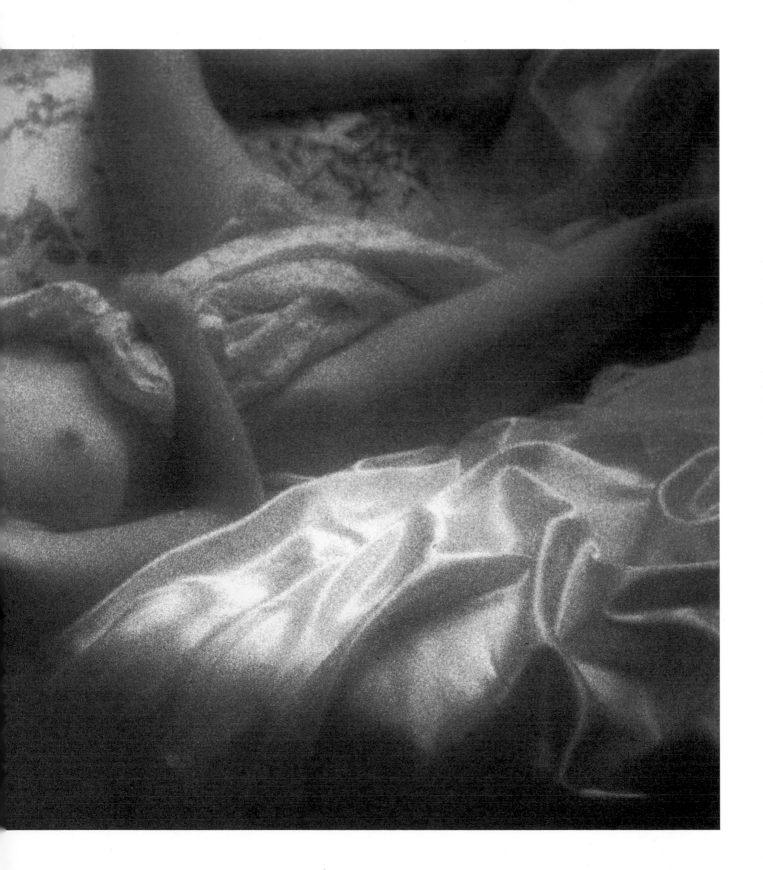

Print Size

When Size Makes the Statement

Part of a viewer's response to a photograph is related to the physical size of the presentations. Presenting an image as a physically small photograph has a significant effect only when the intent is to make the subject seem precious and delicate, and only when there is no need to make the image large enough for the viewer to see fine detail.

The above image of New York City's St. Patrick's Cathedral works well only as a small photograph. By being printed so small, the photograph makes the massive cathedral seem humble, delicate, and private, as if to say, "No matter how imposing these walls appear, no one need be intimidated. All are welcome". Had the image been enlarged to cover the entire page, the photograph would have lost its feeling of intimacy.

Physically large photographs are automatically inspiring. When a photographer wants the viewer to be impressed by the presence of detail and that detail would not otherwise catch the eye, then the large size becomes part of the statement. Such is the case in the photograph at right. It's messages that large cities are overwhelmingly impersonal, is closely related to the image's physical size. Printing the image as small as the one of St. Patrick's Cathedral would have destroyed, or at least altered, the message.

Sometimes a photographer can anticipate at the time he takes the photograph how large he will want to print the image. Just as often, the decision is made after the film is processed.

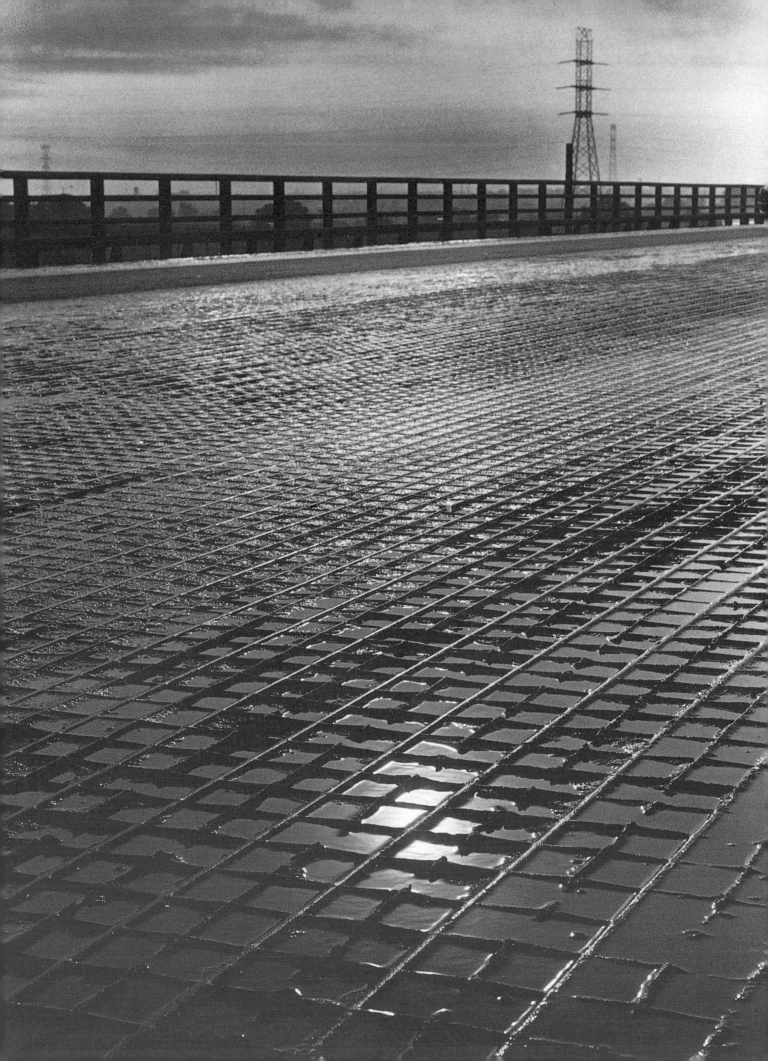

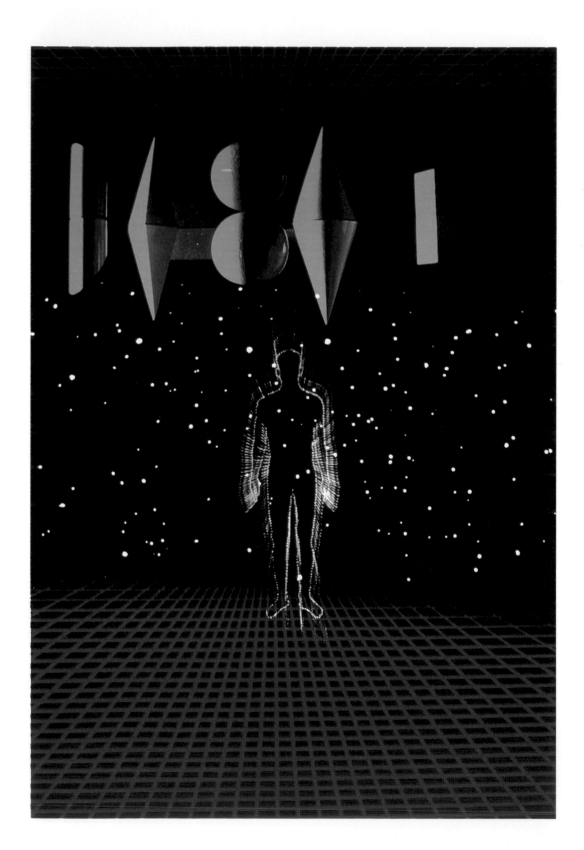

CHAPTER FOUR

COLOUR CONTROLS

A photographer discovers a barn in the middle of a field. He sets about capturing the barn's deep red colour on film. The way the colour of the barn appears to the photographer's eye may be noticeably different from the colour that ends up on the film. In the final image, the precise shade of red, as well as its intensity, will depend greatly upon a variety of factors: type of film, time of day, angle of view relative to the sun, weather conditions, exposure, and even lens accessories. What the photographer sees is not necessarily what he will get—and may not even be what he wants.

Few photographers understand colour as a compositional element. They see colour as an inherent, immutable characteristic of a scene or object, rather than as a controllable, compositional component that must be considered and dealt with purposefully. Although colour control is just as important in photography as in painting, many photographers do not realize that they have at their disposal methods for manipulating colour that range in effect from subtle to severe.

COLOUR AWARENESS
The first step a photographer must take in mastering control of colour is to become aware of the variations in the way any colour may appear to the eye. Because the eye perceives colour as a consequence of the presence of light, a change in light generates a change in colour. As the day progresses, for example, or as the angle between the photographer, the sun, and the object being photo-

graphed is changed, the appearance of the colours in a scene is altered. That at least partly explains why the colour of the fictitious barn discussed earlier may appear different depending on the light conditions under which it is photographed.

A photographer cannot manipulate that which he does not or cannot detect. Therefore, a prerequisite to colour control is the ability to perceive subtle colour differences. Most people are not born with this ability, but can develop it by training themselves to analyze the colour of objects and the changes that occur as lighting conditions vary. Because conscientious observation of the environment under all possible lighting and weather conditions is the means by which colour sensitivity develops, the practice of analyzing the colour in scenes should be ongoing.

FILM

In order to control colour a photographer must not only know what colours he wants, he must know how to use his equipment—especially his film—to achieve those colours.

A photographer cannot expect to produce a given colour unless he knows under what conditions the film he is using will generate that colour. Therefore, control of colour requires complete familiarity with the characteristic responses of the film that is being used over a broad range of conditions.

Unfortunately, the effect of a particular set of conditions on any type of film is not always completely predictable. Experience enables a photographer to know approximately how to reach a certain colour goal, but when colour is critical, a prudent practice is to take more than one photograph. For example, by bracketing (that is, by intentionally over- and underexposing a scene slightly), the photographer maximizes his chances of arriving at the colour he wants. Similarly, different intensities of filtration might be used, so that the image containing the most desirable colour can be selected later, after the film is developed.

COLOUR STATEMENTS

Colour statements result when the photographer responds to the colour of a scene and then makes the photographic decisions necessary to capture that response in the image he creates. In a colour statement, the message a photograph conveys is inextricably linked to the colours it contains.

For example, the southwestern United States is characterized by canyons with walls of brilliant red sandstone. A photographer wishing to prompt a viewer of his photograph into experiencing the feelings those colours gener-

Commonly Used 35mm Colour Films, Filters, Light Source Correcting and ASA Compensations

Make	Film	Speed ISO/ASA	Daylight	
			Correction filter	New
NEGATIVE FILM				
Agfa-G	Agfacolor N80S	80	–	
	Agfacolor N80L	80	85B or CTO12B	
	Agfacolor CNS	80	–	
	Agfacolor 100	100	–	
	Agfacolor 400	400	–	
Fuji	Fujicolor HR100	100	–	
	Fujicolor HR400	400	–	
Kodak	Kodacolor VR100	100	–	
	Kodacolor VR200	200	–	
	Kodacolor VR400	400	–	
	Kodacolor VR1000	1000	–	
	Kodacolor II	100	–	
	Kodacolor 400	400	–	
	Vericolor IIS	125	–	
	Vericolor IIL	100	85B or CT012B	
Konica	Konica CP100	100	–	
	Konica CP200	200	–	
	Konica CP400	400	–	
REVERSAL FILM				
Agfa-G	Agfachrome CT18	50	–	
	Agfachrome CT21	100	–	
	Agfachrome 50S	50	–	
	Agfachrome 50L	50	85B or CT012B	
	Agfachrome 100	100	–	
	Agfachrome 200	200	–	
Fuji	Fujichrome 50	50	–	
	Fujichrome 100	100	–	
	Fujichrome 400	400	–	
Kodak	Kodachrome 25	25	–	
	Kodachrome 64	64	–	
	Ektachrome 64	64	–	
	Ektachrome 200	200	–	
	Ektachrome 160	160	85B or CT012B	
	Ektachrome 400	400	–	
Ilford	Ilfochrome	100	–	
Konica	Konicachrome	100	–	

The first of the correction filter recommendations in the table from the Kodak Wratten range in each case. The second is an Agfa Gevaert filter.

3,200K tungsten		3,400K photolamps	
...ction filter	New ISO/ASA	Correction filter	New ISO/ASA
...or CTB12	20	80B or CTB8	25
—	—	81A or CT02B	64
...or CTO12	20	80B or CTB8	25
...or CT012	25	80B or CTB8	32
...or CT012	100	80B or CT08	125
...or CT012	25	80B or CT08	32
...or CT012	100	80B or CT08	125
...or CT012	25	80B or CT08	32
...or CT012	50	80B or CT08	64
...or CT012	100	80B or CT08	125
...or CT012	250	80B or CT08	320
...or CT012	25	80B or CT08	32
...or CT012	100	80B or CT08	125
...or CT012	32	80B or CT08	40
—	—	81A or CT02B	80
...or CT012	25	80B or CT08	32
...or CT012	50	80B or CT08	64
...or CT012	100	80B or CT08	125
...or CTB12	12	80B or CTB8	16
...or CTB12	25	80B or CTB8	32
...or CTB12	50	80B or CTB8	16
—	—	81A or CT02B	40
...or CTB12	25	80B or CTB8	32
...or CTB12	64	80B or CTB8	125
...or CTB12	12	80B or CTB8	16
...or CTB12	25	80B or CTB8	32
...or CTB12	100	80B or CTB8	125
...or CTB12	6	80B or CTB8	8
...or CTB12	16	80B or CTB8	20
...or CTB12	16	80B or CTB8	20
...or CTB12	50	80B or CTB8	64
—	—	81A or CT02B	125
...or CTB12	100	80B or CTB8	125
...or CTB12	25	80B or CTB8	32
...or CT012	25	80B or CT08	32

The photographer must choose between fidelity to the scene on the one hand and creative distortion on the other. Which approach to follow is a matter of personal choice. Either is compositionally valid.

ate must make several photographic decisions. He might elect to stand in a canyon and use a wide-angle lens, so that the viewer feels engulfed by the towering red walls. He might also choose to take his photograph in the late afternoon, when the light from the sun reinforces the red of the stone. Or, feeling that his film will not be able to reproduce the red with the proper intensity, he might even decide to add a red filter to his lens. If he is successful, the *colour* of the photograph will be as important to its message as any other element—and may perhaps become the most important element of all.

COLOUR DISTORTION

The correspondence between colours in the original scene and in the photographic image is never exact, and varies from film to film and colour to colour. Therefore, in any photograph some or even all colours will be distorted.

Cyan, magenta, and yellow, the colours of the dyes used to generate an image on colour film, are the colours of the photographer's palette. Combinations of these can produce any colour in the visible spectrum. When the colours in a photograph have shifted from those in the original scene, cyan, magenta, and yellow colour-correction filters (available from camera shops) can be laid over the image to indicate the colour adjustment that will restore colour fidelity.

Colour-correction filters can also be used at the time a photograph is taken by holding them in front of the lens to distort the colour in the image. The nature of the distortion depends on which filter or combination of two filters is selected. (Equal intensities of all three filters used together produce only a neutral grey.) The amount of the distortion depends on the density of the filter or filters used. Although the colour filters designed for use with black-and-white film can also be used with colour film, control is minimal and the results usually look artificial. Thus, by using colour-correction filters, a photographer can adjust the colour of a scene in any way and to any extent that he wishes. For example, he might emphasize the natural colour in a sunset by holding a magenta filter in front of the lens. Alternatively, he might abandon all efforts to remain faithful to the colours of the original scene, and instead introduce whatever colours will help him make the colour statement he envisions.

In short, the photographer must choose between fidelity to the scene on the one hand and creative distortion on the other. Which approach to use is a matter of personal choice, and either is compositionally valid. The photographer can guage his success by determining the extent to which his image expresses the meaning he intended.

The Meaning of Colour

Colours are closely associated with human emotions and moods. When one is angry, he "sees red". A person who is depressed feels "blue". People are described as being "green with envy". Cowards are said to be "yellow".

More concretely, no one contemplating painting the interior of his home selects the colour frivolously. Moreover, researchers have found that the productivity of workers may improve or decline as a result of the colour of their surroundings. In short, colour directly affects the human psyche.

PHYSICAL RESPONSES TO COLOUR

The perception of colour is the result of certain physical responses the human body makes to different wavelengths of light. Specifically, light that has been focused by the eye's lens strikes the retina of the eye and stimulates electrical charges in the eye's rods and cones. The optic nerve then carries these charges to the brain, where they are interpreted.

Due to the physical characteristics of light rays, the lens of the eye cannot focus different colours exactly on the retina at the same time. For example, if red is in focus, green will be slightly out of focus. The viewer senses this disparity as colour vibrance, which produces a feeling of discordance and tension. When the two colours lie directly beside each other, the response is particularly strong. The Op artists of the 1960s were noted for exploiting this phenomonen in their works. The illustrations at right, below, demonstrate the effect.

EMOTIONAL RESPONSES TO COLOUR

The emotional responses people feel to a colour are associated with occurrences of that colour in nature. Specifically, yellows and reds, which are associated with the colours of the sun, engender feelings of warmth, and in some circumstances, uncomfortable heat. Conversely, blue, the colour of water, and green, the colour of foliage, induce feelings of coolness and calm. The other colours of the spectrum, which consist of various proportions of blue, green, and red, produce less intense responses that relate to the intensity of the colour's constituent tones.

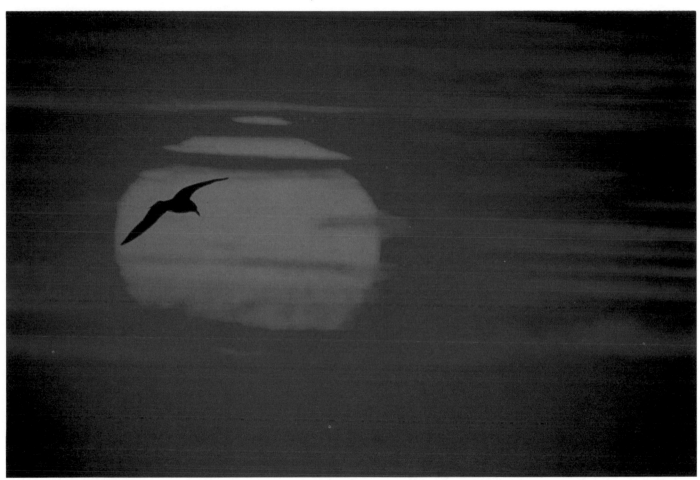

Two Different Colour Moods
The two photographs shown on this
and the previous page are funda-
mentally identical except for col-
our: one is predominantly red, the
other blue. Strictly as a consequ-
ence of the colour difference, the
feelings projected by the two photo-
graphs differ noticeably.

In the one photograph, the hot sun,
rendered as a large globe, is made
more forceful by the introduction of
supplementary red tones. The feel-
ing produced is of heat, dynamism,
and power. In the other, pastel blue
tones introduce a more peaceful
feeling, one that probably would not
have seemed appropriate had the
sun been larger in the frame.

An effective exercise for a photo-
grapher learning to use colour is to
approach subjects regularly with the
specific intent of making a colour
statement. His goal should be to be-
come so accustomed to coordinat-
ing mood and colour that whenever
he is using colour film, the practice
will be automatic.

The Colour Yellow

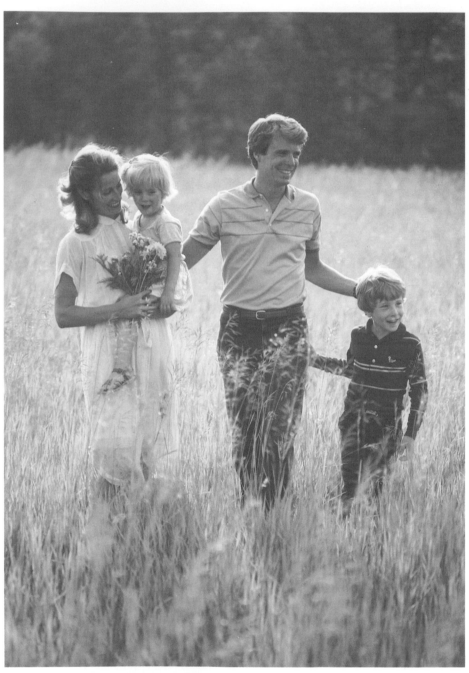

Yellows and reds, the colours that most clearly evoke the warmth of the sun, can be introduced into a scene by shooting at dawn or dusk, by inducing lens flare, or by using warming filters.

At dawn and dusk, light from the sun travels obliquely through the earth's atmosphere and a peculiar characteristic of light rays comes into effect; colours on the red end of the spectrum are bent so that they strike the earth while colours at the blue end are scattered by the atmosphere and pass off into space. Therefore, a scene that under midday light may seem cold and harsh will usually assume a much warmer, golden tone if photographed shortly after the sun rises or shortly before it sets. The photographer who is accustomed to sleeping late in the morning pays for his lassitude by depriving himself of the opportunity to exploit fifty percent of the warmest light rays of the day.

Lens flare is a phenomenon that many photographers studiously avoid, but it can provide another means for introducing warm colours into a scene. Flare occurs when direct rays of light enter the camera lens. In one form of lens flare polygons of light materialize on the film. The other type generates a yellow cast across the surface of the film, with an accompanying decrease in image contrast. In reflex and view cameras the photographer can monitor both types of flare by looking in the viewfinder, but this is not possible in rangefinder cameras.

Properly used, the second type of lens flare introduces a warm—sometimes even hot—feeling to a scene. The amount of flare is controlled by the relative positions of the camera, the subject, and the sun, and by whether the sun's sphere is partially obstructed (by clouds or other objects) or included in its entirety. Moreover, accompanying the decrease in contrast that this type of flare produces is a reduction in the intensity of other colours present in the scene. The ability to predict the exact effect that will be produced by a particular amount of flare comes only with experience.

The Warmth of Yellows
Since companies with something to sell are often interested in associating their product with a particular mood or feeling, commercial photographers are especially attuned to the relationship between colour and emotion.

Both of these photographs were taken for commercial purposes, and both involved the enhancement of warm tones. The photograph above was intentionally taken in the late afternoon, when the yellow tones of the sun are strong. Moreover, in response to the desire of the client to produce a photograph with a warm feeling, the models were purposely dressed in warm-tone clothes. Finally, the photographer positioned himself so that direct sunlight entering the lens produced lens flare, resulting in an overall yellow cast to the frame.

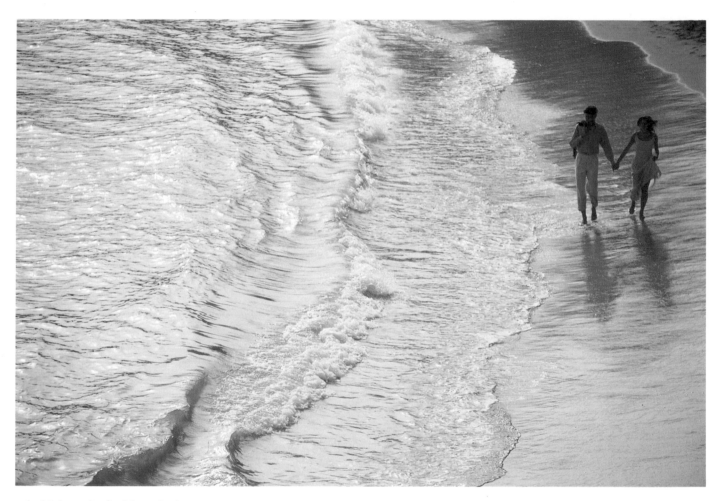

A third method of introducing warm colours into a scene is to affix filters to the camera lens. Any filter or combination of filters that introduces a shade or red or yellow is potentially suitable. For example, an 81A (amber) filter, designed to convert 3400K light for use with 3200K film, produces a subtle "warming" effect when used with daylight film. In some circumstances magenta filters can be used to create pleasing effects.

In general, these three methods are used most effectively for enhancing colours already present in a scene, rather than for introducing colours otherwise absent.

Enhancing Existing Colour
When a photographer wants to add colour to a scene but at the same time wants to avoid a feeling of artificiality, the best approach is to try to enhance those colours already present, rather than to introduce new colours entirely.

In the photograph above, the intent was to produce a photograph containing warm colours, but the actual conditions were less than ideal. Without clouds in the sky to reduce the sun's intensity, the light was too harsh, even as sunset approached. In order to add the desired amount of colour into the scene, the photographer used a yellow and an amber filter in combination, with the results shown above.

In essence, the photographer used what is frequently a successful approach: he identified what was lacking in the scene, introduced a correction, and then for emphasis carried the correction to an extreme.

99

The Colour Purple

The Royal Colour

Purple (and its variants, magneta and violet) is the "royal" colour. Perhaps because it is sparsely distributed in nature, purple has long connoted power and uniqueness. In the minds of most people, the colour is usually associated with gems, flowers, robes, vestments, and spectacular sunsets.

Being so special, purple must be used for a good reason, or else its presence will seem out of place in a photograph. In the photograph at right, magenta was added to help suggest the awesome size, sound, and power of a contemporary jet plane. Without the magenta, the scene would have been predominantly grey. The added colour both enhances visual interest and makes its own statement about the plane. Purples are tricky to use. In this case, the magenta colour was added successfully because no other colours were present to be adversely affected. Had the day not been overcast, or had other colours been distorted by the magenta tones, the unusual colour would have seemed inappropriate.

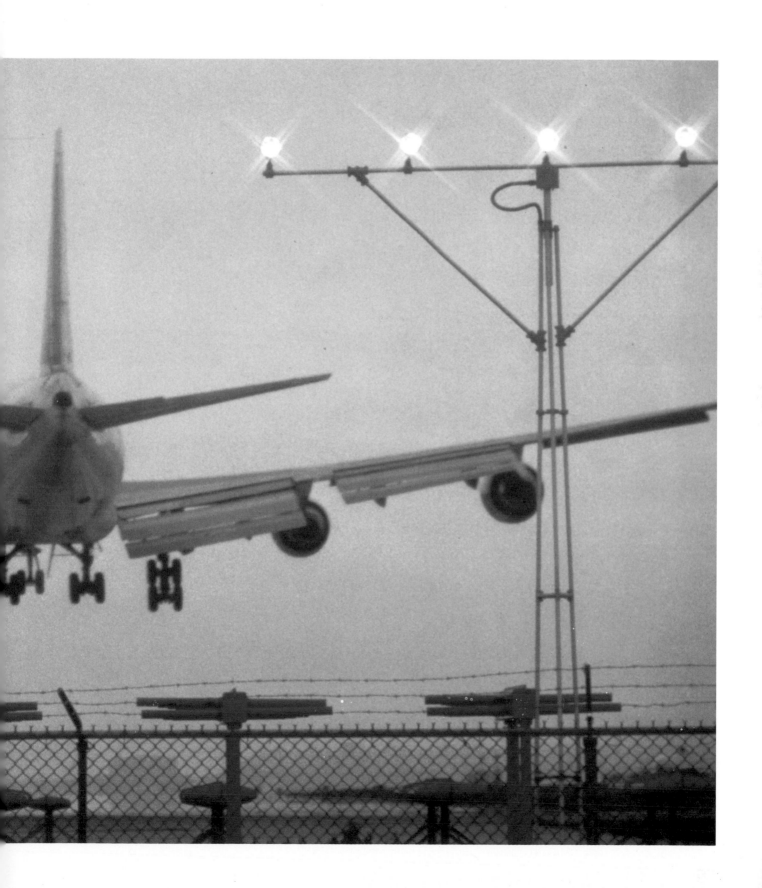

The Colour Green

Green, the colour of grass and foliage, evokes feelings of coolness, lushness, and sometimes moisture. By extension, green can be associated with good health, cleanliness, youth, and growth. Unlike yellows and reds, green cannot be added through the use of filters without looking artificial. If an overall green tone is desired, it must result from the actual colour of objects a photographer chooses to incorporate within the film frame. In other words, green statements generally require a green environment.

One technique is especially useful in transferring the green of foliage to film with full intensity. Because the surface of foliage is smooth, it reflects light. In many scenes, the richness of the green is obscured by the reflections. Often, a polarizing filter will eliminate the reflections, allowing the deep, green colour to show through.

To be effective, a polarizing filter must be orientated properly on the lens. As long as a reflex camera is being used, positioning the filter is simply a matter of looking in the viewfinder while the filter is being rotated, then taking the photograph when the colour appears richest and most pleasing. With other types of camera, the filter must be oriented correctly by eye before it is mounted, and then carefully moved into position in front of the lens.

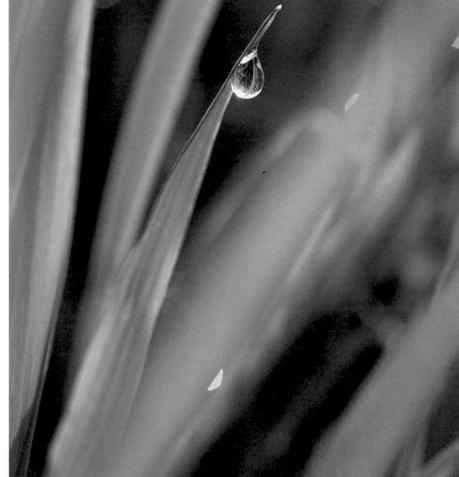

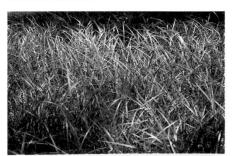

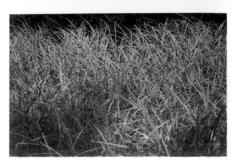

Foliage and Polarizing Filters
The green of foliage can often be purified and enhanced through the use of a polarizing filter.
In the upper photograph, light reflecting off the surface of the grass significantly dilutes the predominantly green colour of the scene. Although to the eye the grass appeared lush, on film their green colour does not seem especially intense.

In the lower photograph, a polarizing filter has eliminated the reflections. The result is a scene in which the green colour is much more prominent. Because of its ability to intensify the colour of foliage, a polarizing filter should be a standard item of equipment every outdoor photographer routinely carries.

A Commercial Use of Colour

Advertisers are especially sensitive to nuances of the intrinsic meaning of colours, and intertionally try to associate their products with colours that evoke particular responses. Because colour is so important to them, even subtle differences in shade can be significant. For example, cigarette manufacturers like people to think of menthol cigarettes as being cool and refreshing. Consequently, menthol cigarette packaging is customarily notable for the presence of the cool colours, blue and green. Advertising agencies know that reds and yellows would not project the image being sought.

For many years, advertisements for a particular brand of cigarettes invariably included a photograph of a waterfall surrounded by green foliage. The concept of the ads was so carefully controlled and the exact colour of the photographs used so important to that concept that a given photograph would be immediately rejected unless it projected exactly the right feeling and colour.

At right are two photographs of the same waterfall. Both are pleasant enough to look at, but the upper photograph conveys a much stronger message of moisture, coolness, and lushness. In the lower photograph, the colours are less intense, and due to the angle chosen, the overall feeling is much weaker. Indeed, the upper photograph was used by the makers of those cigarettes in one of their ads.

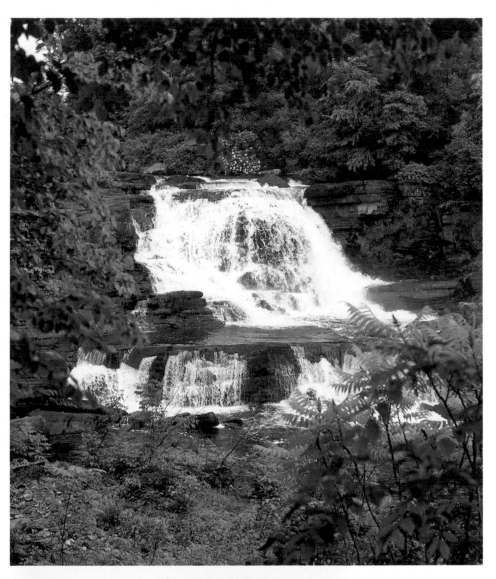

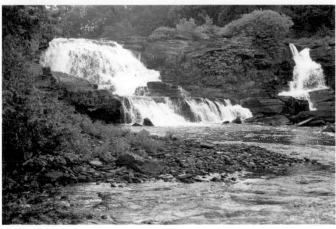

Colour Saturation

Saturation is the term used to describe a colour's intensity. A given colour in its saturated state is deep, rich, and vibrant. In its unsaturated state it is muted, soft, and weak. A physical correlation exists between the degree of saturation a colour is showing and the density of the corresponding pigment on film.

Colour saturation can be controlled photographically. Specifically, saturation is affected by the quality of the light source, the angle and direction of the light illuminating a scene, the weather at the time the photograph was taken, the exposure, and the presence of reflections.

LIGHT QUALITY AND ELEVATION
As was mentioned earlier, light quality is different at different times of the day. Early morning light and late afternoon light generate colours on film that are highly saturated. The nearer the hour is to midday, the lower the saturation of the colours in a scene. Since there is a direct correlation between time of day and the elevation of the sun in the sky, colour saturation can also be said to decrease as the sun climbs higher in the sky and then to increase as the sun descends toward the horizon.

LIGHT ANGLE
The relative positions of sun, subject, and camera affect colour saturation. In a frontlit or sidelit situation, saturation is higher than if the subject is illuminated from behind. With backlighting, saturation can become so low that colours begin to lose their identity and appear grey. (This is especially true when lens flare is present.)

WEATHER
It is important to realize that in order for the full intensity of a colour to be revealed, sunlight must be striking the colour directly, unimpeded by clouds. Under an overcast or hazy sky, or in shadow, colours often appear less than fully saturated, regardless of the time of day, the sun's elevation, or light angle.

EXPOSURE
An exposure that yeilds the best saturation for one colour in a scene may not yield equally pleasing results for other

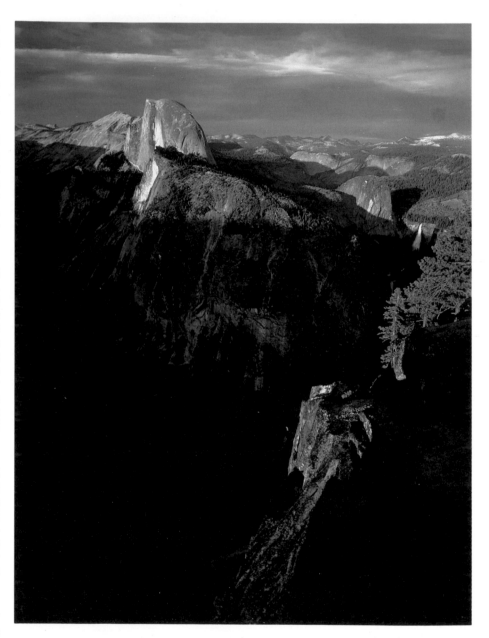

colours in the same scene. Moreover, most light meters measure the average amount of light present in a scene, and do not necessarily indicate the exposure that will be best for rendering a particular colour in full saturation. Therefore, many serious photographers will take several shots of the same scene, changing the exposure each time.

This technique of bracketing expo-

sures simply involves taking one frame at the setting indicated by the light meter, and then taking at least one frame that is overexposed relative to that setting and one that is underexposed. The exposure is usually varied by a full *f*-stop in each direction. (Professionals, recognizing how critical exposure can be to colour saturation, will sometimes bracket in half-stop increments.)

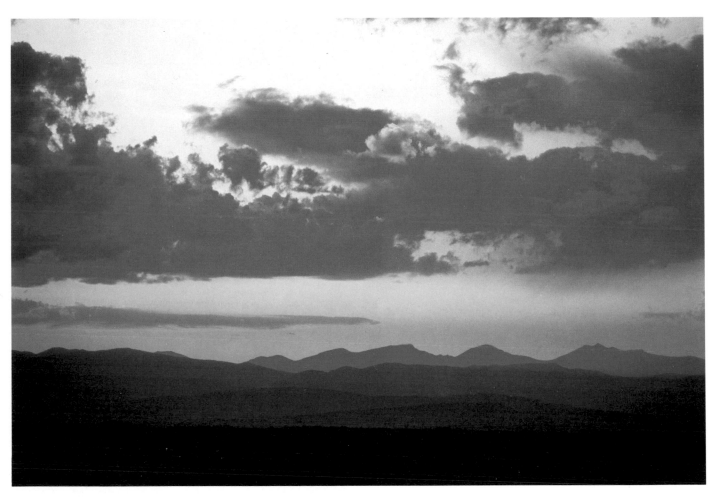

Matching Light to Subject

Different amounts of colour saturation are appropriate for different subjects.

Both of the mountain scenes shown here were taken at sunset, yet they show significant differences in the amount of colour saturation present. In the photograph at left, the goal was to capture on film a specific location: Half-Dome in Yosemite National Park, California. An important aspect of this photograph is that both saturation and contrast are greatest in those objects that sunlight strikes directly. This is especially true in the case of the waterfall in the lower right corner of the frame, which would have been practically invisible if the photograph had been taken only a few moments later, when the area in direct sunlight had shifted.

Moreover, saturated colours help make the subject less abstract than would have been the case had the colours been more muted. To further increase saturation, this photograph was taken through a polarizing filter, which enhanced the blue colour of the sky, and the photograph was underexposed by one half-stop.

The photograph above was taken with the camera pointed towards the sun. Because of this backlit condition, little contrast is present and the colours are highly unsaturated. This treatment helps make the scene more general than the other one, and hence less readily identifiable. In the first photograph the subject is Half-Dome, in the second, simply "Mountains".

Saturation and Exposure

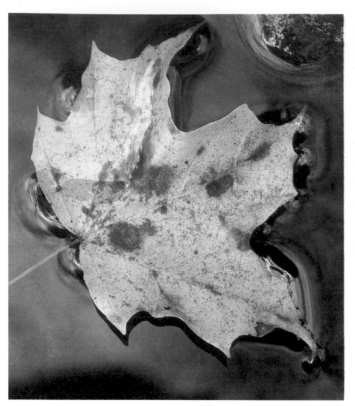

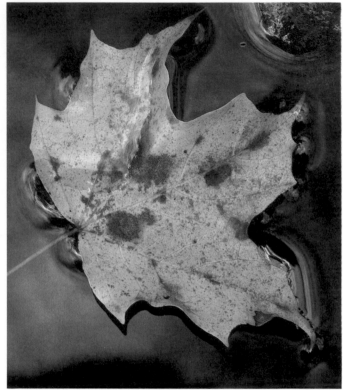

The Effect of Exposure on Saturation

Exposure affects saturations and therefore the statement a photograph makes. Consequently, choosing the most desireable exposure from among several technically correct possibilities is crucial to creating an image that fulfills the photographer's intentions.

Each of these photographs was taken at a different exposure. None is more correct that the others. Each shows good detail in the leaf, but the amount of detail apparent in the water varies, and therefore so does the emphasis. Specifically, in the photograph above, left the emphasis is on the water, above right, the emphasis is shared equally by the water and the leaf; and at right, the emphasis is mainly on the leaf.

A viewer looking at these three photographs together might decide that he likes one better that the others, but each image can stand independently.

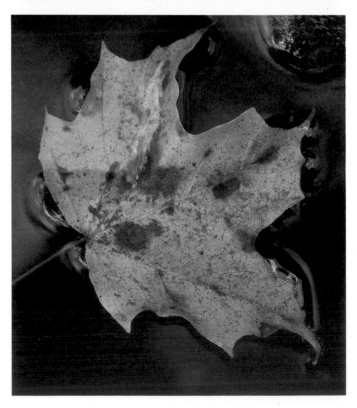

Combining Techniques for Saturation

Achieving pronounced colour saturation often requires appropriate photographic techniques.

The deep yellow colour of the taxi cab in the photo above was originally diffused by the presence of numerous reflections. Just as a polarizing filter can remove reflections from foilage, it can eliminate them from shiny, nonmetallic surfaces. In this case, the filter erased most of the reflections on the surface of the yellow paint used to coat the taxi's body.

In addition, the exposure of this photograph was bracketed one full stop (in half-stop increments) on either side of the correct exposure (as indicated by a light meter). As often happens, the best saturation occurred in one of the frames that was underexposed.

Colour Warmth

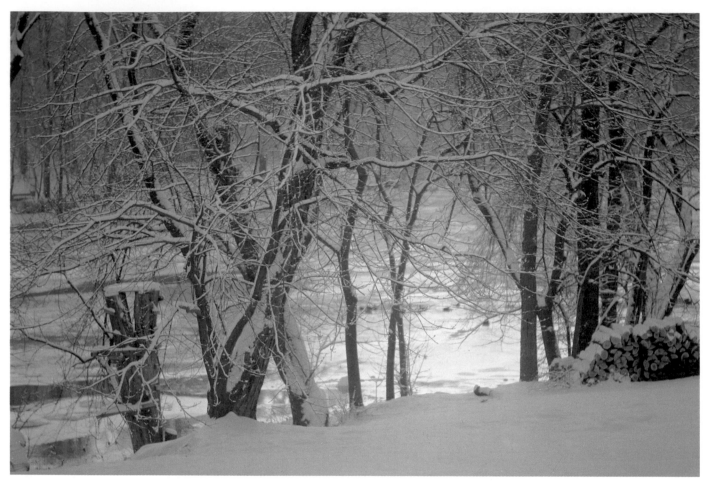

Colour Warmth
Even if only suggested, the presence of the sun can completely change the feeling of a scene.
These two photographs of the same scene were taken within minutes of each other. In the left photo, blue tones clearly evoke the cold of winter. The scene appears bleak and frigid.
A few minutes later the sun appeared and the presence of its golden rays completely transformed the emotional impact of the scene. The effect results not from the sun's actual appearance within the frame, but from the golden colour, which suggests the sun's presence. The pervasive wash of yellow implies that the sun has risen and that its all-encompassing warmth is available to be shared and enjoyed.
The mood of many scenes that have cold or sombre feelings can be completely changed simply by introducing the warmth produced by yellow and reds.

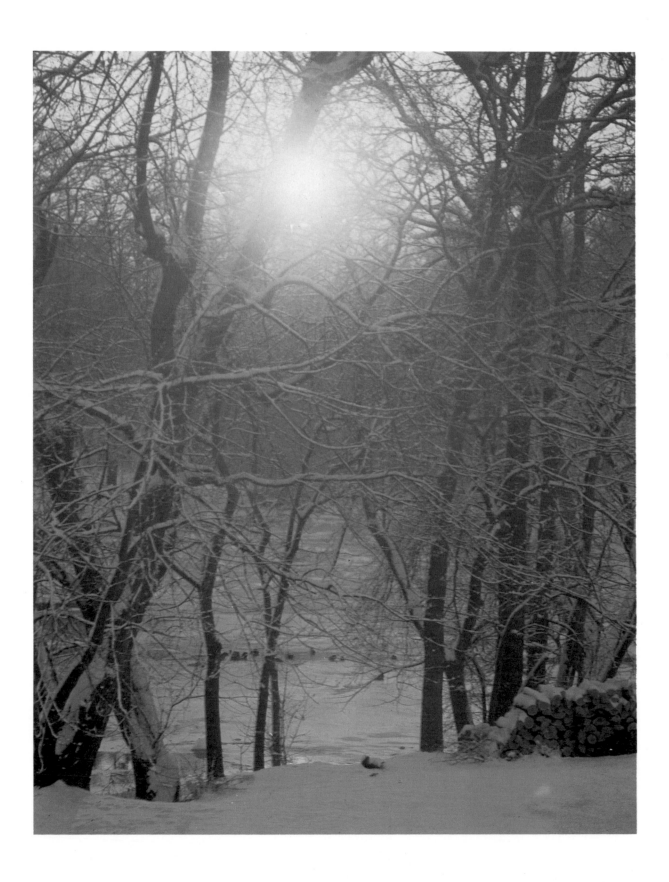

Colour as the Subject

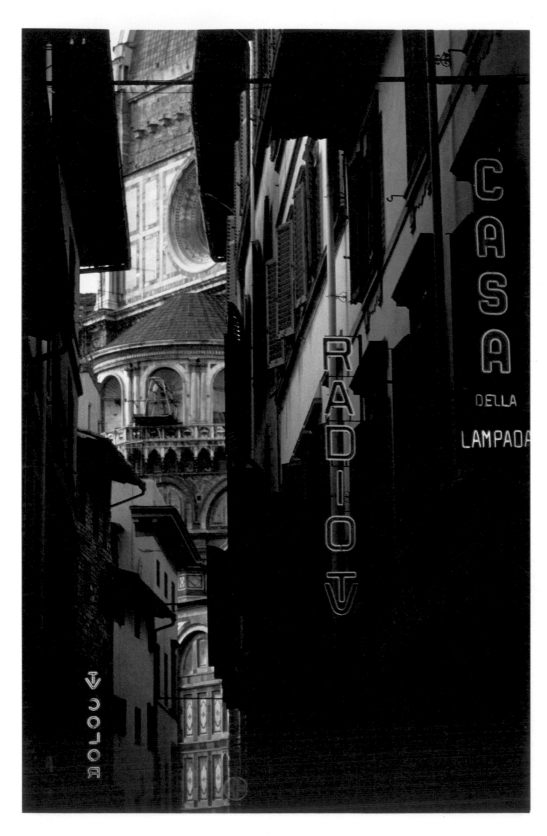

Where Colour Makes the Statement.

In photographs in which colour is used effectively, removing it would significantly change the photograph's statement.

In both of these photographs, colour is essential. At right, colour *is* the statement. The deep red colour, which is highly saturated due to the direct rays of the sun, is reflected in the water, as well. In effect, this is a monotone photograph. In terms of composition, the colour red is absolutely essential to the photograph's meaning. In black-and-white, this image would be dull at best-certainly, its meaning would be changed.

At left, the presence of colour is again critical. Although the centre of interest of this photograph of Florence, Italy is the famous Duomo in the background, the statement the photograph makes is directly related to the bright neon colours in the foreground. These colours contrast with the others present in the scene, drawing attention to the muted earth tones that characterize the older portions of the city and at the same time balancing the weight of the Duomo in the frame. Without the presence of the neon lights, this photograph would not have been making a colour statement at all.

Just because these photographs as they stand could not survive the absence of colour does not imply that these scenes could only have been photographed on colour film. Rather, the implication is that in using colour film, a photographer should be looking for compositions that exploit the film's unique capabilities. Either of these scenes could have been photographed in black-and-white, but the compositions would have had to have been adjusted accordingly.

Film Mismatch

Colour Mismatch

When the colour temperature of the light source does not match the colour balance of the film, inaccurate colour rendition results. Depending on how the shift in colour is used, the mismatch can either detract from a photograph or enhance it.

In this photograph, the goal was to preserve the feeling of a baby peacefully sleeping. The only light falling on the baby was from an ordinary household (tungsten) light bulb.

Since the camera was loaded with daylight film, the easiest approach would have been to attach an electronic flash to the camera. Instead, the decision was made to use only the available light, in the knowledge that the mismatch of film and light source would produce the warm, intimate, yellowish cast.

Due to the low intensity of the light, it was necessary to mount the camera on a tripod and use a cable release. As is often the case, producing an eloquent composition involved extra effort, but the result is a stronger statement.

The constituent colours of light vary depending on the light source. Daylight and electronic flash contain all colours of the spectrum, whereas with both incandescent and fluorescent light sources, some wavelenghts of light are lacking. Moreover, within these broad categories of light courses (i.e., daylight, incandescent, and fluorescent), the exact constituent colours vary. Colour temperature, as expressed in Kelvins, is a measure of the dominant colour in a particular light source.

COLOUR BALANCE

The human eye and mind adjust to some extent for the colour variations produced by different light sources, but film is less accommodating. Each colour film is balanced for light of a particular colour temperature. If a different light is used with that film; the colours are not rendered accurately.

Colour film is manufactured primarily for use with three different light sources: daylight (5500K), photolamps (3400K), and tungsten filament bulbs (3200K). On each box of film is a notation describing the type of light source or the colour temperature for which the film has been balanced.

COLOUR MATCH AND MISMATCH

In most circumstances, a photographer wants to make certain to match his film to the light source he is using. Should he use film balanced for 3200K light with flash or in daylight, the image will appear to have an overall bluish cast. Conversely, using daylight film with a tungsten bulb will generate a yellow cast.

However, in some circumstances mismatching film and light source can be beneficial. As restaurant owners are aware, some lighting conditions are more pleasant that others (how many fine restaurants use fluorescent lighting?). Specifically, rich yellow tones add an aura of warmth and intimacy to a scene. Candles on a table produce their effect as much from the colours they generate as from their dimness.

Since a mismatch of film and light source can create or augment desirable colour effects, mismatching can be used compositionally. In circumstances where a photographer wishes to create a feeling of warmth and intimacy for a family setting, using a daylight film with a tungsten light source will lend a pleasant yellow cast to the scene that can be quite appealing.

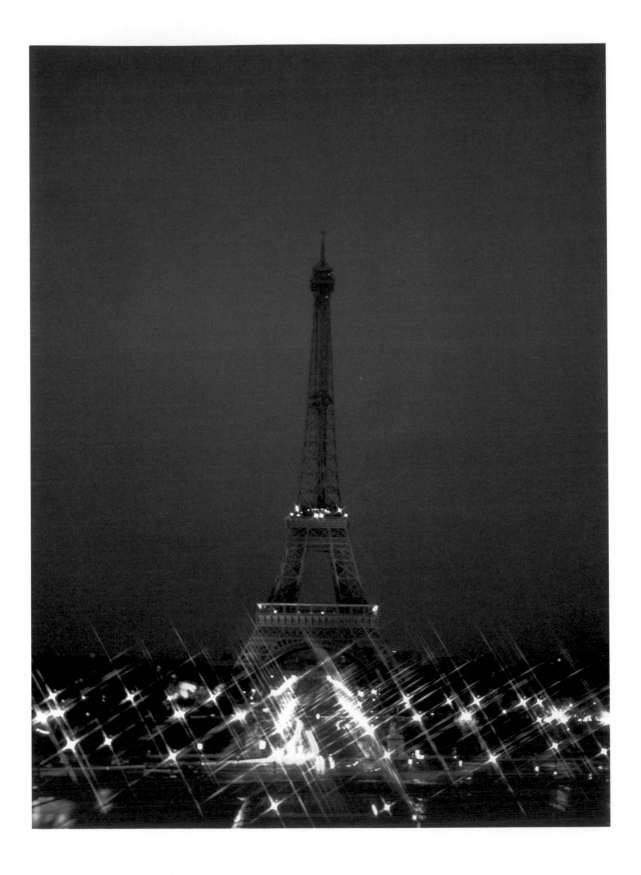

Artificial Colour

When conditions are not ideal for reaching a photographic goal, in order to solve his problem a photographer may need to use the medium creatively. For example, in bad weather it is sometimes useful to employ artificial methods for injecting colour into an otherwise dull scene.

The photographs on these two pages were taken in Paris on a rainy, overcast day-the type of day many photographers feel presents an insurmountable obstacle to successful photography. The sky was overcast, light rain was falling intermittently, and a bitter wind was blowing. Yet, the goal was not to express how bad the conditions were, but to use the resources that were available to capture the essence of the city *despite* the conditions. Good composition requires that a photographer use whatever means he can to extract his message from a scene.

The solution used at left was to wait until dusk. Even when the sky is actually overcast, at dusk colour film often renders the sky in shades of blue. Thus, the blue in the photograph was not directly added, but was simply the result of a characteristic of colour film. Similarly, since the film was balanced for daylight, tungsten streetlights added touches of yellow. Moreover, by dusk, drivers had turned their car lights on, which introduced reds that were further enhanced through the use of a star filter.

In the photograph at right, colour was added in a purely artificial manner. An overcast sky is essentially colourless and assumes the colour of whatever filter is placed over the lens. In this case, a strong red filter was used. The colour is obviously unreal, but because the choice of lens and position converted the Eiffel Tower into a strongly graphic shape, the artificiality is acceptable as a component of a primarily graphic composition.

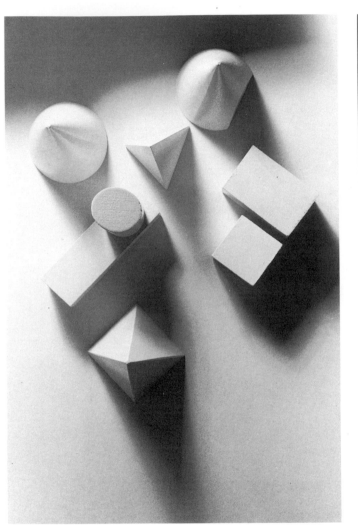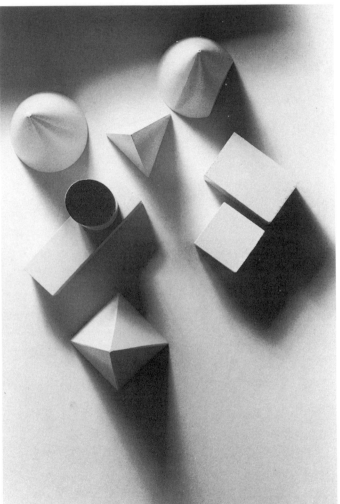

CHAPTER FIVE

TOTAL CONTROL

The dominant and oft repeated theme of this book is that a phographer's work must contain some governing theme, idea, or message. Any discussion of composition is meaningless except in terms of how the photographer uses the visual components of his photograph to express an idea. But, a photographer might ask, how many new and original ideas can there be?

The underlying idea of a photograph need not be either new or original, as long as the idea interests the photographer. The very act of trying to express an idea—any idea—enables a photographer to give his photograph an intellectual focus. This focus forms the reference point by

which a discussion of composition becomes both possible and meaningful. When such a focus is missing, the photographer has no basis on which to make compositional decisions, and a viewer has no basic on which to interpret the significance of the elements he sees presented in the photograph. There is, in short, no communication.

DEVELOPING COMPOSITIONAL COMPETENCE
One reason photographic composition often seems hard to grasp has it roots in the very nature of photography. The medium can generate images so effortlessly and in such abundance that photographers tend to skip quickly from idea to idea. In comparison, painters often fix their attention on a single idea and pursue it in their work again and again, sometimes for years. In other words, a single idea becomes a theme that links a whole series of paintings. Over the course of the series, both the theme and the painter's technique become refined.

A photographer interested in mastering composition can benefit greatly from a similar practice. Rather than trying to express a different idea in every photograph, he can select an idea that he finds interesting and use it as an ongoing theme for his work. Or, he can select a few themes and pursue them in parallel.

For example, suppose a photographer wanted to record his child's birthday. Without a theme to follow, the photographer would probably produce little more that the equivalent of a newspaper report on the event. He might pose the children for a group portrait, or shoot whenever he saw something that struck his fancy, but chances are the photographers would constitute little more than momentos. Their value would rest solely on their ability to recall the event at a later time.

Were the photographer instead to choose a theme to follow, the results would be far different, and would have photographic—as well as compositional—significance. Depending on the photographer's interests and skill level, the theme could be simply, "the excitement of birthdays," or "the colour of birthdays." Or the theme could be more challenging, as in. "youth is wasted on the young," or "birthdays are as much for adults as for children." In the process of shooting to a theme, the photographer will produce images that probe beneath the surface of events.

On a more ambitious level, a photographer might select a theme that runs through his photographs over a period of days, weeks, months, or even years. For instance, this chapter includes a selection of images that represent an effort that spanned approximately twelve months.

Two Composite Compositions
The boundaries of a composition need not be limited by the borders of a single frame of film.

The four photographs on these two pages were taken under the theme that "Reality is subjective." The photographs were all taken separately. The idea was to use seemingly unrelated images to make connections that normally would not be made in the "real" world. Thus, the underlying purpose was to extract the objects from their everyday reality and use them to create a new reality that exists only within the mind of the viewer. For example, people do not normally see any relationship between a roadway and a television screen, or between a

taxicab medallion and a wooden door. Yet, when these objects are photographed and grouped together as they are here, the grouping make visual sense.

The most prominent compositional element in all four images is colour. In the two photographs above, yellow links the images, whereas in the other two, red serves the same purpose. Each of the two separate compositions represents an application of the theme underlying the individual photographs to a collection of images.

In interpreting the compositions, the mind makes associations and sees patterns. In both cases, the eye bounces back and forth from the

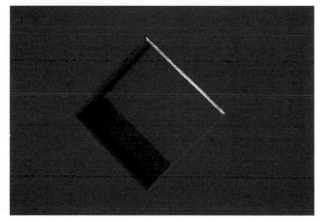

Another method of developing compositional skills and sensitivity for good composition is to study the work of others. Without exception, great photographers are masters at expressing themselves with their cameras. Often, aspiring photographers are hard pressed to understand why a particular photograph is considered great, whereas usually, an evaluation of the photograph's composition reveals that it contains a strong message clearly conveyed through the careful exercise of both graphic and photographic controls. Practice in interpreting the photographs of others helps a photographer with the composition of his own work.

For additional practice in evaluating composition, the reader is invited to inspect again the photographs presented in earlier chapters. However, this time the reader should evaluate the photographs not in terms of the specific point being illustrated, but in terms of all aspects of the photograph that contribute to its meaning. To verify his conclusions, the reader may check the Technical Data section at the back of the book.

TOTAL CONTROL

Prior to this chapter, the intent has been to break down the broad topic of composition into smaller concepts that are more easily grasped. However, no photograph contains only a single compositional element. Moreover, in a tight composition, no element should make a contribution that is independent of the other elements present. Indeed, the sign of a weak composition is the presence of elements that can be removed or altered without affecting the photograph's message.

In the final analysis, then, only if a photographer has assembled all of a photograph's components efficiently and succinctly is it compositionally sound. When, through diligent practice, he has learned to intergrate his knowledge about the constituents of composition, then, and only then, does he have not just graphic control, or photographic controls or colour control, but *total control*.

The purpose of this last chapter is to illustrate how, in practice, total control intergrates the various compositional devices to communicate an idea. These ideas run the gamut from simple to complex to abstract (as in the photographs on this page). In each case, the reader is invited to perform as an exercise his own compositional analysis and reach his own conclusions before reading the captions. Ultimately, of course, the reader is urged to apply the principles of photographic composition to his own work. Mastery of these principles is a time-consuming and challenging pursuit, but one for which the rewards of success are truly great.

upper image to the lower. This movement occurs in the composition on the left due to the presence of vertical lines, which continuously direct the eyes upward. In the composition at right, the same effect occurs due to the presence in both images of identical tones of red. Highly saturated colours make all of the photographs visually arresting. These compositions are effective because viewer involvement is part of the photographer's intent. A viewer instinctively notices similarities and tries to interpret them. He is actively interested in determining what the photographer had in mind, both in creating the images and in presenting them in such a fashion. Al-though the composition are highly abstract in that the actual subjects (a television, a taxi, etc) are unimportant, each composition is unified and expresses a discernible statement-a statement that is more strongly conveyed by the groupings than by the individual images.

While in most circumstances a photographer will choose to make his statement within the confines of a single frame, such a constraint is self-imposed and need not always be observed. The only "rule" is that the grouping should either make the statement more powerfully than the constituent photographs could alone, or should make a different statement altogether.

Concept: The Sterile City

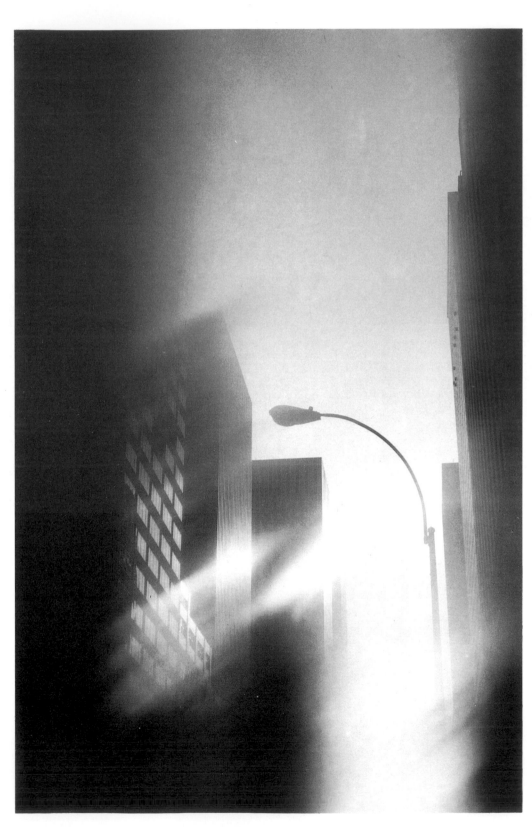

Varying Techniques.

The compositional devices used to pursue a theme can differ significantly from photograph to photograph.

These photographs were taken to illustrate the theme "The loneliness of the urban environment." The more obvious of the two treatments is shown at right. All compositional elements were organized to support the theme. A wide-angle lens was used to include the darkened walls and thereby provide a frame around the figures as they emerged from the bowels of an underground station. The lines of the escalator point to the couple. The treament is intentionally low key, with the predominant tones in the photograph remaining black while the centre of interest is highlighted.

The figures are small relative to the frame, symbolizing their insignificance within the structure of the city. Similarly, they appear to be going from nowhere into nowhere. Even though they stand side-by-side, they are not touching or looking at each other and therefore the psychological lines between them are weak. Clearly, no one viewing this photograph would think the photographer's intention was to suggest "the joys of urban life"

At left, the same theme is presented differently. Here, the viewer must place himself in the frame and analyze his reactions to the scene before him. Compositionally, the point of highest contrast is the curve of the lamp-post, which attracts the eye and leads it onto the building, with its dull, repetitive windows, These windows, which along with the lamp-post are the only objects in clear focus, reflect the sameness of urban life. The softness (of focus) of the surrounding areas helps erase the personality of the city as well as of the person, suggesting a dream world.

A viewer may not agree with the photographer's opinion as expressed in a photograph, but as long as the statement the photographer was trying to make is identifiable, the composition can be considered successful.

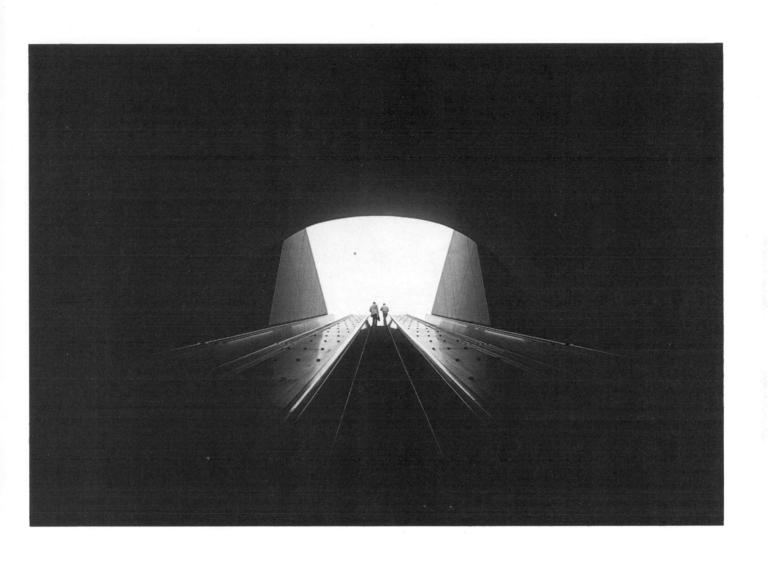

Concept: Man and Balloon

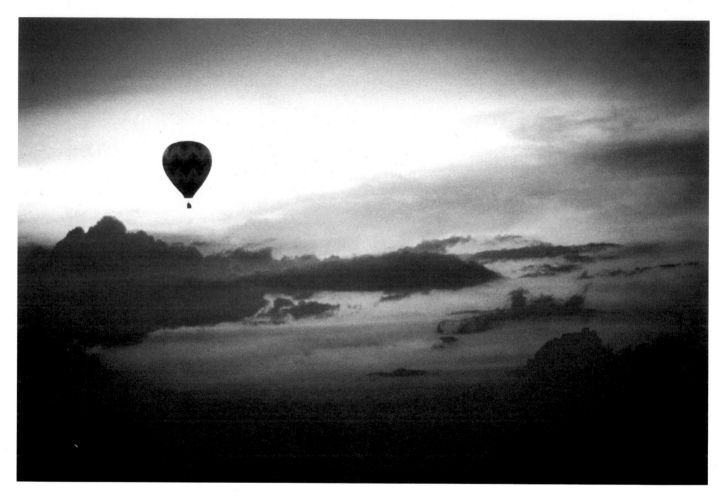

Supportive Compositional Devices
All of the compositional devices used in a photograph should reinforce each other.

The most apparent distinction between these two photographs lies in the size of the centre of interest relative to the frame. Because of these differences, the photograph on the left, above, is a commentary on the small size of the balloon—and by extension, man—in a large but peaceful universe, while the emphasis in the photograph on the right is on the large size and power of the balloon in comparison to the size of the man.

However, supplementary compositional devices are present and are consistent with those same themes. In the left photograph, the message is supported by the way the colours of both the balloon and the sky are muted, and by the line of the clouds, which is horizontal. Because the point of highest contrast in the scene is the balloon, it stands out clearly, despite its small size.

On the right, the balloon's colours are highly saturated and vibrant.

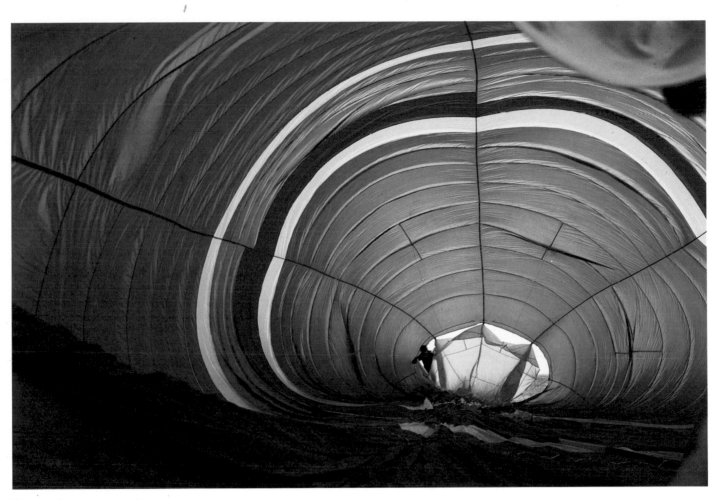

The spiral lines produced where borders of contrasting colours meet form a vortex that draws in the viewer and leads the eye directly to the man, the point of highest contrast. The balloon as presented here is a forceful, dynamic object that must be confronted and is mastered with difficulty.

Rarely, if ever, does a photograph rely for its effect on a single compositional element. Furthermore, if the photographer fails to exercise control over all the factors present, his message will not be clear.

Concept: the Graphic of Snow

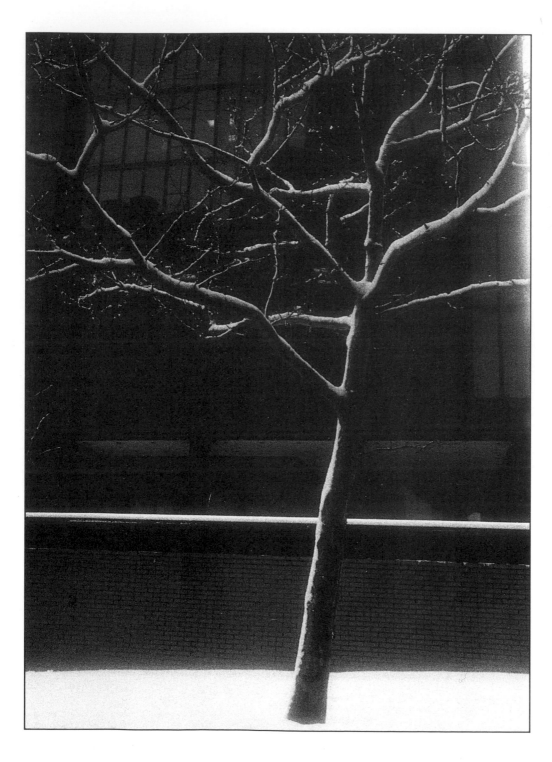

The Graphic Opportunities of Snow

Photographing snow is in many ways like working with "clean" light. Especially in black-and-white photographs, snow provides many opportunities for constructing strongly graphic compositions.

At left, snow lying on the branches of the tree appears as distinct white lines against a much darker background. This highly graphic condition is used to contrast the free form of nature with the more highly-structured forms of man, as depicted by the straight lines of the wall and the regular pattern of the building.

Compositionally, the most prominent characteristics are the nearly random lines of the branches and the horizontal lines formed by the top and bottom edges of the wall. The eye is initially attracted to the intersection where the diagonal line of the tree trunk meets and crosses the line of snow atop the wall, and then travels into the mass of tree limbs and finally onto the background building. Distracting elements in the foreground of the scene were carefully cropped out of the frame before the photograph was taken.

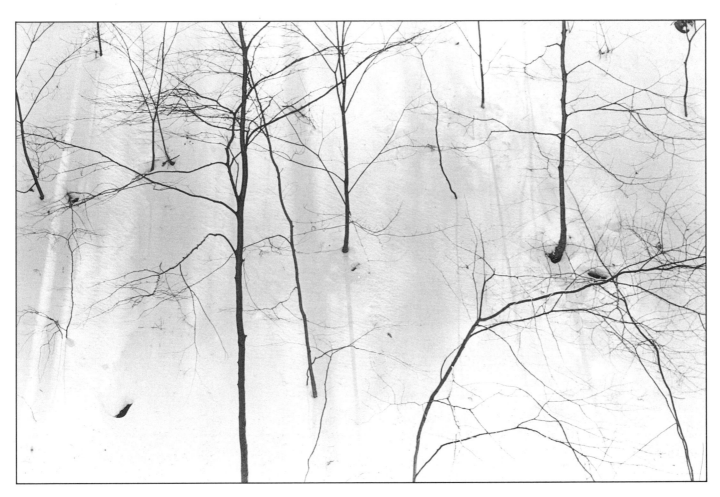

Relating Subject and Treatment

In these two snow scenes, the intent was primarily abstract: to convey a mood, and to illustrate the graphic qualities of snow.

The composition above is somewhat unusual in that there is no strong centre of interest within the frame. It is the lacy pattern of the saplings and their branches against the background of smooth, white snow that attracts attention, rather than the presence of any single element. Because the lines are gently curved, evenly distributed, and for the most part non-intersecting, the overall feeling is of a restful, tranquil pocket of nature. The message is no more grandiose than that this place, at this time, was characterized by a mood of serenity.

In the photograph at right, the mood is notably different. The strong graphic lines formed by the pattern of the pipes in juxtaposition to each other create a feeling of strength and tension that stands in sharp contrast to the mood of the woodland scene. The eye travels from the ends of the pipes along the zigzags and into the middle of the frame, where the patterns intersect in a maze of dynamic lines.

Except in completely abstract compositions, the application of a theme to a subject cannot be divorced from that subject, but must take into account its underlying nature. Thus, although both of these photographs were taken to illustrate the graphic possibilities of photographing in snow, the two images are significantly different because the underlying characters of the two centres of interest were significantly different. To compose a scene effectively, a photographer must consider and accommodate the natural characteristics of the objects he incorporates into the frame.

People

When a photograph includes people, due to some particularly human characteristics, a special task is added to the photographer's compositional responsibilities: that of ensuring the human subjects adequately support the photographer's message and therefore the composition.

Commonly, a photographer's purpose in including people in his photograph is to preserve an event and at some later date recreate the memory of it. In a compositionally competent photograph, this goal is achieved through the careful use of graphic, photographic, and colour controls to convey an idea. The problem is that human subjects, either through self-consciousness, shyness, lack of skills, or even perversity, cannot always fully co-operate. Consequently, part of composition consists of gaining—either openly or covertly—the needed degree of co-operation

CANDID SITUATIONS

One of the most effective means of gaining co-operation is simply to avoid artificial situations entirely. Human subjects who are unaware that a camera is present behave candidly. All of the problems associated with posing are eliminated. However, candid photographs by definition include an element of unpredictability. Images will be missed unless the photographer keeps a camera constantly by his side, in order to capture spontaneous actions as they occur. Moreover, the camera usually must be small and unobtrusive. In most candid situations, a 35mm camera is best.

POSING

Recreating a scene so that it appears to have been photographed candidly is a difficult task for most photographers. More often than not, the figures turn out looking wooden and unnatural. When circumstances do not allow candid photography, there are some principles a photographer can follow to improve his chances of producing satisfactory results.

First, he can try to place his subject in a comfortable, natural position. Nobody ever stands at attention looking straight ahead unless ordered to do so. Indeed, people spend hardly any time at all stand-

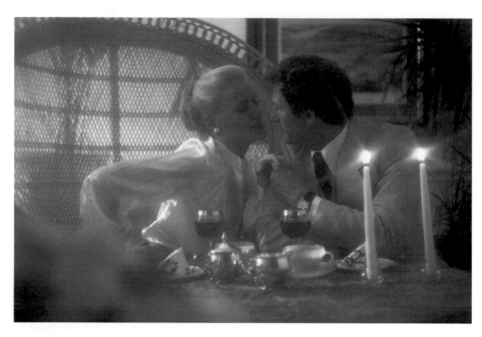

ing stock still. Poses that are more natural result when the subject is engaged in some meaningful activity, such as walking, rocking in a chair, leaning against a tree, or performing some other recognizable task. Especially important are hands and arms, which rarely should be allowed to hang idly by the subject's side. The person's hands should at least be folded or crossed, or, far better provided with an object to manipulate. Obviously, the exact positioning of arms and legs will depend upon the activity the subject is given to pursue.

Second, the photographer should remember that arms and legs can form lines of direction that must be controlled. The lines can usually be oriented to frame or point to the photographer's centre of interest—which may or may not be the person himself.

Third, the photographer should make full use of psychological lines. The direction of the person's gaze, the twist of a shoulder, the tilt of a head, all establish psychological lines that will affect a viewer's perception of the intent of the photograph. Facial expression is of course also important, but is difficult to control with amateur models.

However, human subjects can often be positioned so that their facial expressions are not apparent.

Some Thematic Examples.
In commercial photography, illustration photographers specialize in creating natural looking situations, often using artificial means. Any photographer can use the techniques illustration photographers rely on.
In the photograph on the previous page, every compositional element is chosen to suggest a feeling of intimacy: selective focus forms a psychological separation between the couple and the viewer, contributing to a sense that they are off in their own private world; the film and light source were mismatched, which produced a warm, yellow cast over the image; the candles form a frame that further isolates the couple; eye and hand contact between the man and the woman establish psychological lines between them, as does the thrust of the woman's arm and shoulder toward the man; and the gentle curved line of the chair directs attention onto the couple. Every element in this completely contrived photograph supports the idea that this is an intimate tete-a-tete in which the woman is clearly the aggressor.

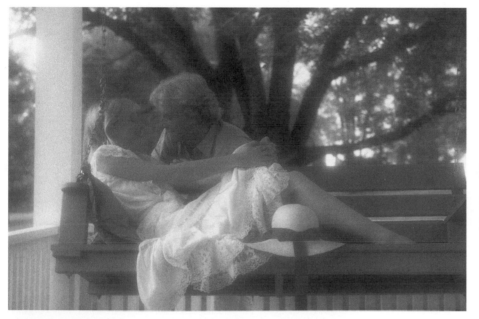

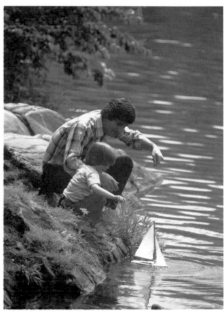

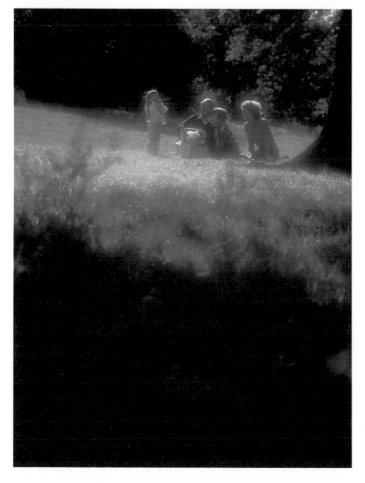

At left, above, is a similar, yet subtly different, photograph. In this case, compositional elements support the idea that the woman is rather willingly "trapped" by the man. She is boxed in by a line formed by the pillar and the lower edge of the swing, but certainly does not appear to be trying to escape. Delicate, warm, and gentle pastel colours produce an intimate feeling. The woman's relaxed body language suggests an ease and familiarity that contrasts with the slightly more rigid tenor evident in the body of the more aggressive woman in the previous photograph. Horizontal cropping complements the overall thrust of the figures in the photograph.

The two remaining photographers are candid family situations. At right, above, the father and son were first given something to do. Then the photographer positioned himself nearby and waited for the compositional elements to merge. At the instant this photograph was taken, the figure's arms were pointing to the boat, which is a point of high contrast

in the frame. This scene tells a delightful little story that contains more substance than the type of family setting in which the subjects are merely standing, looking into the camera.

At right, the family was told to prepare a picnic lunch, then the group went into a local park. Since the youngest member of a family is usually the most difficult to control, the photographer's tactic was to give her the most guidance, and instruct the other people to focus their attention on whatever she was doing. This approach meant that strong psychological lines were established between the girl and the other members of her family. Compositionally, the dark foreground creates a barrier between the viewer and the subjects, thereby established a feeling of privacy. Eventhough the family is small within the frame, they stand out clearly because the scene was taken with backlighting against a dark background. The predominant yellow and green tones contribute both to the freshness of the scene and to its warmth.

Working to a Theme:
The *Urban* Landscape

Earlier, the idea was presented that a photographer can benefit from working to a theme—that is, from selecting an idea that he strives to express again and again in a series of images, all the while refining both his idea and his technique. In this last section of the book, to illustrate the opportunities and advantages of working to a theme, samples are presented from two such excercises.

THEME: THE *URBAN* LANDSCAPE
In the late 1960s, Tom Grill returned to the United States following a two-year Peace Corps stint in Brazil. Not surprisingly, after his extended absence he saw his homeland through fresh eyes.

Knowing that what at first seemed novel would eventually again become commonplace, he set out to compile a series of images that would reflect his immediate impression of the constrast between the relatively primitive Brazil to which he had become accustomed, and the United States in which he suddenly found himself feeling like an outsider. These photographs have been extracted from a portfolio of images that Tom Grill shot to the somewhat sardonic theme. "The *American* Landscape."

Making Photographics Obvious.
Sometimes a photographer tries to de-emphasize in his photographs the fact that his images were produced by a camera. At other times, he may allow the camera's presence to be more apparant. That is, he allows the photographics to be obvious to a viewer.

In this instance, photographics dominate the image. A wide-angle lens produces strongly divergent lines, and unsally high contrast calls attention to the photographic process itself. An impression is created of people rushing toward the camera.

The feel of this photograph is very dependent on the use of early morning light. Because the scene is illuminated from behind, the human figures are silhouettes whose faces are lost in shadow. People are present, but they are nameless. Their world is clearly distinct from that of the viewer. The figures may be animate, but they somehow seem less than human.

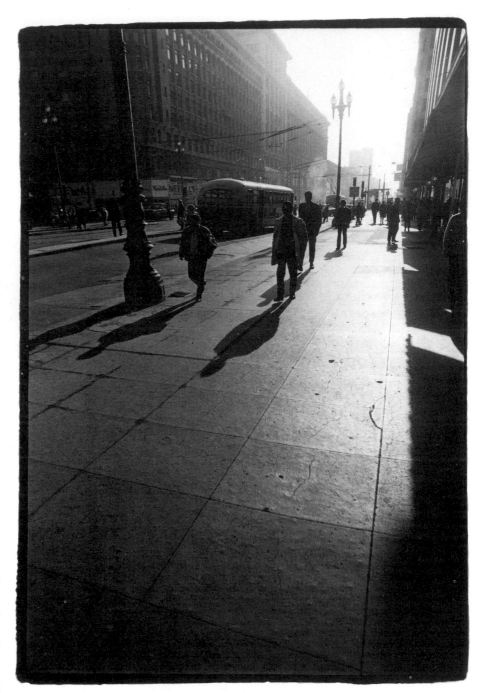

A Broken Convention
Under the right conditions, even widely-accepted conventions can be broken. For example, usually, a photographer does not want the viewer to sense that his photograph was taken from a moving vehicle. However, in the upper photograph, that fact is important to the photograph's message.

A striking characteristic of urban life is that people spend a large proportion of their time in automobiles. This photograph emphasizes that much of what people know about their country has been learned while gazing out the window of a car as it hurtles down the road. The message is reinforced by the placement of the lamp post. In a traditional composition, the lamp post would have been located on the left of the frame, pointing inward toward the centre. However, the placement actually chosen supports the idea that the viewer is streaking past the site. The line in the road and the angle of the railing underscore this effect. The result is that psychological movement is intentionally directed toward the edges of the frame.

The other elements of the photograph—the cloudless, detailless sky, the single, isolated lamp post, and the overall sparsity of objects within the frame—all contribute to an overall feeling of transience and sterility.

A Message from Imbalance
Intentional imbalance in itself can transmit a message.

Cutting off the car and placing it on an unusual angle elicits an unsettled feeling in a viewer. Moreover, the unappealing perspective makes the car look odd, even ridiculous. The viewer is forced to look at the car in a new way, to examine its shape with different eyes. In addition, even through a person is seated behind the wheel, he is faceless. The overall effect is to make the viewer reassess the role of the automobile in life.

Another compositional device active here is the use of lines and angles to lead the eye from the right side of the frame to the left. Also, high contrast between the car and the background makes the car stand out as the ultimate centre of attention.

129

A Critical Value Judgement

The network of highways in the United States comprises endless miles and configurations of concrete pathways. No one who spends any time at all on the interstate system can fail to note its impressive complexity, especially where highways merge and intersect.

In this photograph, sweeping, curved lines that repeat and interlace reflect the convolutions of highway interchanges. However, the stark feeling produced by the very high contrast of the scene indicates that the photographer views it critically. The overwhelming feeling is of cold concrete and a headlong rush to get from here to there. This image contains both an acknowledgement of the expertise that went into construction of the system, and a condemnation of the consequences.

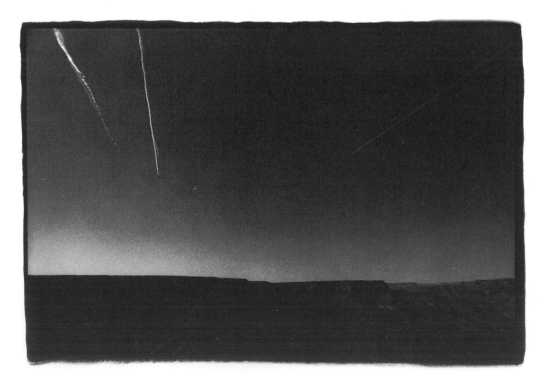

Omnipresent Transportation Technology

Hardly anywhere in the United States can evidence of transportation technology be avoided.

In this photograph, various techniques were used to emphasize the idea that in every corner of the country indications can be found that nobody stands still for long. A red filter over the lens blackened the sky, causing the jet contrails to stand out sharply. These contrails distract from the Grand Canyon, which is dark and devoid of detail. The result is that the canyon seems bland and uninteresting, existing as little more than a horizontal band across the bottom of the frame. Furthermore, the eye follows the converging contrails into the distance.

The conclusion seems to be that in the photographer's opinion, true wilderness no longer really exists as part of the American landscape.

Two Similar Yet Visually Diverse Statements.

When photographs are shot to the same theme, even significantly different treatments can yield closely-related statements. These two photographs contain many similar elements, yet they are composed quite differently. Nonetheless, although they are not identical, the statements share common threads. In the lower photograph, a wide-angle lens produces a sweeping image containing exquisite detail from foreground to background. All lines lead inward.

In the upper photograph, a tele-photo lens compresses many lamp posts into a two-dimensional plane of curves. Here, the viewer again responds to the dominance of the highway system, but instead of a feeling of isolation, the feeling is one of impingement. The comment is not just that the system exists, but that it is overwhelming and dominates everything else.

In one instance the message relates to the loneliness of isolation in a barren landscape, in the other, to the loneliness of endless repetition.

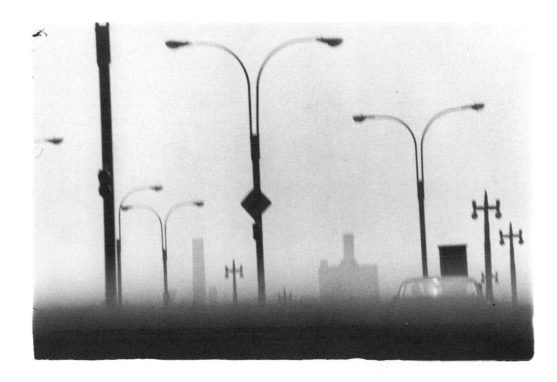

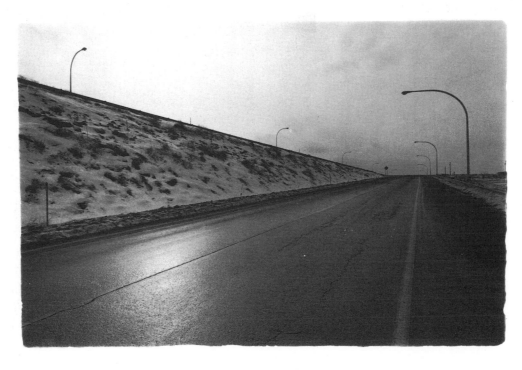

Working to a Theme: Structures

A photographer, or any artist for that matter, is inevitably a mirror of his times. Whether consciously or otherwise, he is influenced by the culture in which he lives and by the values of his peers. His perceptions, his opinions, and therefore his work, are coloured by external forces, and the nature of his work evolves just as inevitably as does his culture.

This final collection of photographs illustrates Tom Grill's response to the theme "Structures". An interval of ten years separates these photographs from those of "The *American* Landscape", and the difference in style is readily apparent. Yet compositionally, the goal is still the same: to use the camera to convey to a viewer the photographer's thoughts about the topic.

In shooting to the theme of "Structures," Grill sought to delve beyond the surface of man-made objects and make a statement about the relationship between an object's underlying design and its place in the world. In these photographs, the literal subjects are not very important. However, the influence of the theme produces strong similarities among the various images. The most apparent of these similarities is the use of soft-focus technique, which diverts attention away from the physical attributes of the objects in the photographs and opens the door for deeper investigation.

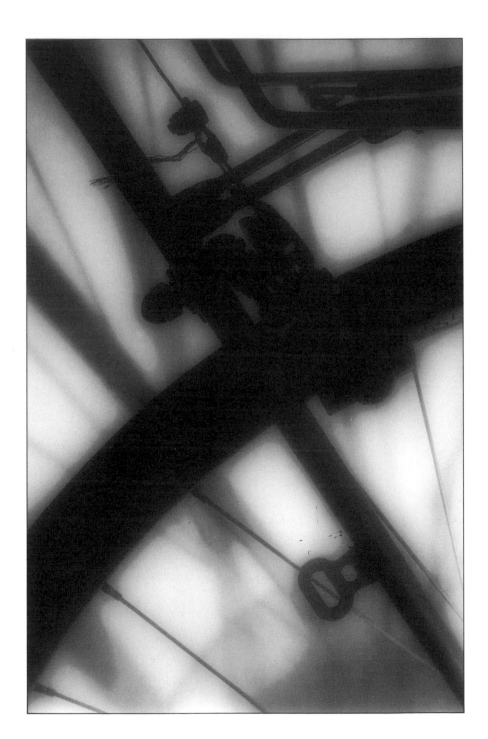

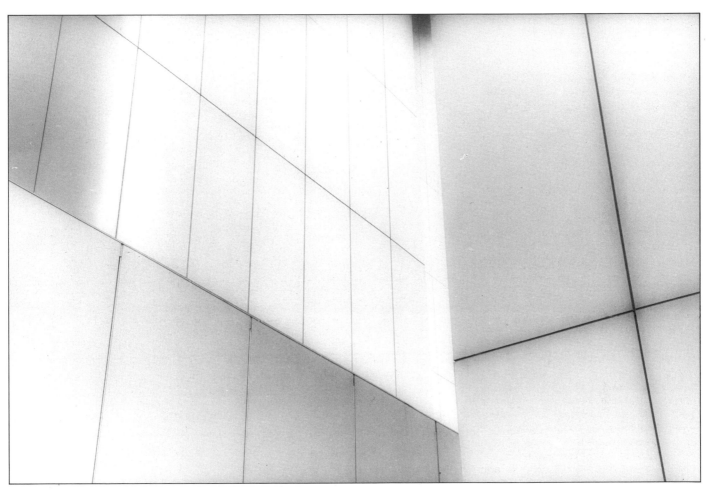

Behind The Design

Underlying any design is the mind of a designer. The intent of these two images was to demonstrate photographically how the structure of these objects, a bicycle and the walls of a building, reflect their designers' goals. The method used was to do within the photograph what the designer did in his design

In the photograph at left, shadowy shapes emphasize the two most important structural elements of a bicycle, its wheel and its frame. Similarly, the brake, which performs a forceful function on a bicycle, appears substantial. In contrast, the spokes, which seem to disappear when a bicycle is moving, are rendered as thin, light lines.

Many architects use design to counteract the massiveness that characterizes most buildings. In the building photographed above, the architect relied greatly on rectangular geometry and thin, clean lines to make the building seem light. Consequently, this photograph was carefully and intentionally composed in a manner that would convey to a viewer the same effect the architect wanted to achieve. The specific angle from which the image was taken, the orientation of the lines, and the overall high-key effect were all intentional and carefully controlled.

The result in both of these photographs is an image that reflects a slice of the designers intellect.

Two Geometric Designs

Geometry is an ever-present aspect of human experience to which these two compositions draw attention. Noticing the regular geometry of the images is unavoidable.

In both photographs underlying influences are apparent. Not only did someone have to decide how best to construct the benches, someone else had to decide where and how to place them. The small gap between the benches in the upper photograph as well as the exact placement of the bench in front of a fence in the lower photograph reflect conscious decisions made by someone trying to intergrate the design of the benches with their function.

Even the graffiti has an underlying, carefully-planned structure that is the product of someone's intellect. Of course, in this environment the graffiti artist's structure conflicts with that of the bench's designer, but the photograph's composition marries the two designs visually.

A Meeting of Design and Time

In contrast to the extremely utilitarian structures portrayed in the four previous photographs, this structure, which is part of a highway entrance ramp, incorporates a desire on the part of the designer to decorate his creation. Nonetheless, the ramp was designed to serve a practical function that is clearly suggested by the regular pattern of the rivets and the presence of hard, straight lines.

In a way, this photograph evokes the history of the ramp and its relationship to the culture in which it exists. A viewer can deduce from the image that the ramp was originally designed to serve both functional and aesthetic purposes, and over the years has been extensively used.

Currently, the ramp has fallen into disrepair and is no longer well-regarded by the populace it serves (as suggested by the presence of refuse). Thus, this composition portrays the ramp as a record of the way design interrelates with time, the changing attitudes of society, and reality.

Just as structures exist as the extensions of men's minds, so do photographs. The images in this last section reflect one man's ideas and perceptions. Another person shooting to the same theme and viewing the same scenes would have composed his photographs differently. Why? Because composition is the means by which a photoghaper expresses himself. And expression is the soul of photography.

A FINAL THOUGHT

Composition is a subject that photographers have traditionally been afraid to confront. The widespread misconception has been that one must be a full-fledged artist to attain mastery of this arcane topic.

Our hope is that the reader has come to realize that composition is an integral, inescapable, yet manageable part of photography. Every photograph has a composition, and that composition can be made to contribute to the expression of the photographer's ideas. We trust that the information we have provided has made the topic of composition not only learnable, but enjoyable, and wish our readers well in their pursuit of both the craft and the art of photography.

TECHNICAL DATA

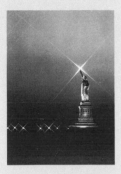

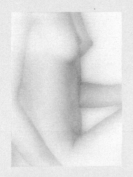

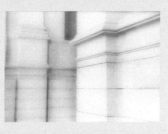

Page 30. Camera: Leica M4 Lens: 35mm. Exposure: 1/30 sec. at ƒ/5.6. Film: Kodak Tri-X rated at ISO 400
For this scene, taken in Paris's Louvre Museum, I wanted as extensive a depth of field as possible. However, rules forbade me from using a tripod. Therefore, since I was forced to hand hold the camera, I took many separate exposures in the hope that at least one would turn out.
Because I did not want the vertical lines to seem to converge, I had to make certain that the back of the camera was exactly parallel to the wall. In order to be sure that at least the objects in the foreground would be sharp, I made the near column my point of focus. Then, when printing the images I used a diffusion filter over the enlarger lens to equalize the apparent sharpness from front to back.
The lighting in the museum was uneven, so during printing I dodged the left side of the image to hold back the shadows and thereby equalize the tones.

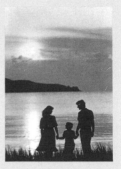

Page 17. Camera: Nikon Lens: 200mm with star filter. Exposure: 4 sec. at ƒ/5.6. Film: Kodachrome 25.
The photograph was taken without any alteration except for the use of a star filter. I intentionally chose a slow shutter speed to smooth out the water, which was a little choppy.
This photograph is a classic sample of the use of the Rule of Thirds. Notice how the frame is divided into thirds both horizontally and vertically by the elements within the frame.

Page 19. Camera: Nikon. Lens: 105mm. Exposure: Electronic flash at ƒ/11. Film: Kodak Plus-X
I used a ringlight to illuminate the woman's figure, specifically because a ringlight produces a pencil outline. Also, the ringlight tends to flatten out three-dimensional objects. By placing the woman close enough to the white background so that it also is properly exposed, I achieved good constrast between the pencil outline around the woman and the wall behind her.
In printing, I placed a diffusion filter over the enlarger lens to eliminate grain and surface detail and under-exposed the image to produce a high-key effect that further accentuates the outline.

Page 34. Camera: Nikon. Lens: 55mm with orange filter. Exposure: 1/250 sec. at ƒ/8. Film: Kodachrome 64.
In order to make this a mood shot rather than a photograph of a particular family at a particular place. I took a number of steps: I lay down in the grass to hide the fact that the family was standing on a beach, shot the grouping as a silhouette, and added colour to the scene by means of an orange filter.
I had to position myself carefully to keep the silhouettes from overlapping the island projecting from the left and to keep the woman's figure to the side of the sun's reflection on the water. Moreover, it was important to keep the outlines of the various family members from overlapping.

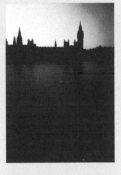

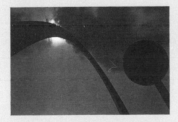

Page 17. Camera: Nikon Lens: 20mm with purple filter. Exposure: 2 sec. at ƒ/4. Film: Kodachrome 25.
The most critical aspect of this photo was timing. The sun had just set, so the sky was still light enough to form good silhouettes. However, I knew that I had only a few minutes before the lights used to illuminate the facades of many of the buildings would be turned on. Therefore, I had to be prepared to take the shots quickly, with a minimum of fumbling around.
Note in this photograph that in order to emphasize the sky and the outline of the city, I placed the horizon in the upper third of the frame. The purple colour comes from a filter.

Page 29. Camera: Nikon Lens: 20mm. Exposure: 1/60 sec. at ƒ/5.6. Film: Kodachrome 64.
I intentionally underexposed this photograph in order to eliminate detail in the foreground lamp. The day was cloudy, but the sun was still strong enough to produce the silhouette I wanted. As might be expected in such a highly graphic composition, much of my effort was devoted to finding exactly the right place to locate the camera.
My original purpose in photographing the Gateway Arch in St. Louis was simply to obtain some pictures of it for my files . Therefore, I spent most of my time photographing it as an identifiable object. Only after I was through with that task did I let my imagination completely loose. I was not surprised to find that the most enjoyment I experienced during this trip was from producing these few abstract images once the "chores" were over.

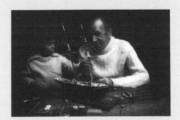

Page 35. Camera: Nikon. Lens: 50mm. Exposure: 1/125 sec. at ƒ/2.8 Film: Ektachrome 400
My goal here was to capture the unique bond that exists between a grandfather and his grandson. To this end, I wanted a soft, filtered light that I achieved by bouncing light from a tungsten-filament floodlamp off a sheet of white cardboard. The warm yellow tones result from the mismatch between film and light source.
White clothing makes the figures stand out against the dead black background, produced by using a bolt of black velveteen. The sawdust and wood shavings on the table add authenticity and help obscure the fact that this photograph was shot in a studio.

Page 41. Camera: Hassleblad. Lens: 150mm Exposure: 1/15 sec at ƒ/32. Film: Kodak Plus-X.

I knew that this shot would work only if extremely sharp, but I was standing so close that depth of field was a problem. Therefore, despite the presence of bright sunlight, I was forced to use a tripod.

By metering different parts of the scene carefully, I determined that the range of tones present was too broad for the film to be able to hold both bright highlights and deep shadows. Consequently, I compressed the tones by overexposing one ƒ-stop and then developing at three-quarters of standard development time.

Page 43. Camera: Nikon. Lens: 20mm. Exposure: 1/4sec. at ƒ/16. Film: Kodachrome 25.

The trick here was to keep the sun from washing out a large area of the frame. By locating a branch in front of the sun, I cut its intensity just the right amount. With the wide-angle lens and because I was using a tripod, I had no problem with depth of field.

Page 48. Camera: Leica M2. Lens: 35mm with red filter. Exposure:1/250 sec. at ƒ/8. Film: Agfapan 100.

The cupola on this barn was illuminated by early morning light. I wanted the image to print dark, so I set the lens to one and one-half ƒ-stops less than the incident meter reading. The red filter produced a black sky, and a diffusion filter held below the enlarger lens softened the sharpness of the image.

In composing the scene, I intentionally made the cupola small in the frame to make it obvious that the cupola was centered. This size makes the asymmetry of the paneless window more apparent. Without the presence of the horizontal line at the foot of the cupola formed by the peak of the roof, the cupola would have seemed to be floating in space.

Page 54. Camera: Nikon. Lenses: 50-200mm zoom, 55mm, and 35mm. Exposure: (several of varying length). Film: Kodachrome 25.

This shot, consisting of nine separate exposures, was very difficult both to plan and to execute.

I wanted to produce an image that would convey to a viewer the impression one receives that Times Square in New York City is a mass of lights. Actually, although lights certainly do abound there, no single vantage point permits a view that would fill the frame with as many lights as I was seeking to include.

My solution was to make a multiple exposure. Knowing that a major problem would be keeping track of which sections of the frame had been exposed and which were still blank, I exchanged the normal ground glass screen in my Nikon for a screen with a grid pattern on it. Also, I packed a tripod.

For the first exposure I used the zoom lens with a star filter attached. For the second, I took exactly the same shot, but this time without the filter and with the lens twisted far out of focus. This produced the large balls of light. The pattern formed in the first exposure by the star filter works with the large balls to form an overall geometric pattern.

For the remaining shots, I had to keep in mind which sections of the frame were still blank and which had already been exposed, while adding theatre signs one by one. In each case, to obtain the correct exposure setting, I had to take a spot reading using a telephoto lens, then, without changing the exposure settings, switch to the actual lens to take the shot.

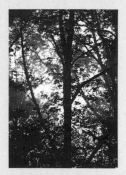

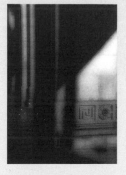

Page 42. Camera: Nikon. Lens: 200mm with sepia filter. Exposure: 1/15 sec. at ƒ/16. Film: Kodachrome 25.

In this shot, I particularly wanted to produce a layered look. Normally, the 200mm lens would have compressed the scene so that everything would appear to be more or less on the same plane. However, in this case, the effect of atmospheric haze preserved a feeling of separation between the foreground and background. Shooting into the sun made the haze particularly noticeable.

Had the scene been more colourful, the filter would not have been necessary. Since the leaves were rather dull, the sepia filter both added colour and helped unify the composition.

Page 45. Camera: Leica M2. Lens: 50mm. Exposure: 1/125 sec. at ƒ/16. Film: Kodak Plus-X

Although I printed this photo mainly as a collection of greys, the actual scene was composed of white marble illuminated by direct sunlight.

The scene seems static, but it required a fair amount of patience to shoot. The diagonal that runs from upper right to lower left was the shadow produced by a flag. Since the flag was waving in the breeze, I had to anticipate when it would be in the right position.

Despite the fact that the subject is identifiable as a building, this is primarily a graphic composition dependent mainly on the strongly geometric use of line.

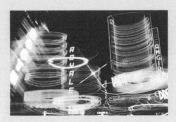

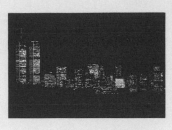

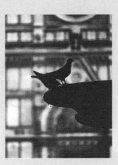

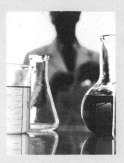

Page 55. Camera: Nikon. Lens: 35mm. Exposure: 1 sec. at ƒ/5.6 and 1/15 sec. at ƒ/5.6. Film: Kodachrome 25.

Here I wanted both to create a dynamic feeling and at the same time to make the scene identifiable as being "Broadway".

For the first exposure, I made a one-second time exposure while moving the camera in a circular motion. To get a smooth pattern, I started the camera moving before releasing the shutter and continued the movement until after the shutter had closed.

For the second exposure, I set the camera on a tripod and photographed a group of signs that clearly define the location.

Page 59. Camera: Nikon. Lens: 200mm with magenta filter. Exposure: 2 sec. at ƒ/4.5. Film: Kodachrome 25.

The key characteristic of this photograph is a careful harmony of light. The sun was just setting behind the camera, and warm rays were striking the faces of some of the buildings. The same rays were hitting the near edges of the World Trade Centre towers, producing the sharp vertical lines.

Because I wanted to make a strong colour statement, I knew that timing would be critical. There would only be a short period of time as the sun was going down when the sky would be light enough to produce a good outline of the city and at the same time pick up enough colour from the filter to form a colour bond with the cityscape. I shot almost a roll of film, but even the photos I took shortly before and after this one were noticeably inferior.

Page 65. Camera: Nikon. Lens: 200mm. Exposure: 1/250 sec. at ƒ/4.5. Film: Kodachrome 64.

Although I focused on the bird in order to give this shot visual impact, this is really a photograph of the building. Therefore, my exposure was based not on the birds, but on the face of the building.

As is often the case with living subjects, gaining co-operation is not always easy. In total, I shot an entire roll of film on this scene, trying to anticipate when the moving silhouettes of the birds would be clearly defined. Only this shot and one other turned out to be acceptable.

Luckily, the fast shutter speed I needed to freeze the birds' motions also permitted me to use a wide lens aperture for a strong selective focus effect.

Page 65. Camera: Nikon. Lens: 105mm. Exposure: Electronic flash at ƒ/4. Film: Kodachrome 25.

The most difficult aspect of this photograph was the lighting. I wanted an overall white effect, with the liquid (which consisted of food colouring dissolved in water), the only source of colour. To light the liquid, I placed the beakers on a sheet of translucent acrylic plastic with floodlights underneath. I situated the man against a background of white seamless paper illuminated directly. Large white reflectors bounced light from the background onto the front of the man. I took the exposure reading through the beakers, then adjusted the intensities of the lighting on the man and the background so that they would be in balance with the light passing through the liquid. By experimentation, I was able to locate the optimum distance for the man to stand behind the beakers to generate the amount of blurring I wanted.

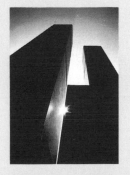

Page 58. Camera: Nikon. Lens: 20mm with star filter. Exposure: 1/250 sec. at ƒ/8. Film: Kodachrome 64.

The problem in this shot was to manœuvre myself so that the sun would peak out just enough to form the point of highest contrast without allowing the sky either to wash out or causing it to be rendered black. In addition, I adjusted my angle of view carefully so that the white line between the buildings would be slim, thereby adding a feeling of delicacy and fineness to a subject that is normally thought of simply as being massive.

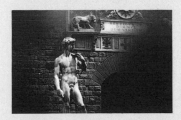

Page 65. Camera: Nikon. Lens: 35mm. Exposure: 1/500 sec. at ƒ/4.5. Film: Kodachrome 25.

This type of selective focus photograph, in which the foreground is extremely close to the lens, almost *demands* a single lens reflex camera. With a rangefinder camera, it is difficult—if not impossible—to tell exactly where the foreground elements will fall within the frame. The closeness of the foreground flower made it so unrecognizable that its compositional role is only to act as a frame and to add a touch of colour to the scene. The statue's legs are cutt off for a very practical reason; tourists surrounding its base would otherwise have been included in the frame.

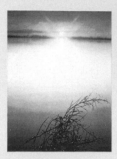

Page 69. Camera: Nikon. Lens: 55mm. Exposure: 1/250 sec. at f/2.8. Film: Kodachrome 25.

When a star filter is being used, the sharpness of a star is determined by how sharply in focus the light source is. In addition, some filters generate stars with more than four points, and others produce rays that are either finer or wider than the ones produced here. (The fineness depends on the number of lines per millimeter engraved in the glass.) If a star filter is used to photograph a scene that does not contain a sharp light source, the only effect is to diffuse the overall image.

In this photograph, the main compositional role of the arms of the star is to act as a frame around the bush.

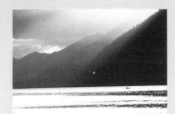

Page 73. Camera: Nikon, Lens: 200mm. Exposure: 1/30 sec. at f/4.5. Film: Kodachrome 25.

The centre of interest of this photograph, the fishermen in the small boat, could easily have been lost because of their small size. The reason that the boat attracts attention is that strong diagonal lines point to the boat, which is distinctly outlined against a bright background.

Although the boat is the photograph's centre of interest, most of the message comes from the intrinsic graphic aspects of the other elements within the frame. The horizontal lines help the scene seem peaceful, and the muted tones emphasize the feeling of calm. Moreover, the small relative size of the boat contributes a feeling of isolation. The abstract qualities of the photograph—the sweep of the lines, the subtle tones, the placement of light and dark areas—all bespeak a feeling of calm. Take away the boat, and a coherent—though somewhat different—photographic statement remains.

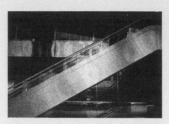

Page 74. Camera: Leica M4. Lens: 35mm. Exposure: 1/500 sec. at f/11. Film: Kodak Recording Film.

This film, which is used primarily for surveillance purposes, has a pronounced grain structure and generates a high-contrast image. Developing the film in Dektol (a paper developer) for approximately 2 minutes at 75° F (24° C) further increased the grain and helped reduce the contrast.

This photograph is primarily a study in lines, light, and shadow. The broad diagonal moving from lower left to upper right is counterbalanced by the downward-moving line formed by the shadow in the upper portion of the frame.

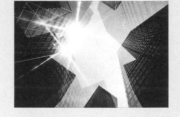

Page 77. Camera: Nikon. Lens: 24mm. Exposure: (Double exposure). Film: Kodachrome 25.

This photograph resulted from a double exposure. I took one exposure using a star filter combined with a magenta filter, and the other using only a blue filter. My goal was to find buildings with a distinctive geometry. The filter produced an interesting colour pattern and generated good colour contrast between the shapes.

The strong star effect is compositionally important because it creates a focal point within the photograph and increases the feeling of angularity that I was trying to convey.

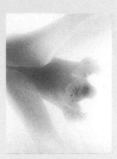

Page 79. Camera: Nikon. Lens: 55mm. Exposure: 1 sec. at f/11. Film: Kodak Tri-X.

The light I used to take this photograph came from a window covered with a thin, white curtain. I placed the orchid on white paper, then added fill light by surrounding the flower with white cardboard reflectors.

To further soften the image, I placed a diffusion filter over the camera lens. I could have used the filter below the enlarger lens when I printed the negative, but that would have eliminated the appearance of grain.

I overexposed the frame by one and one-half stops above the meter reading in order to produce the high-key effect.

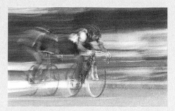

Page 82. Camera: Nikon. Lens: 105mm. Exposure: 1/15 sec. at f/16. Film: Kodak Plus-X.

There is no reliable way to estimate the best shutter speed to use when panning with a moving subject. When shooting a racecar, 1/250 sec. might be too slow, whereas when shooting a person walking, 1 sec. might be too fast. As is usually the case in this type of situation, I simply estimated what I thought the best shutter speed would be and then took plenty of exposures, some at faster speeds and some at slower speeds. In this instance, the exposure taken at 1/15 sec. turned out to be best.

The most important determinant of the success of a pan is the timing of the camera movement. Almost always, the best effect occurs if the panning motion is started before the shutter is released and continued until after the shutter closes again.

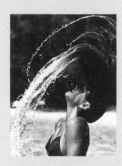

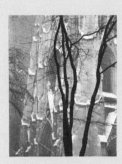

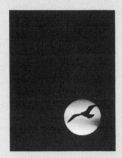

Page 83. Camera: Nikon. Lens: 55mm. Exposure: 1/1000 sec. at ƒ/4. Film: Kodachrome 64.

In general, I prefer to use Kodachrome 25, but sometimes the extra stop-and-a-half of speed attainable with Kodachrome 64 is important. Such was the case here. Notice that even at a shutter speed of 1/1000 sec., blurring occurred where the woman's hair and the water flying off it were moving the fastest.

Compositionally, the problem was to orient the girl so that the water flying from her hair would contrast well with the background. Backlighting did the trick.

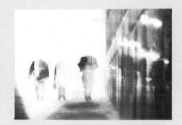

Page 85. Camera: Nikon. Lens: 400mm. Exposure: 1/8 sec. at ƒ/8. Film: Ektachrome 400 rated at ISO 800.

I took this photograph in the late afternoon of a winter day, so the actual scene was significantly darker to the eye than is apparent here. Since I wanted a blur motion effect, the slow shutter required by the dark conditions did not bother me. In fact, I stopped the lens down to ƒ/8 to keep the shutter speed slow.

Usually, when I want to create a blur motion effect through camera movement, I start the camera moving before I press the shutter button. However, in this case, I wanted to be sure that at least some of the image would be sharp. Therefore, at the instant I released the shutter, I was holding the camera still, but then started it moving immediately thereafter.

Page 87. Camera: Hasselblad. Lens: 150mm. Exposure: 1/60 sec. at ƒ/22. Film: Kodak Plus-X.

Many photographers are under the mistaken impression that camera motion will not affect image sharpness unless the shutter speed is 1/60 sec. or less. In fact, even at what most people consider high shutter speeds (1/250 sec. and above), hand movement can easily result in an image that is less than perfectly sharp. Consequently, whenever I want the sharpest possible image, I make it a point to use a tripod and cable release, regardless of shutter speed.

The use of a tripod and cable release helps account for the extreme sharpness here. It is true that I was using a high-quality, fine-grain film, a medium-format camera, and had stopped the lens way down, but even at a 1/1000 sec. shutter speed, had I held the camera in my hand, the sharpness of the image could have been inferior to the sharpness evident here.

Page 90. Camera: Leica 3F. Lens: 90mm. Exposure: 1/60 sec. at ƒ/8. Film: Kodak Tri-X rated at ISO 400.

This photograph was quite dependent on the weather conditions prevailing at the time—specifically, snow. The snow serves two compositional functions: without it, the details on the church's facade would not have been well defined; and the presence in the atmosphere of falling snow, which has little effect on the foreground tree, causes the image of the church in the distance to appear somewhat diffused. As a result, the silhouette of the tree contrasts well with the background.

Viewing this scene, I was struck by the comparison between the meandering pattern of nature versus the structured pattern of the church. The layered look of this photograph helps convey that impression by causing a viewer's attention to shift back and forth between the fore-ground and the background. Notice that in selecting the exact position from which to take the photograph, I took care to superimpose the branches of the tree over the duller sections of the facade.

Page 96. Camera: Nikon. Lens and Exposure: (Double Exposure). Film: Kodachrome 25.

This type of photograph is almost impossible to take naturally; instead, a film "sandwich" must almost always be made.

First, I took a series of photographs of seagulls against an overcast sky, overexposing the film so that the gulls would appear as silhouettes surrounded by a perfectly clear area on the film. At another time, I shot a series of sunsets, using no filters or alterations of any sort. The photograph shown here I formed by taking a single frame from the seagull series and laying it on top of one from the sunset series. I removed the pieces of film from their respective slide mounts, combined them in a new mount, then copied the sandwich using a slide copier.

In selecting the frames to use, I intentionally chose two in which the psychological thrust of the gull would appear to be simultaneously into the body of the sun and into the overall frame.

Index

143